SUPER-VILLAINS

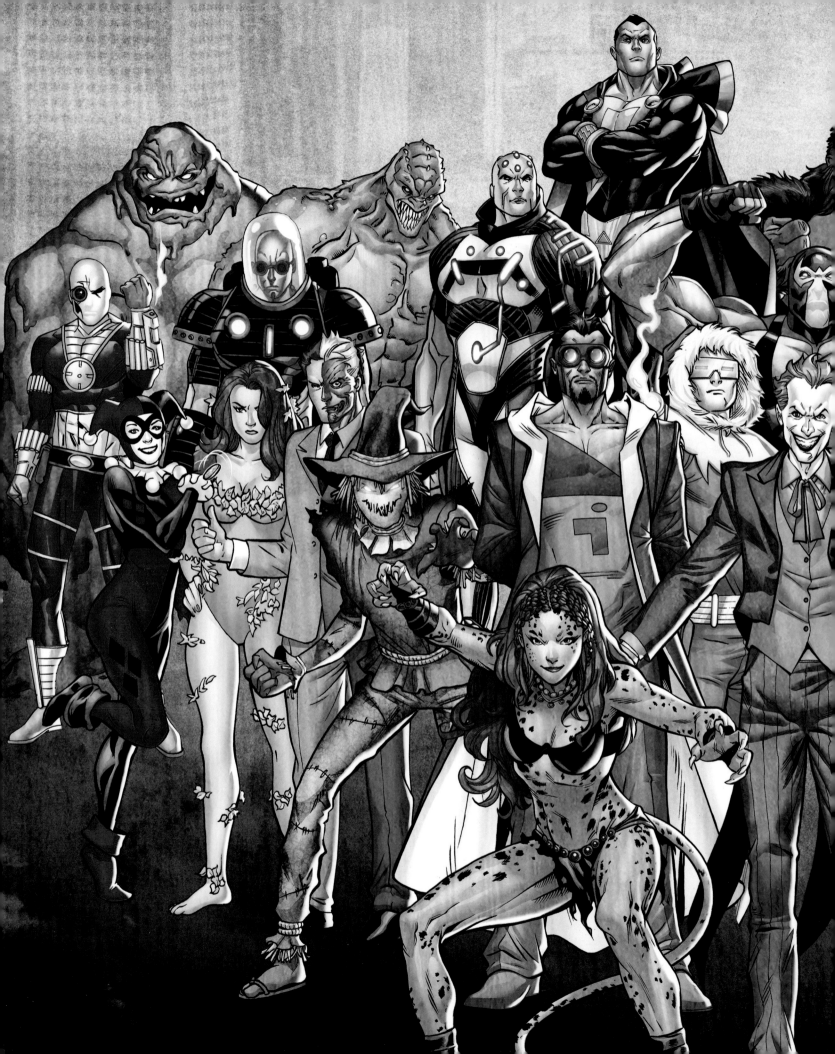

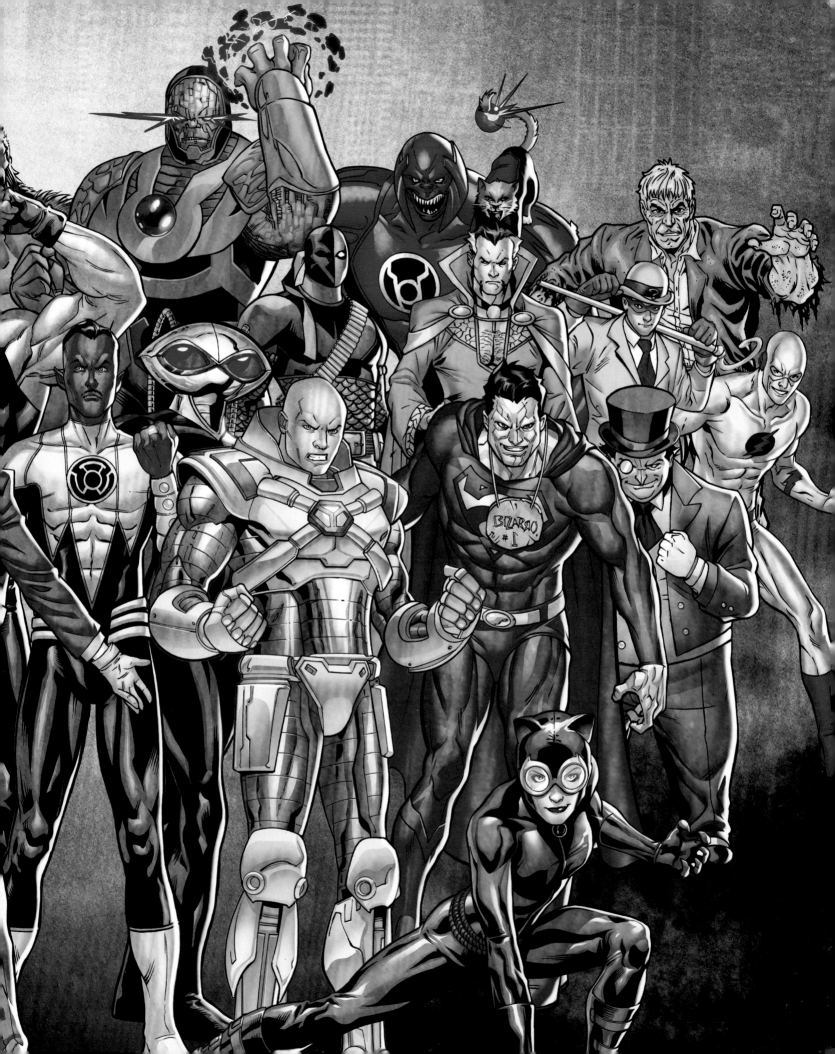

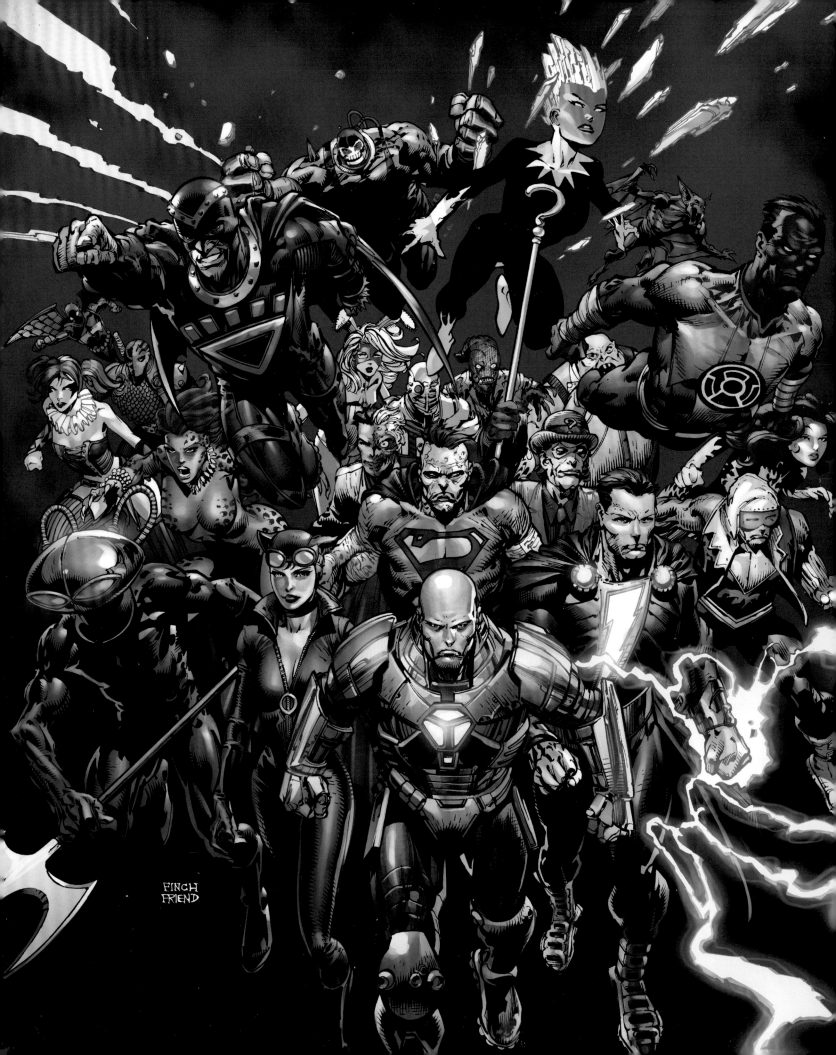

SUPER-VILLAINS

THE COMPLETE VISUAL HISTORY

WRITTEN BY DANIEL WALLACE

FOREWORD BY KEVIN SMITH

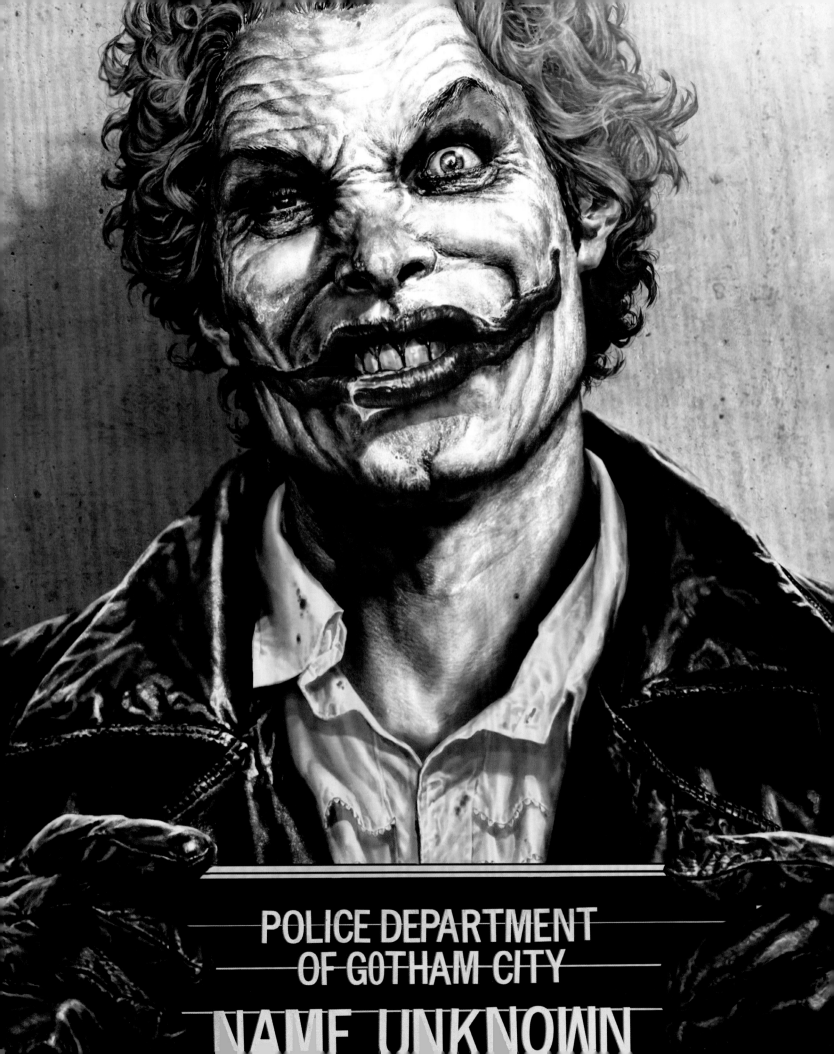

CONTENTS

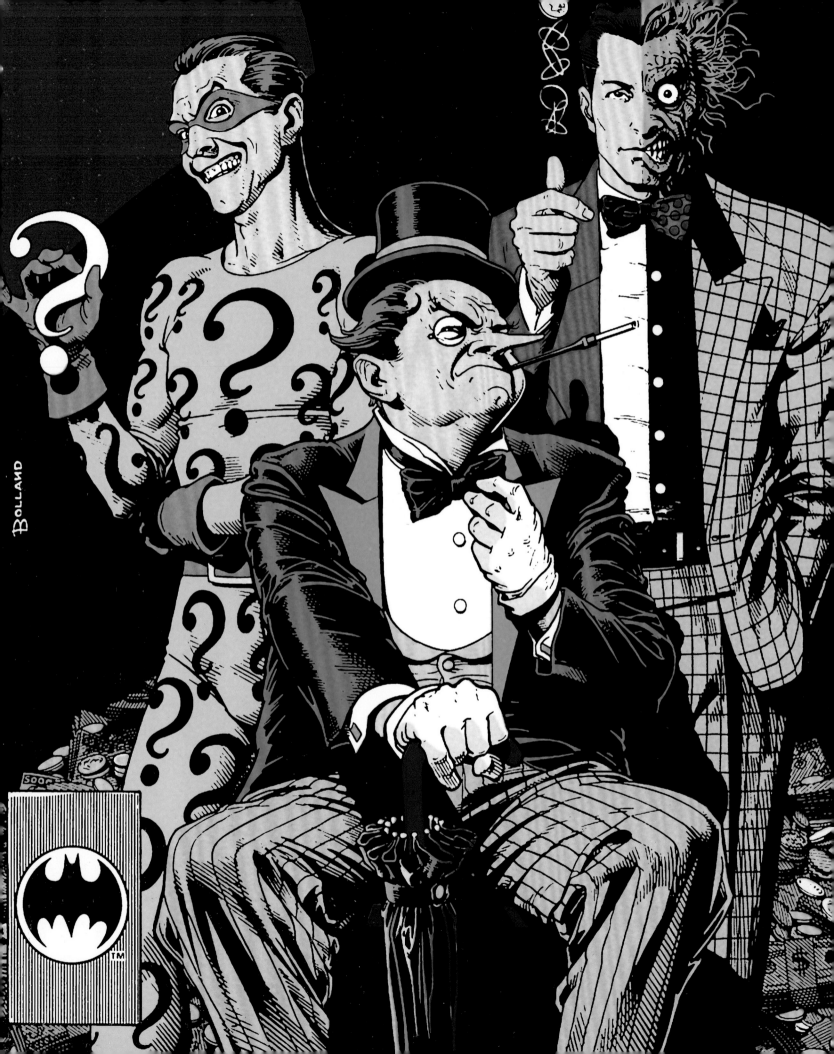

FOREWORD

ON BEING BAD

If you're ever in conversation with someone who suddenly speaks with admiration about his or her favorite serial killers, walk away.

Conversely, if you're ever engaged on the subject of comic book baddies by a fan of such, buckle up for the show of a lifetime—because our type tends to speak with the eloquence of Socrates when discussing super-villains. We carefully measure psychotic deeds against questionable haute couture to arrive at a metric for our criminal affection that is so complicated (both mathematically and psychologically), it'd make Pythagoras quit numbers forever.

When I was a kid on the school playground and my classmates were choosing who'd play which position in Wiffle Ball, I'd always wind up in left field—where no Wiffle Ball ever travels. Sports were not my thing: The world of cartoons and comic books was where I lived and breathed. So every afternoon, I pushed to play "Challenge of the Super Friends"—based on the Saturday morning cartoon renditions of all our favorite DC Super Heroes. It was this simple: If I could sway enough of my classmates to choose fantasy over the dopey tetherball line, we'd leave the athletics to the athletes and head for the Hall of Justice.

Now, whenever Wiffle Ball bats were cast aside for Batman, it was my job to assign the roles. In a prototypical exercise of what would later become my profession (telling people to pretend to be someone else for a little while), I'd cast our lunchtime adventure based on my friends' personalities. So Janine would be Wonder Woman. John would be Superman. Mike would be Batman. Chris would be Aquaman. But with the big guns spoken for, which role would the game master play? Each and every time we trod the boards as the Super Friends during grade school recess, I'd squeeze into an imaginary wet suit and become Black Manta.

The Joker? Lex Luthor? Cheetah? Morons. My favorite villain in childhood was a ▢▢▢ Black Manta. Black Manta's creators gave him an elegant Darth Vader-ish black suit with giant, illuminated eyeholes. And, as depicted in *Challenge of the Super Friends*, he spoke through a voice modulator—which made him sound like a

you could see the greedy humanity and angry eyebrows employed to distinguish the bad guys and girls from their law-abiding counterparts. Manta's face, however, was buried in a giant metal helmet, his humanity hidden completely, so you could easily imagine him as a deep-voiced killbot who swam with sharks. The Black Manta in *Challenge of the Super Friends* was the villain of choice for any kid who loved both *Jaws* and *Star Wars*.

Thank Grodd we have comic book villains to assuage any real interest in being bad. And nobody does a Rogues Gallery better than DC Comics. Whether tragic victims of circumstance or evil incarnate, the villains of the DC Universe loom large throughout not just pop culture but culture in general. In a world where even my mom could describe the Riddler for a police sketch artist, DC Comics super-villains have captured imaginations and built a big, bad brand that travels far beyond the fan base.

And it's fine to be a fan of these shimmering psychopaths, each colorful character more hell-bent on domination than the next. We have to quietly cheer them on—if for no other reason than to invoke the heroes who always vanquish these nefarious foes and fools. It's omelets and eggs: You can't have good guys without the bad guys.

So as you flip through these pages, should you feel an inexplicable affinity for Captain Boomerang or Doomsday, it doesn't mean you need to talk to a therapist or priest. Rooting for a DC Comics super-villain is half the fun of reading a DC comic book. And as long as the other half of the fun involves wanting the DC Super Heroes to bust with the justice and make it all better again, you're doing it right.

But if you ▢▢▢ Batman and love the Joker, seek help.

—Kevin Smith

INTRODUCTION

If heroes are defined by the challenges they face, there's a big question worth asking: Without villains, how could heroes exist at all?

In the world of comic books, mutated psychopaths and lab-coated masterminds have always plotted to take over the world. Their struggles have provided the conflict behind thousands of four-color adventures, making super-villains one of the driving forces behind the 20th and 21st century success of comics as an industry and an art form. Without the Joker to bedevil Batman or Lex Luthor to challenge Superman, the DC Universe might never have achieved its current state of multimedia dominance.

Action Comics #1 (June 1938) ushered in the era of the Super Hero. That issue and the rush of comics that followed welcomed Superman, Batman, Wonder Woman, and other paragons into the Golden Age of Comics. But the same period saw the debuts of Lex Luthor, the Joker, the Cheetah, Two-Face, and Solomon Grundy. As soon as writers and artists realized their costumed stars didn't have to fight nondescript gangsters, the antagonists in comics became equally as colorful.

"Playing bad is more fun," admits prolific DC Comics writer and editor Mike Carlin. "It's a way to break the rules. Everybody has that side to them, where they want to do something they're not supposed to do. These characters allow us to act out those fantasies."

The prevailing mood of each decade influenced the villains who starred in it. The sci-fi fun of the Silver Age birthed alien invaders like Brainiac and super-intelligent simians like Gorilla Grodd. During the Bronze Age of the 1970s, comics found room for global ecoterrorists like Rā's al Ghūl.

"We're always building on whatever the fears of society are," explains DC Comics copublisher Dan DiDio. "Villains are very contemporary in their actions and behaviors. And there's a core to each one in what they stand for, something that resonates across generations."

What gives DC Comics' villains such staying power? One answer came in the 1980s, when the company erased the continuity of its comic books with the series Crisis on Infinite Earths and started over from scratch. The post-Crisis Lex Luthor carried a new backstory, but his essence remained.

"Every decade, certain fashions will be in and others will be out," says artist and DC Comics copublisher Jim Lee. "Super-villains also go through a cycle of what looks hip or contemporary. But there are timeless elements to every character that capture what they're all about, symbolically and graphically."

Those core elements are what keep DC Comics' stable of super-villains in top shape no matter where they appear: in animation, movies, television, or video games. And the comics universe keeps presenting more opportunities for reinvention, with 2011's New 52 event delivering makeovers for nearly every hero and villain in the DC Universe. What's more, the 2016 Rebirth event validated some previous storylines and character histories, once again fine-tuning and refining the DC Universe and its heroes.

DC Comics' super-villains embody archetypes—trickster, warlord, monster, lunatic—and those traits shine through no matter what surrounds them. "Archetypal characters have a theme that makes them memorable," says writer Chuck Dixon. "What does the Riddler do? What does the Joker do? Even people who have never read comics understand their *modus operandi*. The theme is indelibly bonded with their appearance."

With a publishing history going back eight decades, DC Comics has seen the creation of thousands of villains—but the ones between these covers are the best of the best. Each character has been shaped by the talents of numerous writers, artists, and editors as they pass the baton to the next team in the collaborative world of comics.

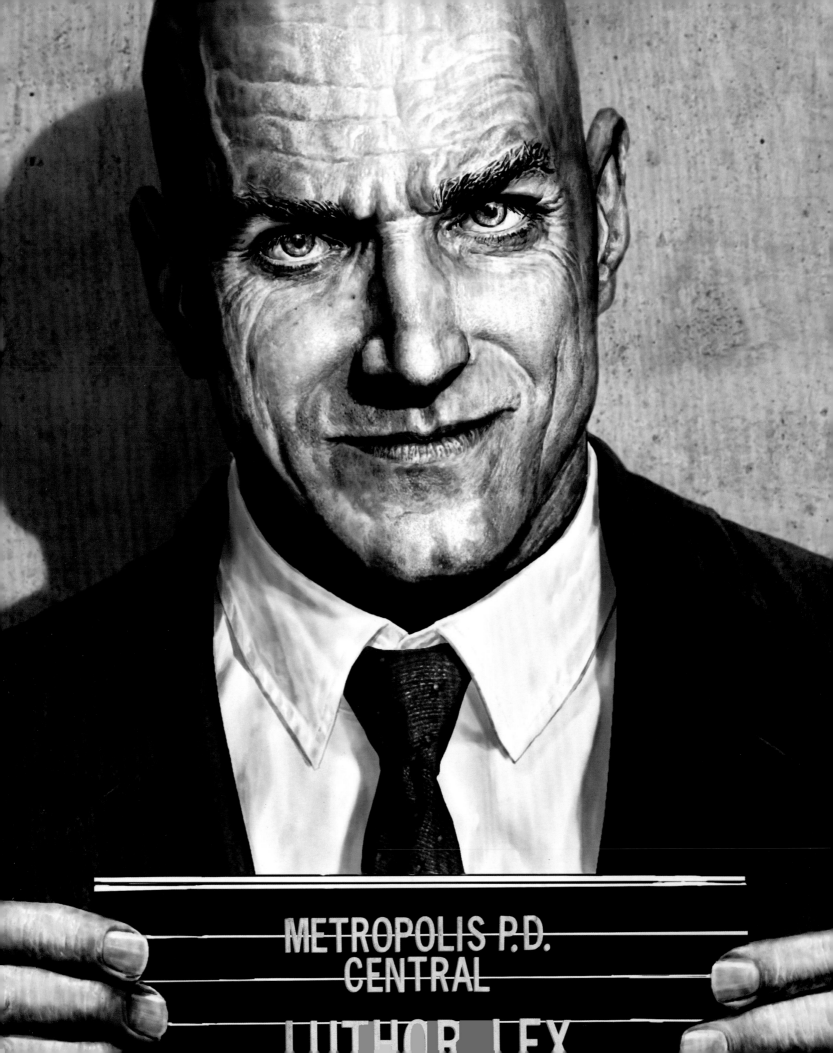

METROPOLIS P.D.
CENTRAL

LUTHOR LEX

1

MENACES OF METROPOLIS

Superman's foes seem to come at him from all angles. Geniuses like Lex Luthor and Brainiac test his wits. Powerhouses like Doomsday can deliver a fatal punch. And mystical foes like the Silver Banshee have supernatural methods of getting under Superman's skin.

"Superman has so many powers that I was always looking for something he couldn't deal with," says writer Marv Wolfman. "I wanted to pit him against things that were beyond him, things that were greater than him."

OPPOSITE: Even when he's brought to justice, Lex Luthor doesn't stay behind bars for long. [Art by Lee Bermejo, *Absolute Joker/Luthor Omnibus*]

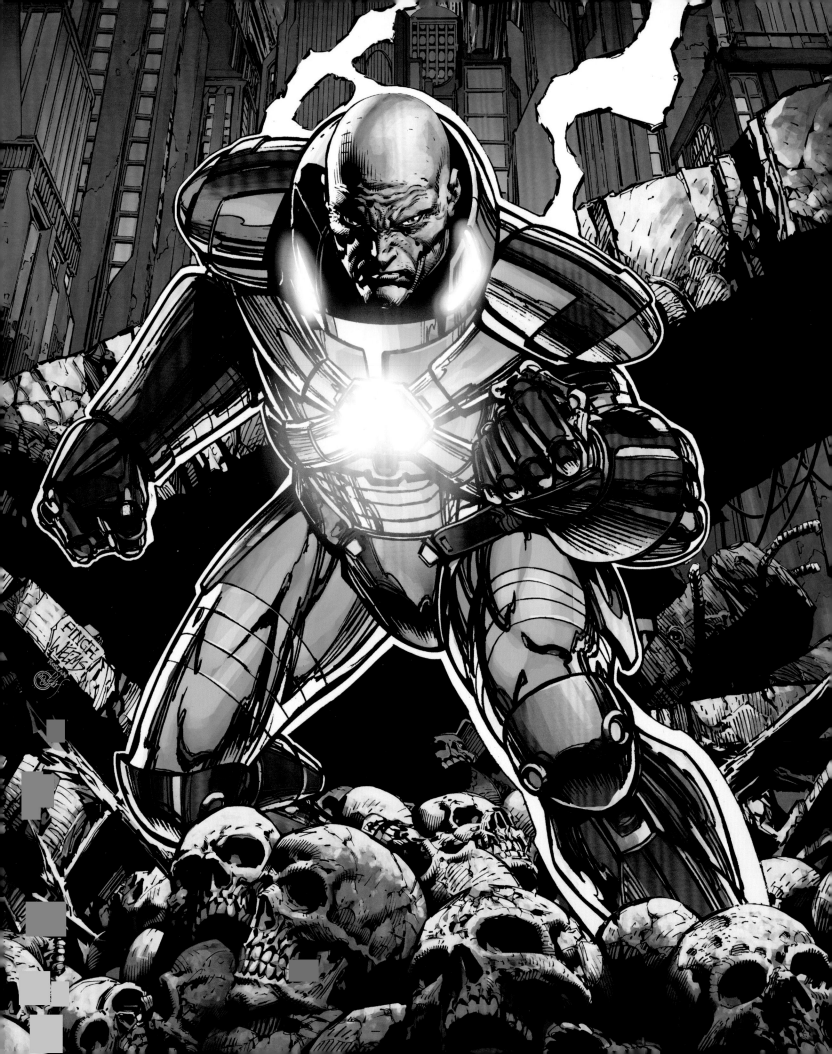

LEX LUTHOR

He's a genius unlike any the world has ever seen, but there's nothing superhuman about Lex Luthor. He perseveres despite his lack of superpowers, and in Superman he sees an alien who has done nothing to deserve his remarkable gifts. Luthor is a master of every field he deigns to study, a charismatic titan of industry, and a Machiavellian manipulator without equal. On the movie screen, the part of Lex Luthor has been interpreted by actors as diverse as Gene Hackman and Kevin Spacey.

Luthor first appeared in *Action Comics* #23 (April 1940) and was described in the story by Jerry Siegel and Joe Shuster as an "ordinary man, but with the brain of a super-genius." Living in a flying city driven by an airship, Luthor tried to incite war between the nations of Europe.

This first version of Luthor sported a full head of red hair. Later interpretations rendered him completely bald, and this depiction stuck. In the 1960s, writers addressed the discrepancy by casting the teenaged Luthor as a friend of Superboy, the young Clark Kent, until a laboratory fire triggered rapid baldness and caused Luthor to blame the Boy of Steel.

"The motivation is a little silly, perhaps," says writer Kurt Busiek, who tackled the Man of Steel during a 2006–2007 run on *Action Comics*, "but I love that Superman thinks of that as a turning point he'd do anything to correct. He views Luthor's villainy as a great loss for the world and wants to fix it. He wants to redeem him. Luthor, on the other hand, is all ego. He wants to prove himself the better man."

For a time, Lex Luthor donned a green and purple battlesuit so he could go toe-to-toe with his rival, but after *Crisis on Infinite Earths,* DC Comics introduced a new brand of villain whose power came from his corporate assets. This Lex Luthor debuted in the 1986 miniseries *The Man of Steel.*

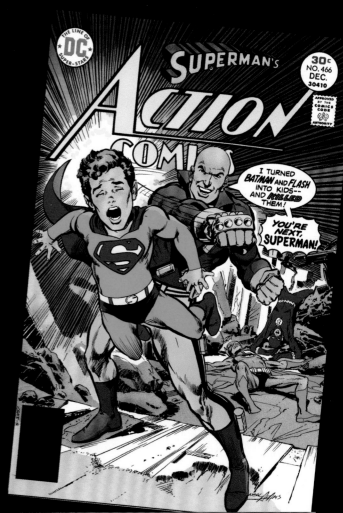

"LUTHOR is a... Machiavellian manipulator without EQUAL."

"The 'businessman Luthor,' whose fingers were in everything, was an idea I had pushed several years earlier," says writer Marv Wolfman, active on DC Comics titles from the '70s through the '90s. "My belief was that Luthor should not be a character who fights Superman physically. Superman's always going to win. But Superman can't win against someone who's smarter than him."

A true self-made man, the post-*Crisis* Luthor received a windfall from a life insurance policy he took out on his late parents. He founded LexCorp and dominated Metropolis, but to his displeasure Superman refused to dance to his tune.

"We got a new Luthor, in many ways simpler," says Busiek. "He didn't want to accept that anyone could be better than he was, so he wanted to prove Superman a fraud and a threat to humanity. His ego was stung by Superman, and he wanted desperately to humble him. Superman wanted just as desperately to redeem him, to get Luthor to become a force for good."

OPPOSITE: Luthor's armored battlesuit provides simulated superpowers. [Art by David Finch, Joe Weems, and Peter Steigerwald, *Action Comics*, Vol. 1, #890]

ABOVE RIGHT: Luthor stacks the deck in his favor. [Art by Neal Adams, *Action Comics*, Vol. 1, #466] **RIGHT:** After absorbing the power of the New God Darkseid, Luthor gains a level of power to match his limitless ego. [Art by Jason Fabok, *Justice League*, Vol. 2, #50]

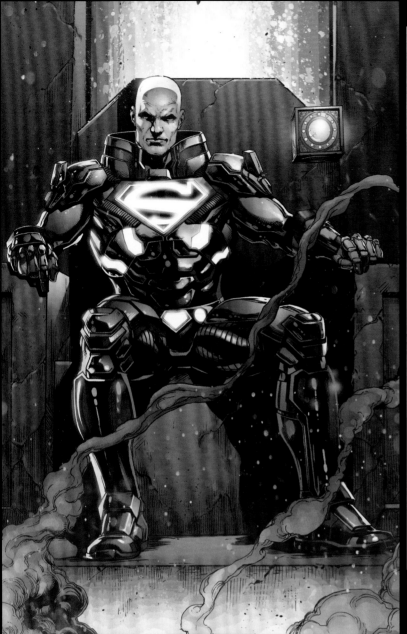

Throughout his encounters with Superman, Luthor remained mostly untouchable. A Kryptonite ring kept the Man of Steel at bay, though its radiation eventually cost Luthor his hand. He sought political office and was sworn in as President of the United States in 2000.

In 2003's *Superman: Birthright*, Mark Waid revisited Lex Luthor's origin and restored his pre-*Crisis* years in Superman's hometown of Smallville. This change, as well as the introduction of Lex's father Lionel Luthor, doubled as a hat tip to the TV series *Smallville*, which starred Michael Rosenbaum as Lex.

One of the last Lex Luthor stories prior to DC Comics' 2011 reboot found Luthor embarking on a quest to seize the energy of the gods. When he finally achieved absolute power, he refused to bring about paradise, since the act would require sharing the bliss with Superman.

In DC Comics' relaunched continuity, Lex Luthor accepted an offer from General Sam Lane to trap and study the mysterious hero Superman. Convinced that the alien was an advance scout for a Kryptonian army, Luthor entered into a secret alliance with Brainiac for what he believed to be the good of humanity.

Luthor temporarily slaked his thirst for power when the New God Darkseid perished in battle with the Anti-Monitor, an omnipotent entity with the power to erase entire universes. By absorbing Darkseid's energy, Lex Luthor became the new ruler of Apokolips. But it was an entirely different death that gave Luthor the opportunity he had long craved. With Superman seemingly out of the picture, Luthor donned power armor emblazoned with an "S" shield and filled the role of Metropolis's greatest defender, earning the praise that he felt should have been his all along.

The fear of being outclassed by someone who's smarter, richer, and better connected is a universal part of the human condition, and Lex Luthor remains one of the DC Universe's most chillingly realistic foes. Superman, despite his powers, considers himself a citizen of the world. In Luthor's worldview, Lex Luthor stands alone.

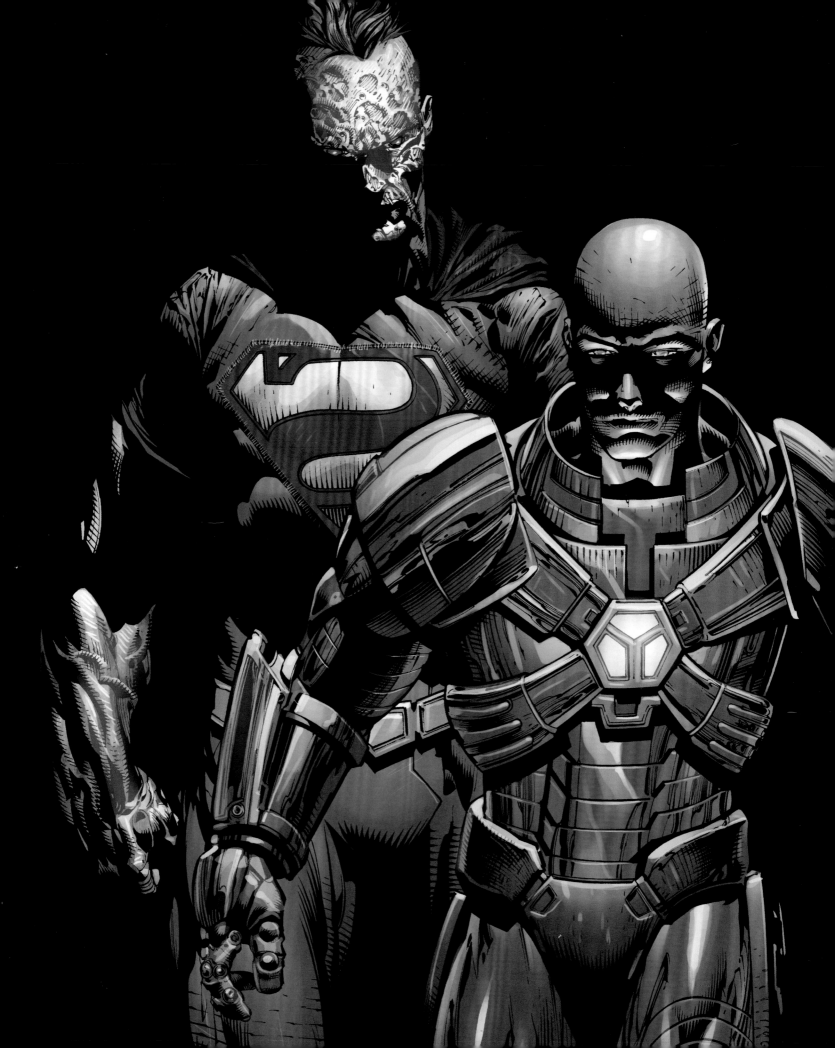

BIZARRO

Many villains follow a mirror-image theme to contrast them with their heroic counterparts, but few of them are as surreal as Bizarro. This reflection is a funhouse distortion with more than a few cracks marring its surface.

Bizarro is able to match Superman in raw power, but his special abilities are reversed: freeze vision, flame breath, and X-ray vision that only lets him see through lead. He is strengthened by green kryptonite, but blue kryptonite will kill him.

DC Comics' New 52 continuity revealed that Lex Luthor had plans to grow his own Kryptonian clone, code-named B-Zero, over the course of ten years. When the Crime Syndicate took over the planet, Luthor was forced to decant his experiment early. His half-baked Bizarro put his suit on inside-out, resulting in his reversed "S" insignia.

> ## "BIZARRO is able to match Superman in raw power, but his special abilities are REVERSED: FREEZE VISION, FLAME BREATH, and X-RAY VISION that only lets him SEE THROUGH LEAD."

This portrayal is not all that far from where Bizarro started. *Superboy* #68 (October 1958) gave the character cover billing as "the Super-Creature of Steel," and in this introductory adventure by Otto Binder and George Papp, Bizarro had a similar science-based origin as the product of a malfunctioning duplicator ray.

Bizarro's rough-hewn, chalky-white appearance caused civilians to turn away in disgust. Later stories introduced Bizarro's famously backwards language, in which "bad" meant good and "good-bye" meant hello. Bizarro used a duplicator to create a Bizarro Lois and an entire population of other Bizarros, and found a home for them on the cube-shaped Htrae (Earth spelled in reverse).

"I think the most effective Bizarro is one that's a mix," says writer Dan Jurgens, who penned a story arc starring Bizarro in 1994. "The humorous Bizarro has an appeal to him that could still work today. However, you need to pull back on it and add some of the Frankenstein aspect to make him tragic. The character should always feel lost in a world he doesn't understand."

A new Bizarro appeared in John Byrne's 1986 miniseries *The Man of Steel* but died before the end of his debut issue. A more enduring introduction came at the end of 2000's "Emperor Joker" storyline. The reality-warping mayhem caused by the Joker and Mister Mxyzptlk provided the perfect excuse for DC Comics to generate a fresh Bizarro out of thin air.

The moody "Escape from Bizarro World" in 2007 saw a troubled Bizarro kidnap Jonathan Kent to live with him on his cubical homeworld. The story also costarred Bizarro duplicates of Lex Luthor, the Justice League, and Doomsday.

The New 52 reintroduced Bizarro as "Subject B-0," a lab-grown monster loyal to his creator, Lex Luthor. Though this Bizarro perished in a battle with the world-conquering Crime Syndicate, Luthor brewed up a replacement Bizarro who eventually joined Red Hood's Outlaws as the team's most powerful member.

"There's both comedy and sadness mixed in with the character," says Jurgens. "And if you remove that, it just doesn't feel like Bizarro."

TOP: Bizarro adopts an uncomfortable disguise. (Art by John Byrne and

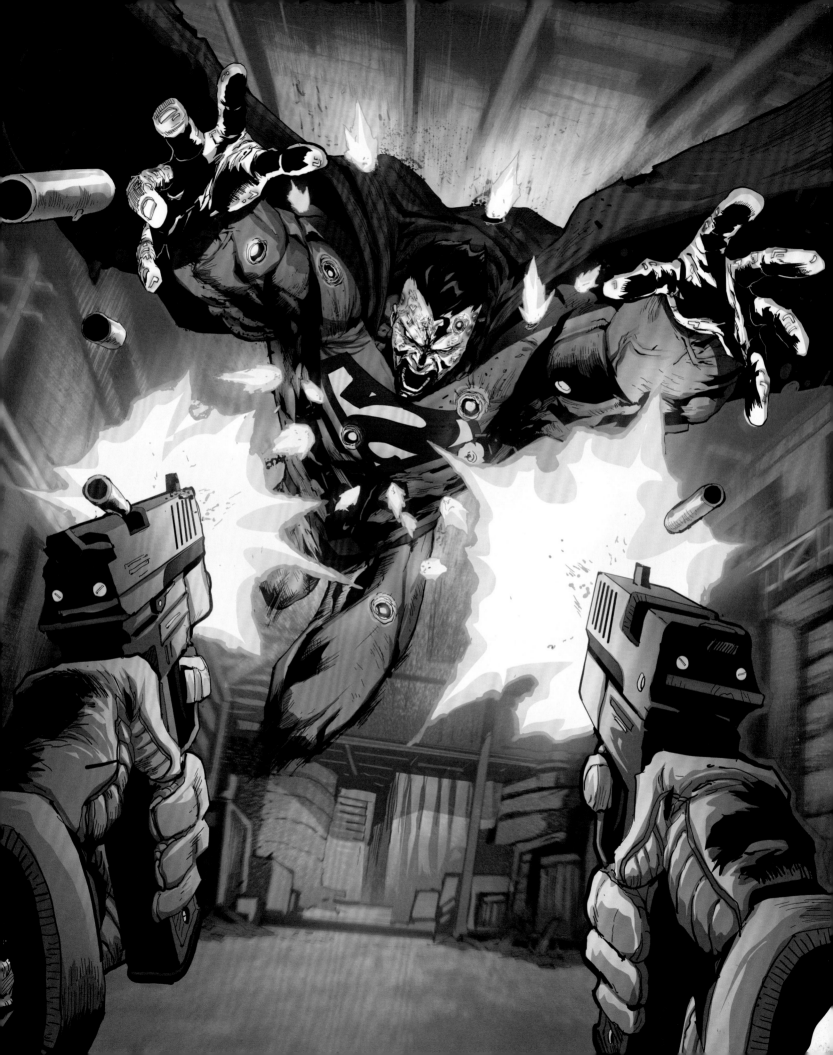

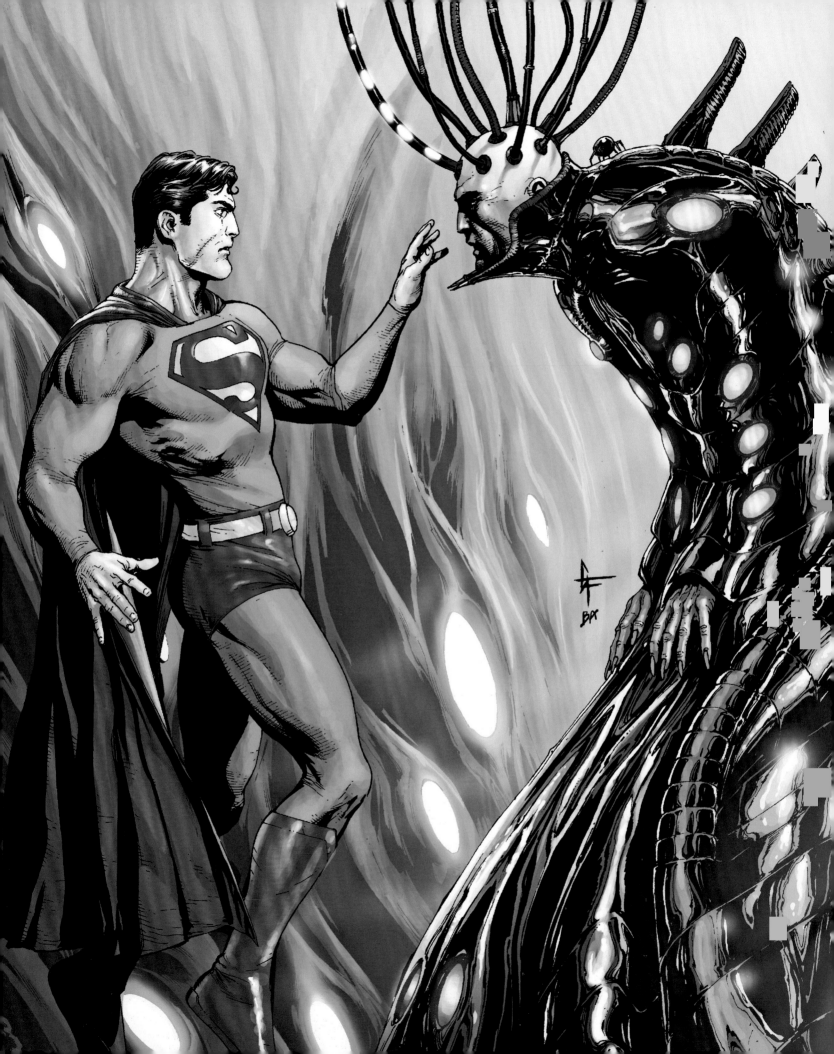

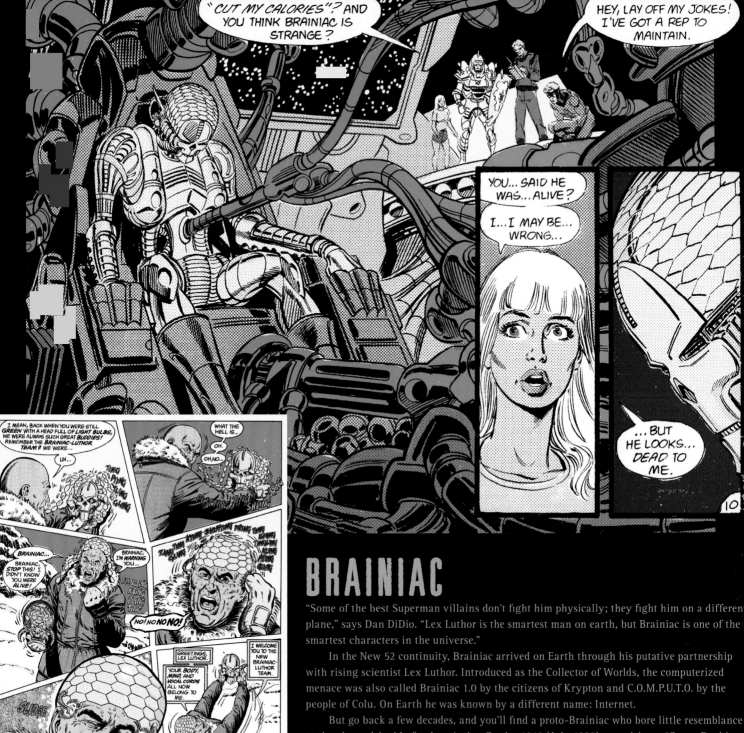

BRAINIAC

"Some of the best Superman villains don't fight him physically; they fight him on a different plane," says Dan DiDio. "Lex Luthor is the smartest man on earth, but Brainiac is one of the smartest characters in the universe."

In the New 52 continuity, Brainiac arrived on Earth through his putative partnership with rising scientist Lex Luthor. Introduced as the Collector of Worlds, the computerized menace was also called Brainiac 1.0 by the citizens of Krypton and C.O.M.P.U.T.O. by the people of Colu. On Earth he was known by a different name: Internet.

But go back a few decades, and you'll find a proto-Brainiac who bore little resemblance to the plugged-in AI of today. *Action Comics* #242 (July 1958), promising a "Super-Duel in Space," unveiled a green-skinned, bald-headed alien who wanted to shrink Earth's cities and bottle them for storage. Superman's discovery of the city of Kandor in Brainiac's collection gave him a permanent—if tiny—piece of his home planet.

"There is a simplicity to the earliest version of Brainiac that I like," says *Superman* writer Dan Jurgens. "He is essentially a zookeeper on a grand level."

Expansions of Brainiac's backstory followed. In *The Legion of Super-Heroes*, a teenaged hero named Brainiac 5 claimed to be Brainiac's future descendant. A later tweak to Brainiac's origins stated that he had been constructed by the Computer Tyrants of Colu entirely from mechanical parts.

Brainiac continued to hound Superman and eventually teamed up with Lex Luthor so the two could pool their intellectual brilliance. Both characters received upgrades in the early 1980s, with Luthor acquiring a powered battlesuit and Brainiac growing unsettlingly automated.

OPPOSITE: Wearing cables like a crown, Brainiac goes face-to-face with his nemesis. (Art by Gary Frank and Brad Anderson, *Action Comics*, Vol. 1, #868)
TOP: A deactivated Brainiac wired into his skull ship. (Art by George Pérez and Jerry Ordway, *Crisis on Infinite Earths* #11) **ABOVE:** Brainiac and Lex Luthor's fatal team-up. (Art by Curt Swan and George Pérez, *Superman*, Vol. 1, #423)

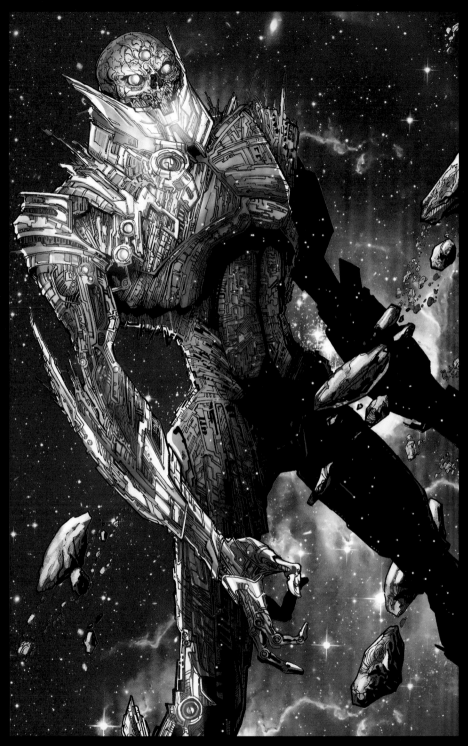

"I proposed the new Brainiac as more robotic and cybernetic," explains Marv Wolfman, who helped introduce the new character in the pages of *Action Comics*. "I was the first of the New York comic book writers to have a computer, and my view was that computers were taking over. To me, Brainiac controlled everything. He could 'modem' himself into his spaceship and become the ship. He could become any computer. He could affect machinery. His character was no longer just a physical presence, and therefore he could become phenomenally powerful against Superman."

The new Brainiac traveled the stars in a silvery vessel shaped like a skull with metal tentacles dangling beneath it. His polished frame had sharp metal talons and a braincase covered by interlocking hexagons.

After *Crisis on Infinite Earths*, Brainiac received a rebooted, down-to-earth origin. Small-time carnival mind reader Milton Fine accidentally downloaded the mental energies of Coluan scientist Vril Dox and gained true psychic powers in the process. Over time, the Milton Fine persona receded in favor of the classic version of Brainiac, with 1992's "Panic in the Sky" crossover bringing back the familiar skull ship as Brainiac invaded Earth with help from Mongul and Warworld.

With Y2K mania closing out the millennium in 1999, the Superman titles introduced the far-future Brainiac 13—a version of the tyrant hailing from the 64th century. This villain gave Metropolis a futuristic architectural upgrade courtesy of the techno-virus B13.

"Whenever SUPERMAN goes up against BRAINIAC, you know you're in for a heck of a FIGHT!"

Action Comics #866 (August 2008) launched a storyline that merged all of the previous incarnations in Brainiac's fictional history. Returning to his habit of shrinking and bottling cities, Brainiac once again counted Supergirl's home of Kandor as his most valued prize. Superman prevented Brainiac from snatching Metropolis, too, but the fighting claimed the life of his adoptive father, Jonathan Kent.

DC Comics' New 52 reboot reverted Brainiac to his city-bottling ways and saw the villain miniaturizing Metropolis during one of the earliest adventures of the new Man of Steel. But this technological prowess paled in comparison to Brainiac's actions in DC Comics' companywide "Convergence" crossover. In this 2015 event, an alternate version of Brainiac possessing godlike powers gathered characters from myriad realities—including those thought "erased" during DC Comics' New 52 relaunch—for one last, nostalgic hurrah enjoyed most by fans with long memories.

"Brainiac is one of my all-time favorite villains," says writer Sterling Gates. "Whereas Superman demonstrates what

ABOVE: Brainiac's mastery of parallel realities during the Convergence event made him a cosmic-level threat. [Art by Ethan Van Sciver, *Convergence* #0]
OPPOSITE: His telepathic control of machinery means Brainiac is rarely unarmed. [Art by Francis Manapul, *Superman: Secret Files 2009*]

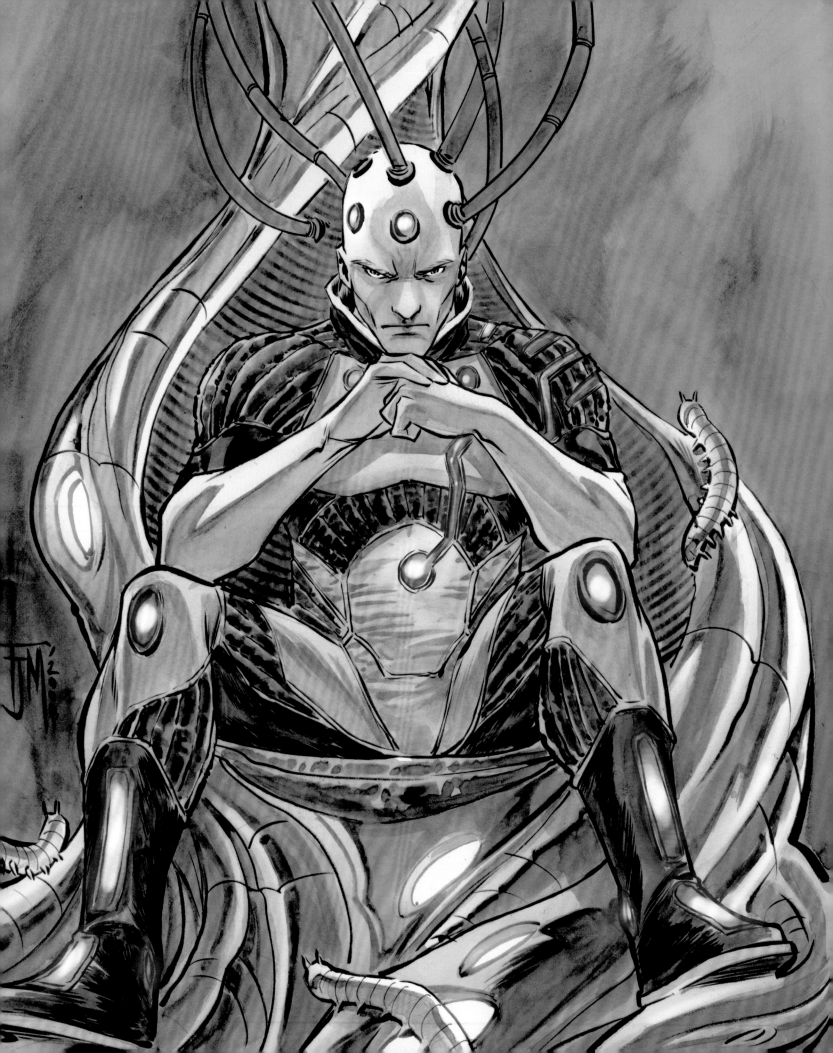

GENERAL ZOD

Dru-Zod of Krypton debuted in *Adventure Comics* #283 (April 1961) but didn't earn true fame until actor Terence Stamp's coldly cruel portrayal in the feature film *Superman* (1978) and its sequel, *Superman II* (1980). In 2013's *Man of Steel*, actor Michael Shannon embodied a monomaniacal Zod who practically vibrated with rage.

"I generally feel that Superman should be the Last Son of Krypton, and there shouldn't be lots of others around," says writer Dan Jurgens. "But it's good to have *one*. If for no other reason, it's someone who can function at Superman's level of power."

As the head of Krypton's military, Dru-Zod holds the rank of general and exhibits contempt for weaklings. In most versions of his backstory, Zod attempted to overthrow the planet's ruling council and earned a lifetime in the Phantom Zone as punishment. The extra-dimensional Phantom Zone ironically kept Zod safe from his homeworld's destruction, and he escaped from exile to embark on a life of conquest.

DC Comics' continuity-altering *Crisis on Infinite Earths* decreed that Superman should stand alone as the sole survivor of his species, a decision that left little room for Zod. What followed was a long series of experiments as writers sought loopholes and introduced Zods by the multitude.

"As creators and editors on a book change, everybody does their own take," says Mike Carlin. "They want to leave their mark, and sometimes they disagree with a previous incarnation. It's refreshing to put a new spin on it sometimes. It helps the current creator take a little ownership."

Adds Jim Lee, "What's interesting about the world of Super Heroes is that it's very open to creators coming in and tinkering. It's up to the fans to decide what they like or don't like. There's a sort of natural selection that goes on over the decades."

The first of the new Zods existed in a pocket universe exempt from the "no Kryptonians" rule. After General Zod and his companions, Quex-Ul and Zaora, exterminated all life on their pocket Earth, writer John Byrne presented Superman with the ultimate moral dilemma, which resulted in Superman deciding to execute Zod to prevent future genocides.

Another Zod starred in 2001's "Return to Krypton" storyline. This General Zod ruled a domain that was eventually outed as an artificial reality conjured by Brainiac 13.

The "Russian Zod" had a little more longevity, though he wasn't a true Kryptonian. He gained superpowers at birth thanks to a radiation surge experienced by his cosmonaut parents when they passed too close to Superman's rocket. Weakened by Earth's yellow sun but strengthened by red solar rays, this Zod wore chroma-filtering armor and emerged as the dictator of the fictional eastern European nation of Pokolistan.

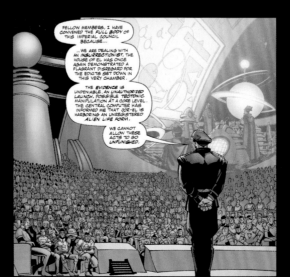

TOP: A sneering Zod faces justice at Superman's hands. [Art by John Byrne, *Superman*, Vol. 2, #22]

LEFT: General Zod addresses the people of Krypton. [Art by Duncan Rouleau and Marlo Alquiza, *Adventures of Superman*, Vol. 1, #589]

OPPOSITE: Kneeling in obedient submission is the only way Zod's opponents can avoid a fight. [Art by Jim Lee and Scott Williams, *Suicide Squad*, Vol. 5, #2]

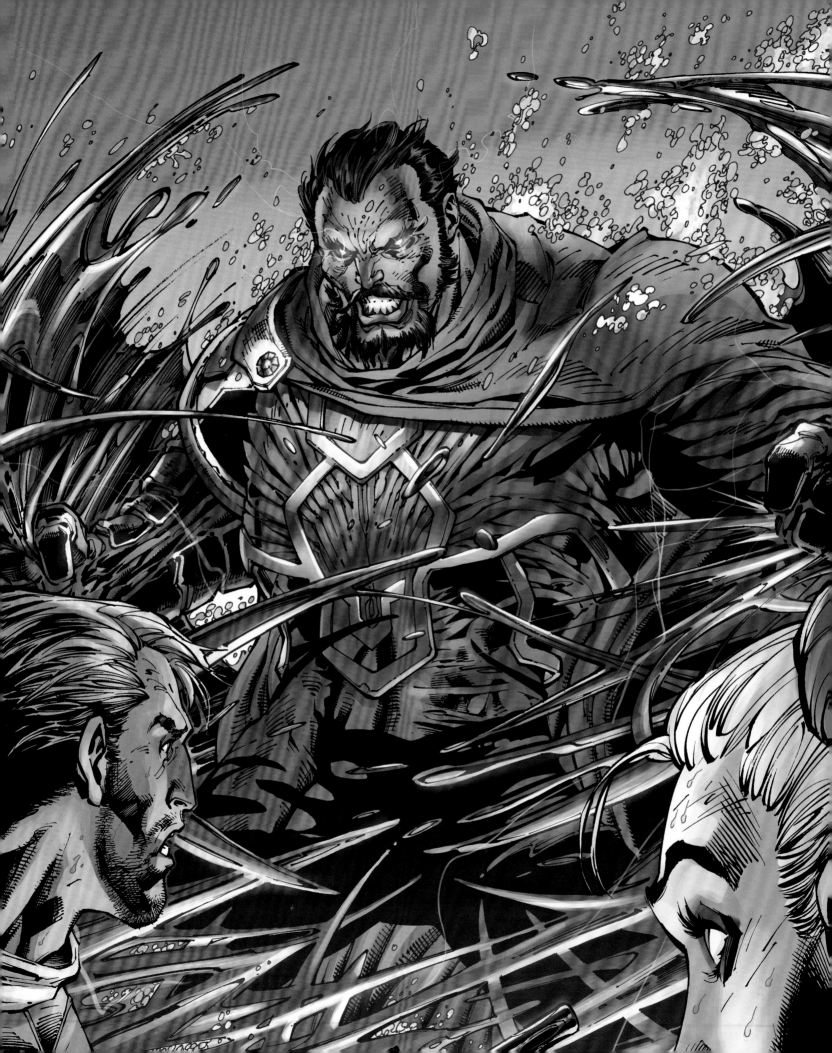

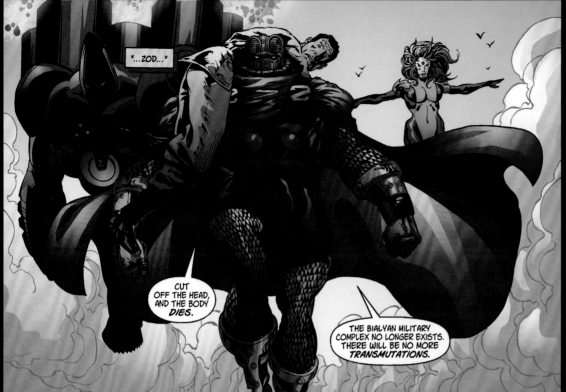

"...ZOD..."

CUT OFF THE HEAD, AND THE BODY DIES.

THE BIALYAN MILITARY COMPLEX NO LONGER EXISTS. THERE WILL BE NO MORE TRANSMUTATIONS.

A final alternate Zod emerged as a threat inside the Phantom Zone. He starred in Brian Azzarello and Jim Lee's twelve-part "For Tomorrow" (2004).

Geoff Johns and *Superman* director Richard Donner brought back the classic Zod in "Last Son," which wove elements from the first two Superman films into comic book canon. Here, General Zod and his lieutenants—brutish Non and cruel Ursa—escaped from the Phantom Zone and sought revenge on the son of Jor-El. Lor-Zod, the innocent child of Zod and Ursa, briefly found refuge with Clark Kent and Lois Lane by changing his name to Christopher Kent.

Zod received a new backstory in the New 52 continuity. After his family's shuttle crashed in the jungles of Krypton, young Zod left his parents to be devoured by monsters and survived on his own until he was rescued. A standout soldier, Zod went too far when he staged a false flag attack to drum up support for war against the alien Char. Jor-El turned him over to the Council for banishment in the Phantom Zone. Faora now fills the role formerly played by Ursa, following Antje Traue's striking turn as Zod's loyal assassin in 2013's *Man of Steel*.

The Phantom Zone is frequently a prison for Zod, but it is hardly escape-proof. In one story, the Suicide Squad—the special missions force composed entirely of super-villains—accidentally breached the barrier, allowing Zod to escape and roam the Earth once more.

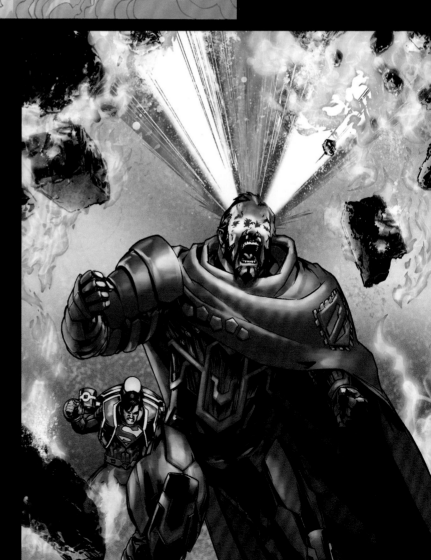

OPPOSITE: The Zod from the Phantom Zone launches his attack. [Art by Jim Lee, Scott Williams, Sandra Hope, and Richard Friend, *Superman*, Vol. 2, #213]
TOP: The "Russian Zod" dispenses cold justice. [Art by Tom Derenick and Norm Rapmund, *Action Comics*, Vol. 1, #802] **RIGHT:** When angered, Zod can

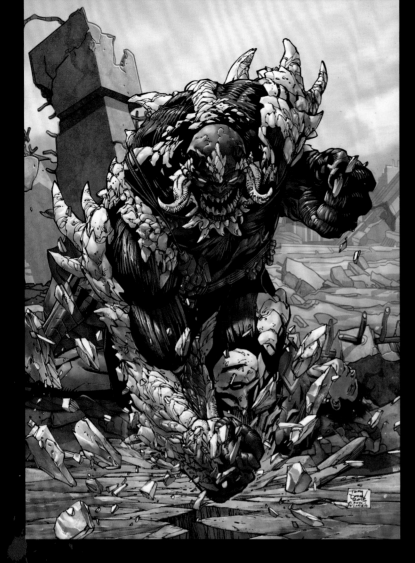

DOOMSDAY

Comic ads promised the "coming of Doomsday," and the creature fated to kill Superman appeared for the first time in *Superman: The Man of Steel* #17 (November 1992). The one-page sequence didn't even provide a full reveal of the villain. Readers saw only a fist punching a wall, battering its way toward daylight with a resounding *KRAANG!*

The "Death of Superman" saga was one of the seminal comics events of the 1990s, and Doomsday was its linchpin. Conceived by writer-artist Dan Jurgens, Doomsday was a monster with limited intellect who had been engineered to be the ultimate killing machine.

"From the very start, I wanted to come up with a very physical, bestial sort of character," says Jurgens. "I was always frustrated by the fact that so many of Superman's adversaries, like Lex Luthor and Brainiac, were cerebral, nonphysical types. At first I didn't see Doomsday as part of the 'Death of Superman' story, but we ended up combining the two concepts to come up with a rather epic solution."

Mike Carlin, editor of the Superman titles at the time, agrees: "Superman's villains are thinkers—Luthor, Toyman, Prankster. They're all just people. In a way we were reacting to that with Doomsday, because he's everything *but* a thinker."

How was this newcomer able to kill the Man of Steel when so many others had tried and failed? Doomsday received an origin story that dated back to Krypton's prehistoric age and an experiment in "forced evolution." A scientist threw a baby into the savage wilds and cloned the infant after its inevitable death. Repeating the experiment, the scientist discovered that his test subject could develop defenses against whatever had killed it. When Doomsday had

reached perfection, his first act of violence was to murder his creator.

Doomsday's rampage across space ended when aliens subdued him and launched him into the void, bound by cables and wrapped in a shroud. He landed on Earth but remained inert for hundreds of years, finally punching his way free in modern times.

Doomsday clashed with the Justice League on his disastrous trek across the eastern United States. Superman tried to prevent the monster from reaching Metropolis, only to discover that Doomsday existed in a class by himself. His strength, stamina, and invulnerability exceeded Superman's own, and his bone spurs could cut Kryptonian skin. Though Doomsday couldn't fly, he could easily leap tall buildings in a single bound.

Superman #75 (January 1993) chronicled the end, in a best-selling issue consisting of twenty-two full-page panels. Doomsday and Superman slugged it out in front of the *Daily Planet* building until both collapsed. As Lois Lane held her champion's dying body, Jimmy Olsen snapped a photo of Superman's tattered cape.

TOP LEFT: Doomsday is the immortal product of Kryptonian science. (Art by Tony S. Daniel, Sandu Florea, and Tomeu Morey, *Batman/Superman* #3.1: *Doomsday*)
ABOVE: Still wearing his burial wrappings, Doomsday takes a punch. (Art by Tom Grummett and Doug Hazlewood, *Adventures of Superman,* Vol. 1, #497)
OPPOSITE: A demonic Doomsday clutches the costume of his prey. (Art by Ken Lashley and Alex Sinclair, *Superman: Doomed* Vol. 1, #1)

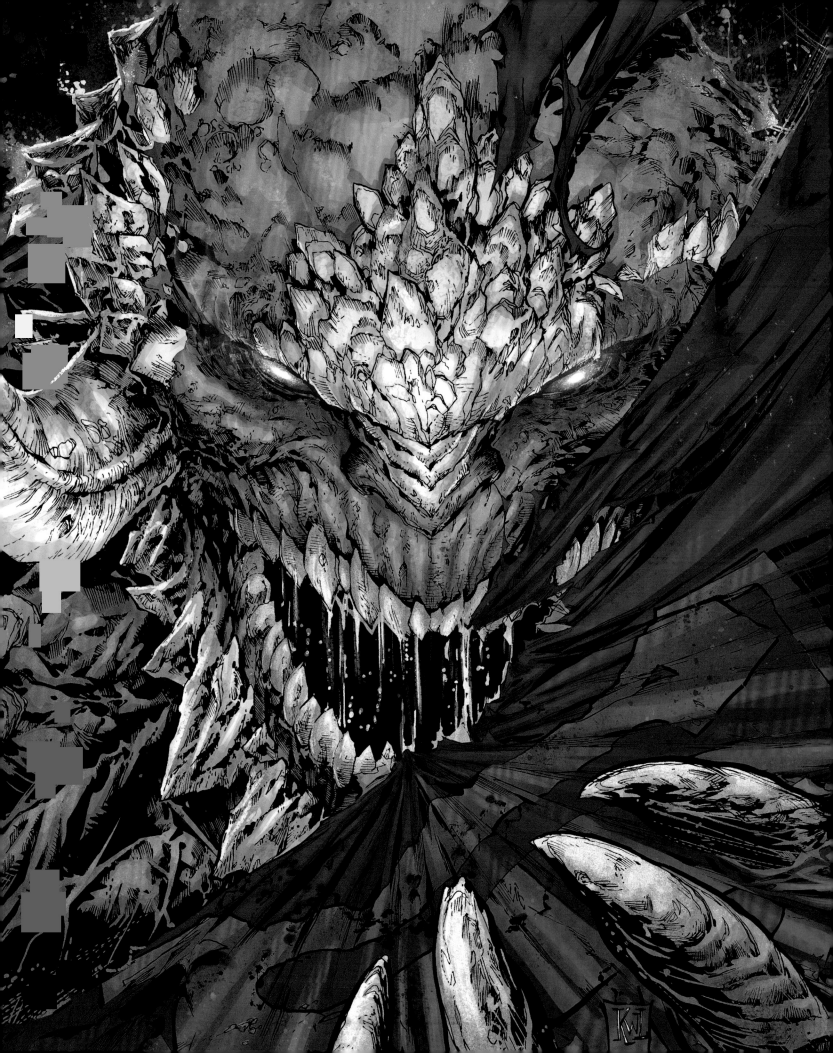

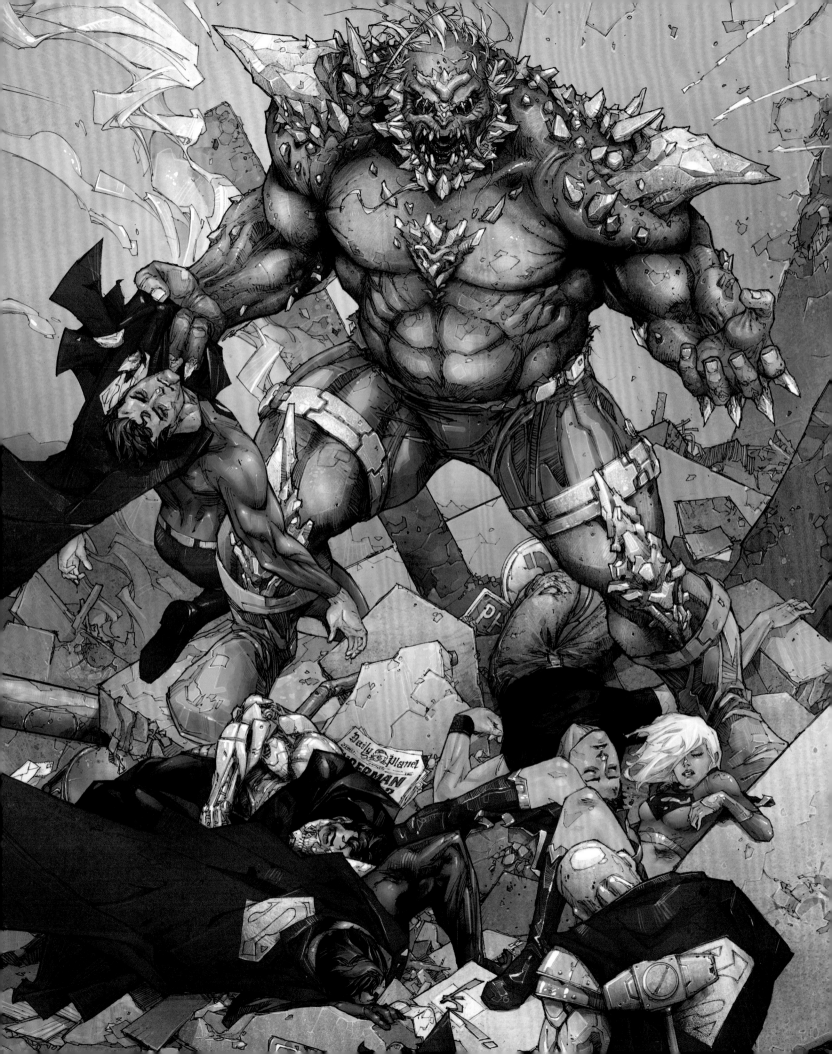

"DOOMSDAY is a character that's PHYSICALLY STRONGER than SUPERMAN."

Superman came back to life, and so did Doomsday. The villain found a new opponent in deep space, besting Darkseid and visiting destruction across Apokolips. Another adventure briefly gave him the incalculable intellect of Brainiac. The cosmic conqueror Imperiex reduced Doomsday to a charred skeleton, but he regenerated back to full health.

One Doomsday was bad enough, but multiple clones starred in 2011's "Reign of Doomsday" storyline. Each Doomsday clone acquired a unique set of powers sourced from Supergirl, the Cyborg Superman, and others. Events culminated in the reveal of Doomslayer, a genetic amalgam determined to exterminate all life on Earth.

The 2014 "Superman: Doomed" saga gave the character his biggest role in DC Comic's New 52 reboot. Superman, desperate to contain the virulent "death field" emitted by his rampaging foe, killed Doomsday and inhaled the toxic aura. Infected by the Doomsday virus, Superman slowly transformed into a mutated berserker as his friends searched for a cure. In 2016, the "Path of Doom" story arc saw Superman and Lex Luthor team up to put an end to Doomsday's latest rampage through Metropolis.

"With a lot of Superman's villains, it's the brains against brawn concept," says Dan DiDio. "And then you have characters where there's that physicality. Doomsday is a character that's physically stronger than Superman."

THE DEATH OF SUPERMAN!

OPPOSITE: Doomsday stands victorious above all challengers. (Art by Kenneth Rocafort, *Action Comics*, Vol. 1, #901)

ABOVE: The iconic cover of *Superman* #75. (Art by Dan Jurgens and Brett Breeding, *Superman*, Vol. 2, #75)

LEFT: With powers that evolve over time, Doomsday is an enemy that is constantly upgrading. (Art by Ken Lashley, *Superman: Doomed* #1)

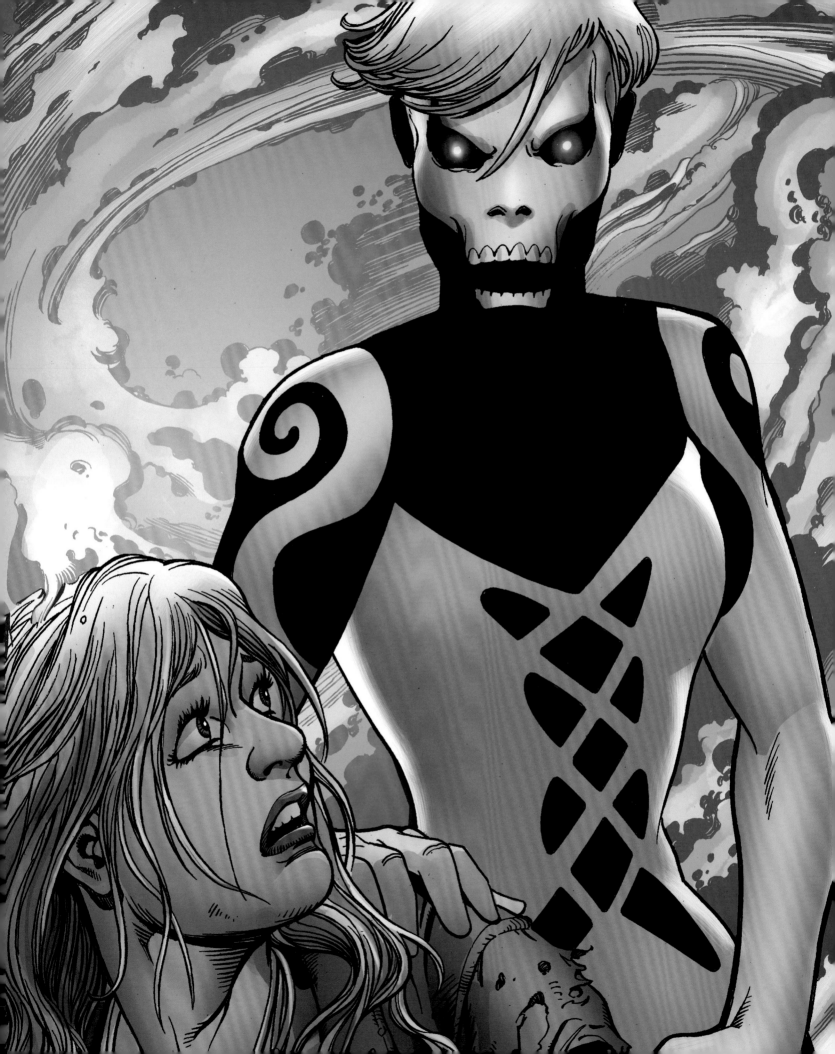

SILVER BANSHEE

A killer with a death's-head visage and a Celtic flair, Siobhan McDougal first appeared as the Silver Banshee in *Action Comics* #595 (December 1987). She was the first post-*Crisis* villain to earn a permanent spot on the Man of Steel's enemies list.

In DC Comics' New 52 reboot, struggling musician Siobhan Smythe appears in *Supergirl* #7 (May 2012) as a more sympathetic version of the character. She lends a hand to Supergirl during a confrontation with the National Guard and later shelters her in her Metropolis apartment. When Siobhan's dead father, the Black Banshee, rises from the inferno, she transforms into the Silver Banshee to confront her family's wicked destiny.

The Silver Banshee's powers are dark gifts from the netherworld, bestowed upon a member of the McDougal clan to safeguard the family's bloodline. Siobhan stole the birthright meant for her brother, gaining superhuman strength, speed, and hypersonic screams that kill—as long as she knows her victim's true name. The Silver Banshee's sonic gifts have other benefits as well, providing her with instant fluency in every language.

Superman has traditionally been vulnerable to supernatural attacks, yet his roster of villains includes surprisingly few supernatural foes. With the Silver Banshee, the Man of Steel has a formidable opponent who doesn't need Kryptonite to take Superman down.

Originally illustrated by John Byrne, the Silver Banshee was a black-and-white horror with long sweeping hair and the facial markings of a decayed corpse. "She has a wonderful design," says Kurt Busiek. "I used her as one villain among a mess of villains, so I didn't really get to explore what makes her special. But she looks great, and that was enough."

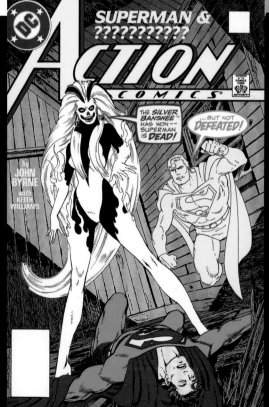

OPPOSITE: The Silver Banshee's short-haired redesign. [Art by George Pérez and Bob Wiacek, *Supergirl*, Vol. 6, #8]

TOP: The Silver Banshee's signature wail. [Art by John Byrne and Keith Williams, *Action Comics*, Vol. 1, #595]

ABOVE: Dark magic makes the Silver Banshee a match for the Man of Steel. [Art by John Byrne, *Action Comics*, Vol. 1, #595]

MISTER MXYZPTLK

The back pages of *Superman* #30 (September–October 1944) ushered in the "absurd being" known as Mister Mxyzptlk. In a tale by Jerry Siegel and Joe Shuster, a curious, bowler-hatted man proved to be more than a Metropolis pedestrian by raising himself from the dead after getting flattened by a passing truck. And when Mxyzptlk unleashed the full extent of his reality-warping super-science, Superman's powers seemed practically ho-hum in comparison.

Superman forced the magical imp to return to his home dimension by getting him to speak his name backward: "Kltpzyxm." But that didn't stop Mxyzptlk from returning, and he eventually adopted a new look with an orange jumpsuit and wild tufts of white hair. As a comedic villain, Mxyzptlk served as an outlet for laughs while challenging writers to come up with new ways of tricking the trickster and sending him back to his fifth-dimensional homeworld of Zrfff.

"The original stories were much simpler, grounded in science fiction and fantasy," says Dan DiDio, who points out that Mxyzptlk's wizard-like ability to restructure reality is a puzzle that Superman can't solve through punching. "[In a Mxyzptlk story] it's about, how do you change Superman's physical environment to bring new challenges to him?" Mike Carlin sees the value in humor as a way to let off steam. "Characters like Mister Mxyzptlk are a way to change the pitch so it's not serious all the time," he says.

"In the mainstream Superman comics, MISTER MXYZPTLK SURVIVED with his jocular spirit intact."

Whatever light-hearted tone Mxyzptlk may have carried vanished with the 1986 publication of Alan Moore's "Whatever Happened to the Man of Tomorrow?" When Superman's enemies turn murderous, Mister Mxyzptlk takes a bow as the one who's been pulling their strings. He claims to have grown bored with mischievousness and vows to spend the next 2,000 years of his life in the pursuit of evil. To save the world, Superman takes Mxyzptlk's life.

In the mainstream Superman comics, Mister Mxyzptlk survived with his jocular spirit intact. During the "Krisis of the Krimson Kryptonite," he teamed up with Lex Luthor. When Mxyzptlk made the worst mistake of his life by lending his powers to the Joker, Earth became a house of horrors as the events of "Emperor Joker" unfolded.

In DC Comics' New 52 continuity, Mister Mxyzptlk received a fresh backstory during Grant Morrison's initial run on *Action Comics*. A former entertainer in the fifth-dimensional employ of the King-Thing Brpxz of Zrfff, Mxyzptlk fled his home after a false accusation of murder. This cleared the way for his rival, Vyndktvx, to launch an invasion of Metropolis.

"It has to be fun," says Superman writer Dan Jurgens, on the rules for a good Mxyzptlk story. "Superman must be presented with a quandary to confront. And no matter how you cut it, there has to be a certain element of looniness."

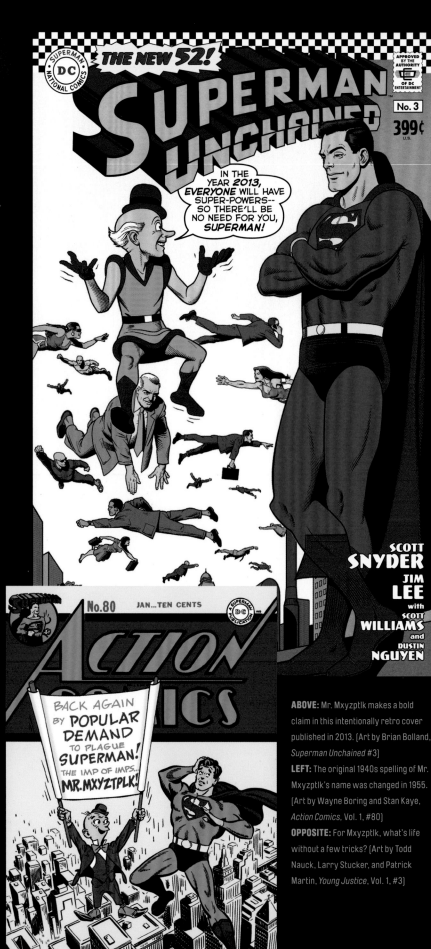

ABOVE: Mr. Mxyzptlk makes a bold claim in this intentionally retro cover published in 2013. [Art by Brian Bolland, *Superman Unchained* #3]

LEFT: The original 1940s spelling of Mr. Mxyzptlk's name was changed in 1955. [Art by Wayne Boring and Stan Kaye, *Action Comics*, Vol. 1, #80]

OPPOSITE: For Mxyzptlk, what's life without a few tricks? [Art by Todd Nauck, Larry Stucker, and Patrick Martin, *Young Justice*, Vol. 1, #3]

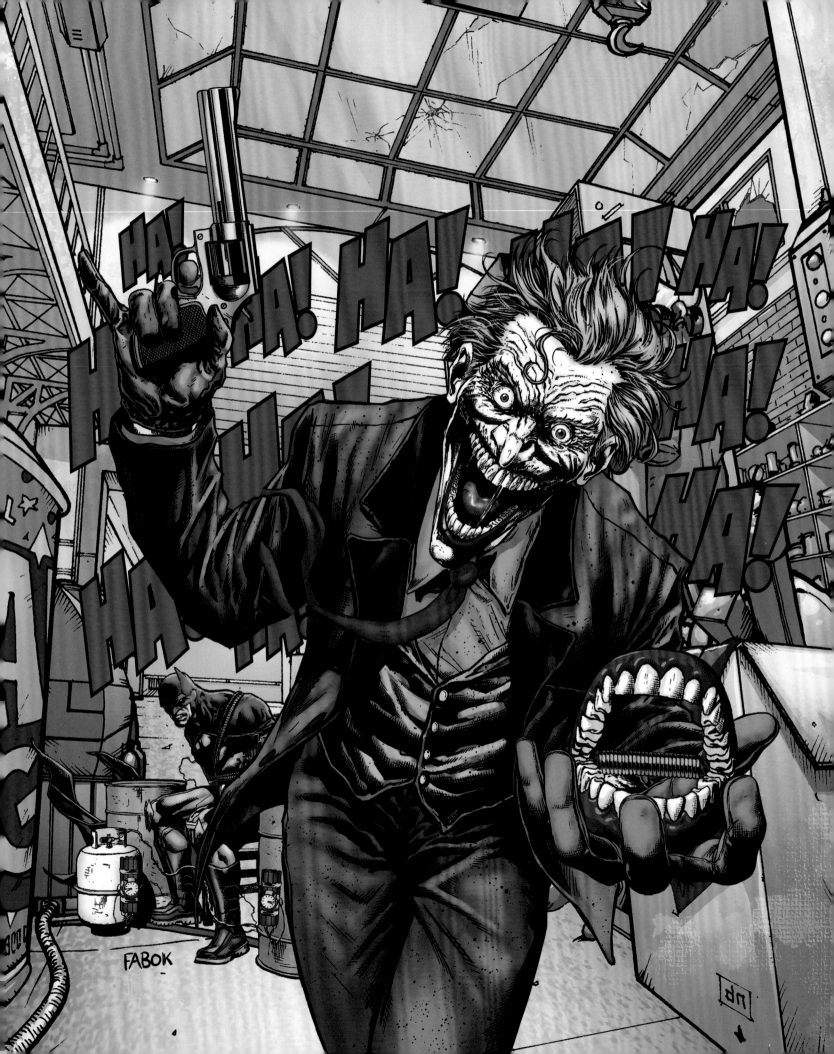

GOTHAM CITY'S ROGUES GALLERY

Mike Carlin doesn't mince words: "Batman has the best Rogues Gallery of all our characters."

It's tough for any fan to disagree. The villains of Gotham City seem cut from the same cloth, with their madness, disfigurements, formal wear, and outrageous gimmicks defining the look of a troupe whose members spend their downtime in padded cells at Arkham Asylum.

"Batman's villains are ordinary people who have been turned insane," says Marv Wolfman. "Two-Face, a district attorney who fought crime, now fights the very people he worked for. The Joker, a minor criminal, became a white-faced disaster. They were suddenly deformed. That changed not only their physical presence, but their morality as well."

OPPOSITE: The Joker brandishes two of his favorite things. (Art by Jason Fabok, *Batman*, Vol. 2, #23.1: *The Joker*)

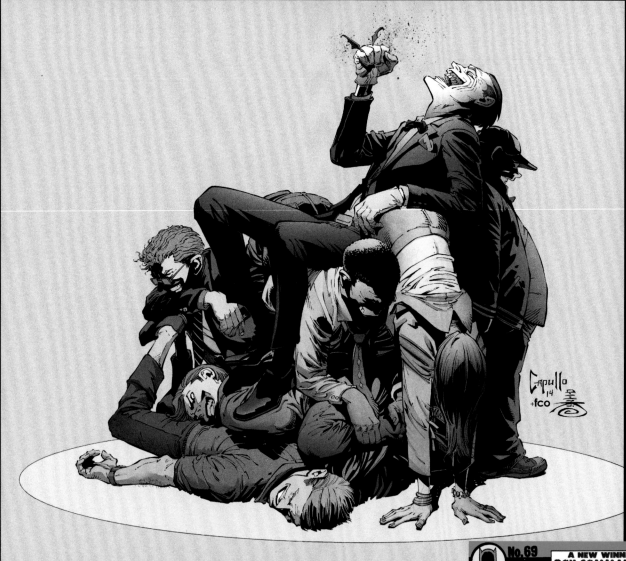

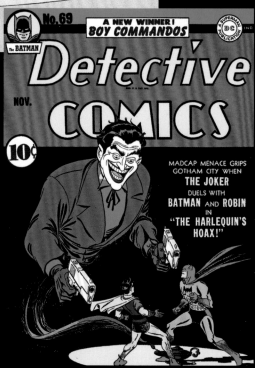

THE JOKER

The Clown Prince of Crime. The Harlequin of Hate. These titles try to capture the Joker's innate contradiction as a showman gone sour, but the character is far too chaotic to be summed up by a label. As one of the biggest figures in popular culture, the Joker is in the unique position of being more popular than many DC Comics heroes. As Chuck Dixon, writer on the Batman titles during the 1990s, puts it, "Joker stories are not about Batman. They're about the Joker."

Bill Finger, Bob Kane, and Jerry Robinson brought the Joker to life in *Batman* #1 (Spring 1940), where the chalk-faced jester immediately racked up a body count. The character returned throughout the Golden Age, often armed with his signature "Joker toxin," which left a grinning rictus of death on his victims.

The regulatory Comics Code Authority of the 1950s dulled the Joker's edge by turning him into a theatrical, mostly harmless trickster. *Detective Comics* #168 (February 1951) is notable for giving the Joker an origin story, introducing his criminal past as the Red Hood, a villain who experienced an unfortunate fall into a tank of chemical waste. The industrial accident bleached his skin, tinted his hair green, and pushed him into insanity.

The *Batman* TV series of the 1960s gave Cesar Romero the first crack at capturing the Joker's manic cackling on screen. Decades after Romero exposed the Joker to a primetime audience, Hollywood legend Jack Nicholson put his stamp on the villain in 1989's *Batman*. actor Heath Ledger's turn as the Joker in 2008's *The Dark Knight* earned Ledger a posthumous Academy Award® for Best Supporting Actor. Meanwhile, Mark Hamill voiced the Joker in *Batman: The Animated Series* and the *Batman: Arkham* video games.

Unique interpretations of the Joker by writers, artists, and actors all share a common core of madness. "The Joker reinvents himself every morning," explains Dixon. "He's whatever

TOP: A triumphant Joker exults in the death and abasement of his enemies. [Art by Greg Capullo, Danny Miki, *Batman*, Vol. 2, #39]

ABOVE: The Joker looms large on this Golden Age cover. [Art by Jerry Robinson, *Detective Comics*, Vol. 1, #69]

OPPOSITE: Bat icons symbolize the Joker's obsession in this chilling piece. [Art by Jock, *Detective Comics*, Vol. 1, #880]

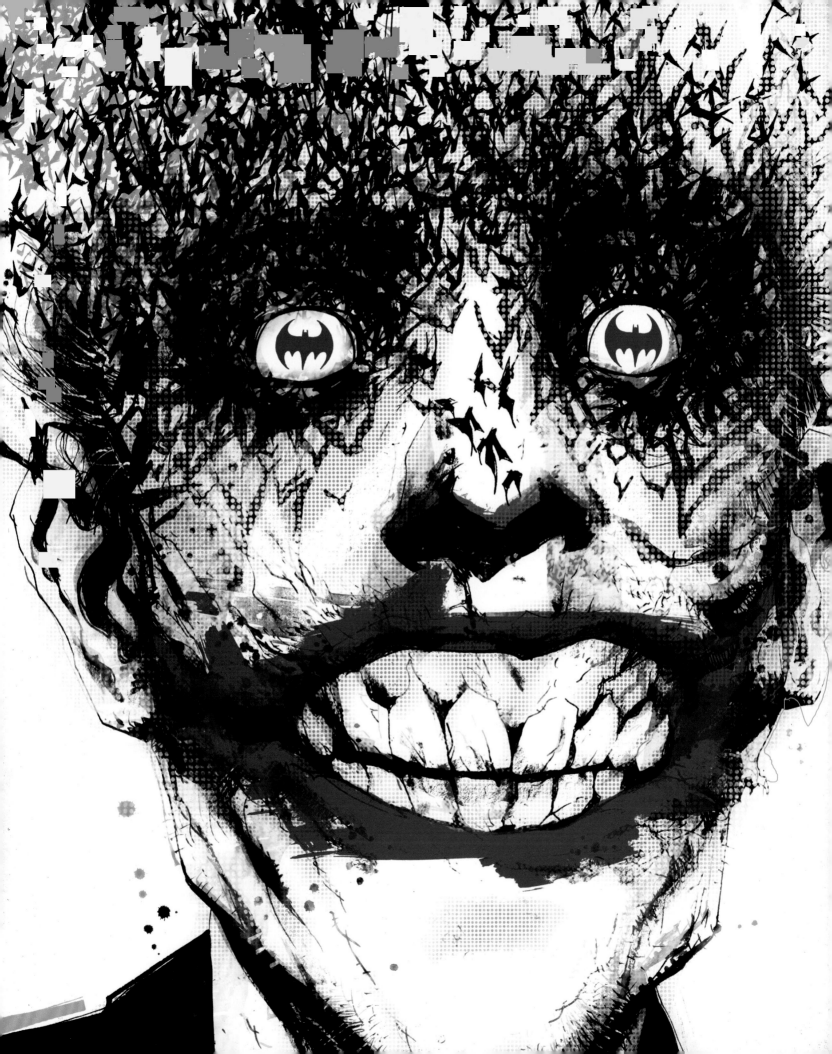

you need him to be. He presents an intellectual, psychological, and physical challenge for Batman. He's the whole package."

Jim Lee sees brilliance in the Joker's design. "He's this thin, wiry, very over-the-top caricature of the creepy clown from people's nightmares," he says. "That contrasts well with the shorter, blocky, shadowy silhouette of Batman. And his whites, reds, and greens really pop against Batman's grays and dark blues."

DC Comics restored the villain as a threat to be reckoned with in "The Joker's Five-Way Revenge" from *Batman* #251 (September 1973). Dennis O'Neil and Neal Adams had no qualms about showing the Joker feeding a man in a wheelchair to a great white shark.

"With the JOKER, you can't ANTICIPATE what he's doing or why he's doing it. He PLAYS AGAINST all your FEELINGS."

A dark descent started in the mid-1980s, beginning with Frank Miller's *The Dark Knight Returns*, which showed a grim future Gotham City as it hosted Batman and the Joker's final battle. In the mainstream *Batman* comics, the "A Death in the Family" storyline concluded with the Joker murdering Robin. This outcome was decided in a fan contest run by DC Comics in which calls to a telephone service determined the Boy Wonder's fate. 1988's *The Killing Joke* by Alan Moore and Brian Bolland explored how "one bad day" transformed the Joker into a fiend.

"With the Joker, you can't anticipate what he's doing or why he's doing it. He plays against all your feelings," says Marv Wolfman.

The Joker gained his own personal fan club with the introduction of Harley Quinn, an ex-psychiatrist who fell for his mind games and signed up as his sidekick. Other storylines raised the stakes to unprecedented levels: "Emperor Joker" saw the villain steal Mister Mxyzptlk's omnipotence, while, in "The Joker's Last Laugh," he celebrated his impending death by unleashing Jokerized super-villains across the globe.

In DC Comics' New 52 reboot, the Joker cut off his own face and allowed others to believe he'd died. He left the grisly trophy in police custody but returned after a year of hiding, attacking Batman's allies as he continued his mad dance with the Dark Knight.

The epic scheme depicted in the "Endgame" story arc involved an attack on Batman by a Joker-controlled Justice League and the Joker's kidnapping of Batman's closest friends. The Joker survived what looked like certain death at the story's conclusion, amid hints that an exotic chemical may have given him the gift of immortality.

The Joker remains one of DC Comics' cornerstone villains, and a challenge for creators who hope to put their own stamp on the character.

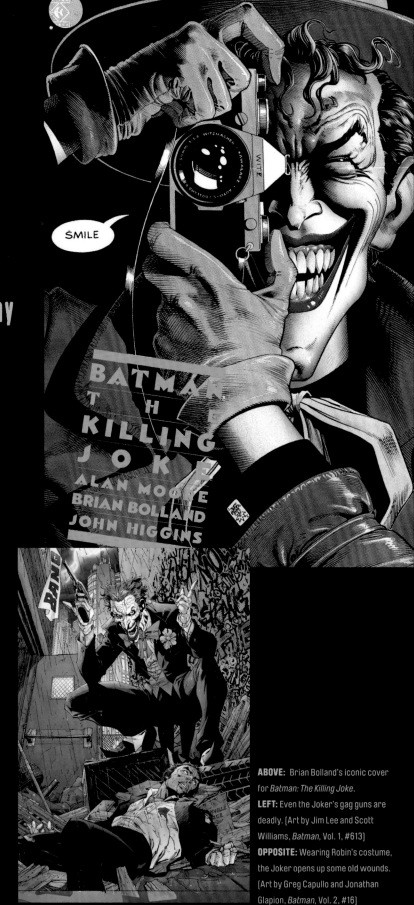

ABOVE: Brian Bolland's iconic cover for *Batman: The Killing Joke.*
LEFT: Even the Joker's gag guns are deadly. [Art by Jim Lee and Scott Williams, *Batman*, Vol. 1, #613]
OPPOSITE: Wearing Robin's costume, the Joker opens up some old wounds. [Art by Greg Capullo and Jonathan Glapion, *Batman*, Vol. 2, #16]

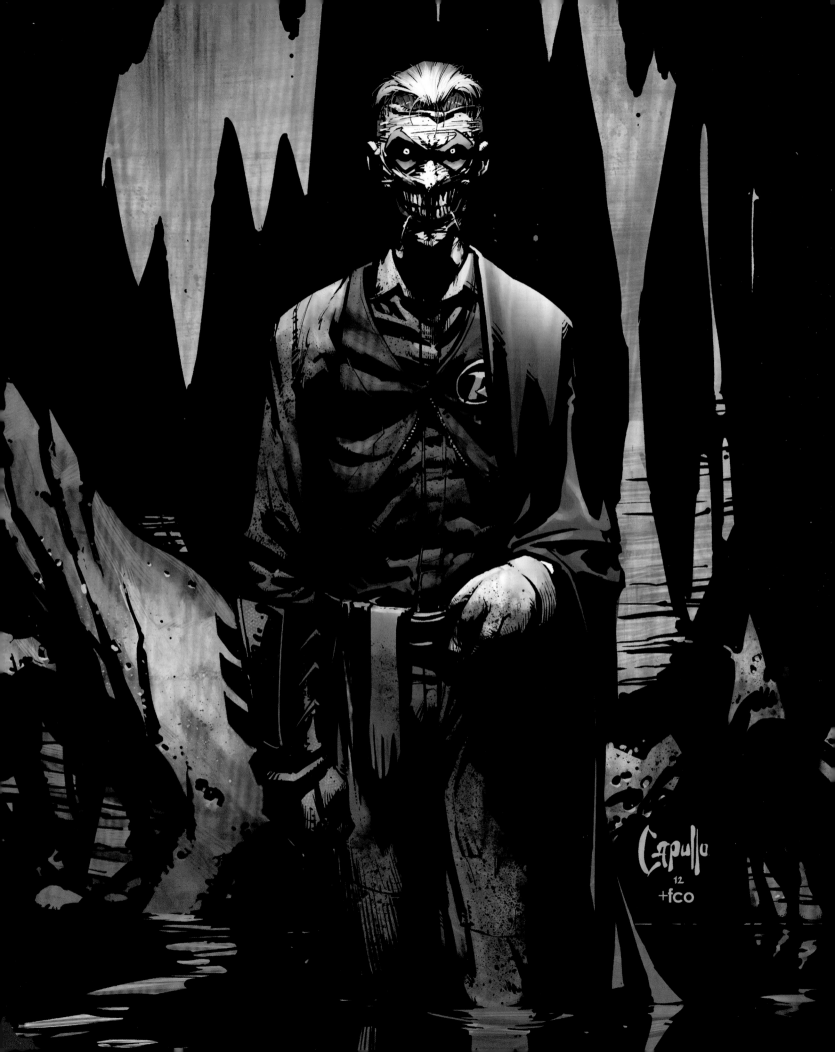

CATWOMAN

Both a playful villain and a reluctant hero, Catwoman is a morally ambiguous Gothamite with a cruel streak. Made famous on the big screen by actresses Michelle Pfeiffer, Halle Berry, and Anne Hathaway, Selina Kyle hasn't come close to using up her nine lives.

"She's more like a part of Batman's life than she is a villain to chase," says Chuck Dixon. "But her role is constantly changing. She can be Batman's ally or his adversary. Of all the characters in Batman's Rogues Gallery, Catwoman is the only one who is happy with who she is."

Bob Kane and Bill Finger introduced a jewel thief called "the Cat" in *Batman* #1 (Spring 1940), who tried to rob a luxury yacht and was stopped by the Dynamic Duo. When Batman didn't lift a finger to prevent the Cat's escape, Robin concluded—not inaccurately—that his partner had been bewitched by her feminine wiles.

By her third appearance, Catwoman had taken to wearing a furry cat mask, and she gradually acquired feline-themed gear, including an automotive "Cat-illac." An expert with a bullwhip and a cat o' nine tails, she wore gloves tipped with sharp claws and used her gymnastic skills to bound across Gotham City's rooftops.

Following the implementation of the Comics Code Authority in the 1950s, Catwoman disappeared from comics for over a decade—presumably to avoid the slightest hint of

sexual tension between her and the Caped Crusader. But the character's popularity exploded during the run of the *Batman* TV show, in which the purring temptress was variously played by Julie Newmar, Lee Meriwether, and Eartha Kitt.

"I think she was popular not only because she was a villain, but also because she was very seductive," says Marv Wolfman.

In 1987, "Batman: Year One" presented a rebooted origin for the Dark Knight while also alluding to Selina Kyle's unseemly past. The story, by Frank Miller and David Mazzucchelli, also introduced Holly Robinson, a young runaway whom Selina took under her wing.

A 1989 four-issue miniseries by Mindy Newell added new layers to Catwoman's origin, including her life on the streets, her education as a pickpocket, and her combat training courtesy of Golden Age hero Wildcat. In 1993 Catwoman received her own series that ran for ninety-six issues.

"Catwoman is fantastic," says writer Fabian Nicieza, who showcased the character in a *Batman Confidential* story arc. "It was fun because I got to play her off of a very young, very raw Batgirl. I love a character who's self-confident and self-aware. Catwoman is self-centered and a Robin Hood at the same time. She knows she's not good, but she also knows she's not bad."

Batman: The Long Halloween and its sequel *Batman: Dark Victory* provided new stages for Catwoman in their

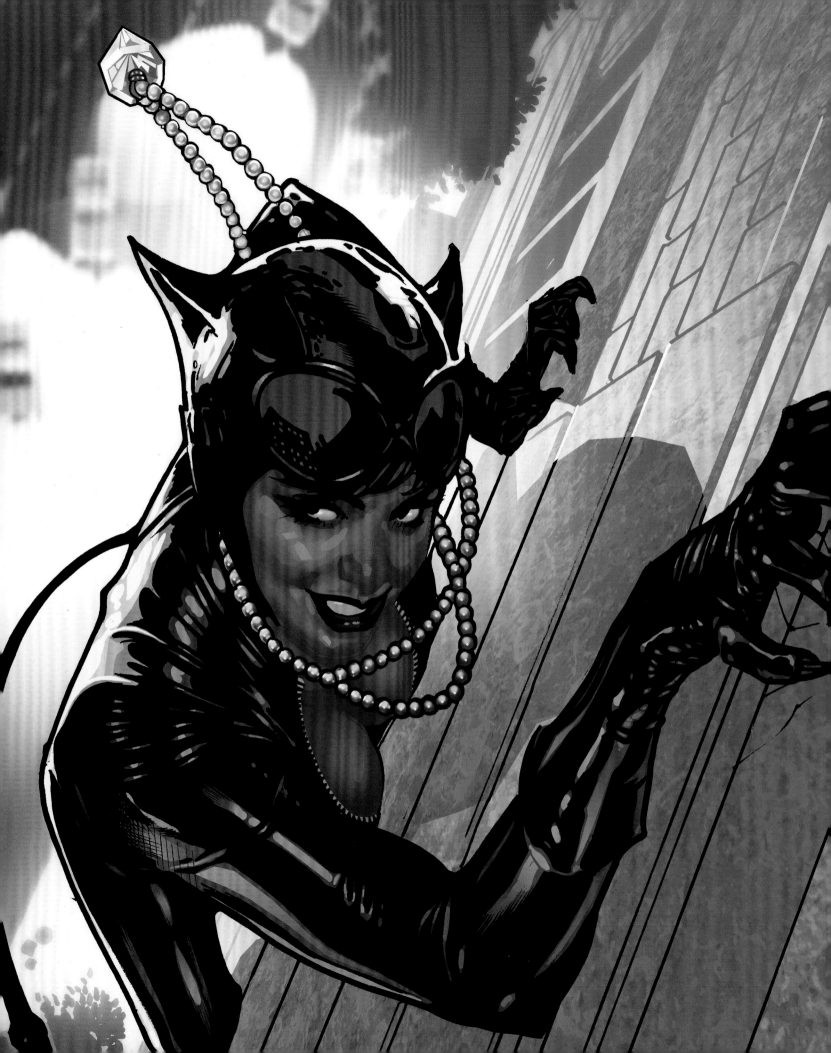

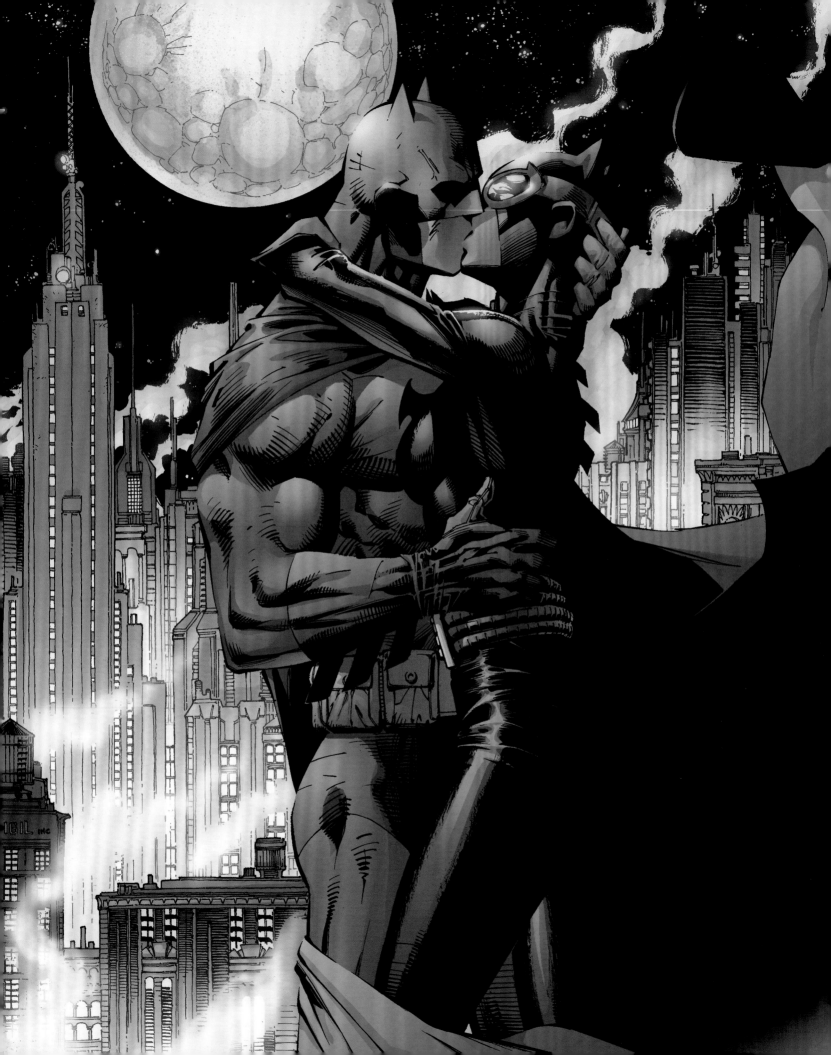

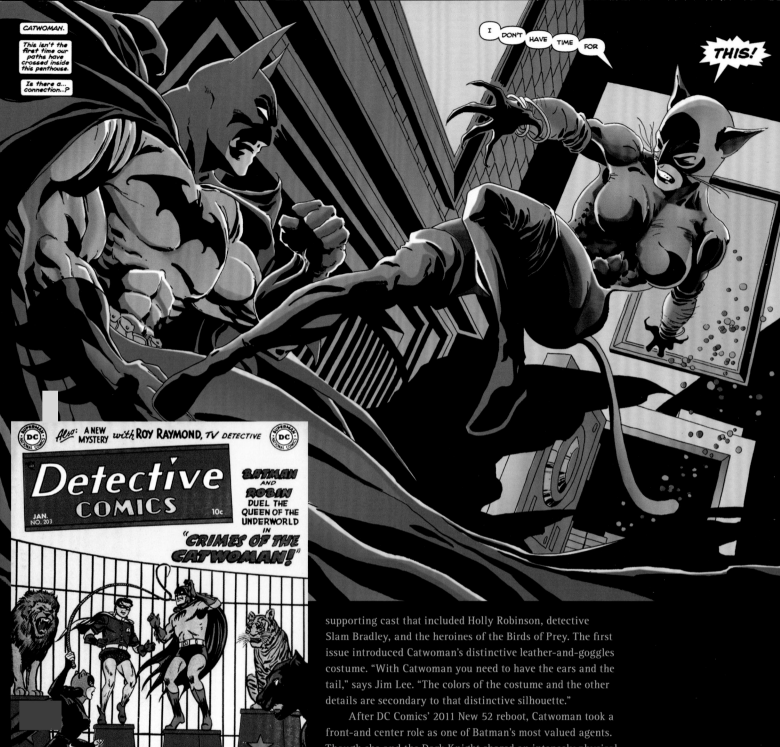

CATWOMAN.

This isn't the first time our paths have crossed inside this penthouse.

Is there a... connection..?

I DON'T HAVE TIME FOR THIS!

stylish depiction of Batman's early cases. Selina Kyle suspected she might be the daughter of Gotham City criminal kingpin Carmine Falcone, and Catwoman's attraction to Batman became more than subtext as the two entered into a professional and personal partnership.

The 2001 *Catwoman* series, initially written by Ed Brubaker with art by Darwyn Cooke, costarred a robust supporting cast that included Holly Robinson, detective Slam Bradley, and the heroines of the Birds of Prey. The first issue introduced Catwoman's distinctive leather-and-goggles costume. "With Catwoman you need to have the ears and the tail," says Jim Lee. "The colors of the costume and the other details are secondary to that distinctive silhouette."

After DC Comics' 2011 New 52 reboot, Catwoman took a front-and center role as one of Batman's most valued agents. Though she and the Dark Knight shared an intensely physical relationship, Bruce was still reluctant to let her in on his closely-guarded secrets.

Subsequent events uncovered Selina Kyle's familial connection to the Calabrese crime family, allowing her to seize the reins of the organization as well as its legal front, the cat-themed nightclub "The Egyptian." With Kyle's attentions elsewhere, rival Yakuza heiress Eiko Hasagawa took up the Catwoman mantle.

Since 2016 and the continuity tweaks of DC's Rebirth event, Catwoman's relationship with Batman has become decidedly more antagonistic. The "I Am Suicide" storyline saw Dark Knight free Catwoman from her cell in Arkham Asylum, but only to exploit her unique talents on a dangerous mission in a foreign land.

OPPOSITE: Catwoman and Batman share a forbidden kiss. (Art by Jim Lee and Scott Williams, *Batman* Vol. 1, #610) **TOP:** Her claws out, Catwoman strikes. (Art by Tim Sale, *Batman: The Long Halloween* #1) **LEFT:** Even circus cats do Catwoman's bidding. (Art by Win Mortimer, *Detective Comics*, Vol. 1, #203)

TWO-FACE

With his internal Jekyll/Hyde struggle etched into his flesh, Two-Face is one of the DC Universe's most gruesome villains. As Gotham City's incorruptible district attorney, Harvey Dent had been a friend to both Batman and Commissioner Gordon. But after a mobster on the witness stand threw acid in his face, the scarred Dent chose to treat his wounded side as the personification of his id. Becoming Two-Face, Dent dressed in bisected suits and chose every action based on the outcome of a coin flip.

"Batman is a character who wrestled with his personal demons, and he controlled them by becoming Batman," says Dan DiDio. "But Two-Face is a character Batman can relate to. You can see how he's 'Bruce Wayne gone wrong.'"

Could Two-Face one day redeem himself? That's certainly the Dark Knight's wish, and in 2006's "Face the Face" storyline, Harvey Dent returned to heroism. After restoring his good looks with plastic surgery, he earned Batman's trust enough to temporarily stand in for him as Gotham City's protector. But his dark impulses resurfaced while under investigation for murder. Dent carefully applied acid to his face while staring in a bathroom mirror, becoming Two-Face once more.

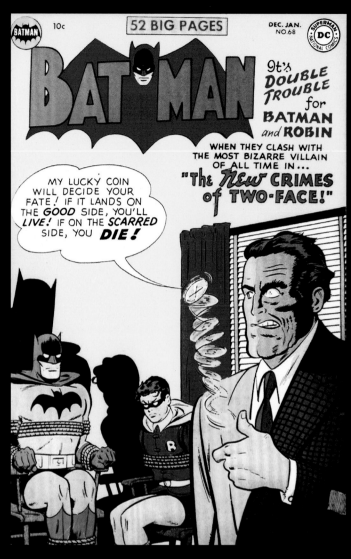

First appearing in *Detective Comics* #66 (August 1942), Two-Face is defined by his tragic fall from grace and his tortured ongoing struggle. On the big screen, both Tommy Lee Jones (1995's *Batman Forever*) and Aaron Eckhart (2008's *The Dark Knight*) have given memorable performances as the character.

When it comes to the coin, Batman writer Chuck Dixon recalls disagreeing with editor Dennis O'Neil on Two-Face's faithfulness to the gimmick. "Denny insisted on Two-Face's rigid adherence to the number two," he says. "That was set in cement: the 50/50 chance, and Two-Face being a slave to it. My take was that Two-Face would find a way to cheat. If the coin didn't come up how he wanted? Best two out of three!"

In the 1989 graphic novel *Arkham Asylum: A Serious House on Serious Earth*, doctors try to cure Two-Face of his reliance on his coin by moving him up to a 78-card tarot deck. Deprived of his binary logic, Two-Face finds himself unable to make any decisions at all.

The two-sided talisman surfaced again in 2013's "Forever Evil" event, which saw the superpowered Crime Syndicate seize control of Earth. The Scarecrow tried to recruit Two-Face as one of the Syndicate's minions. Though he considered the offer, Two-Face soon remembered that he takes orders from just one source: his coin.

Two-Face is a perfect villain for comics, with every panel an opportunity for a visual contrast of light and shadow or beauty and ugliness. Combine that with resonant psychological depth and you have a villain with true staying power.

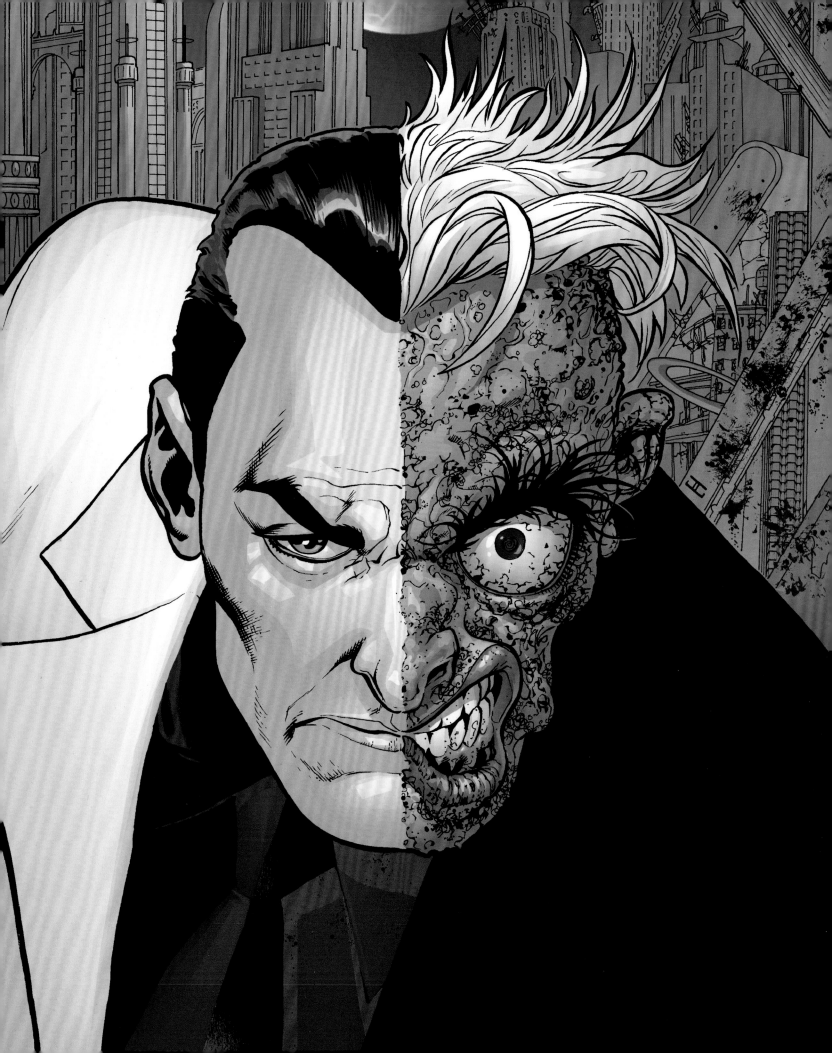

THE PENGUIN

In *Detective Comics #58* (December 1941) the Penguin strutted through Gotham City as a tuxedoed dandy with an umbrella in the crook of his arm. Batman dismissed him as a harmless eccentric, allowing the Penguin to show his evil underbelly by executing a gangster and appointing himself the new mob boss to fill the power vacuum.

The Penguin made dozens of appearances as a foe of the Dark Knight during the early decades and received additional small-screen fame through Burgess Meredith's portrayal in the 1960s *Batman* TV series. The Penguin has been a pop-culture mainstay ever since, especially after actor Danny DeVito's depiction of the character as a deformed outcast in 1992's *Batman Returns*.

In the comics, the Penguin is one of the few sane Batman villains who has no reason to find himself in Arkham Asylum. He loves themed gimmicks, including top hats, monocles, umbrellas, and birds of all breeds. As Oswald Chesterfield Cobblepot, the Penguin is the heir of a wealthy family of Gothamites and enjoys both the privileges of high society and the power of the black market.

Any umbrella carried by the Penguin is never *just* an umbrella. The handle could contain a miniature machine gun or a sharp-tipped rapier, or a hidden nozzle might spew flame or poison gas. Some umbrellas spin so rapidly they become single-passenger helicopters.

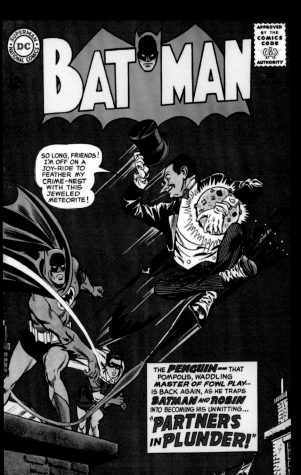

For Batman writer Chuck Dixon, the Penguin never really clicked in the role of art thief or bank robber. "Once Batman gets his hands on him, it's over," he says. "I suggested the Penguin was better served running a crooked nightclub, as a sort of Sydney Greenstreet character. He's the spider in the middle of the web. And he's actually scarier in that role, because physically there's nothing to him."

The introduction of waterfront nightclub the Iceberg Lounge gave the Penguin a home base, not to mention a shield of legitimacy for when the Gotham Police come knocking. Behind closed doors, the lounge is a hotbed of money laundering, information trading, and seedy backroom deals. Batman has a tense working relationship with the Penguin, and Cobblepot knows better than to test the Dark Knight's patience.

The Penguin is frequently a string-puller who gets others to do his dirty work. In the *Batman: Eternal* series, his mastery of the underworld recently put him into conflict with deposed mafia boss Carmine Falcone. Events soon escalated into all-out mob war.

The Penguin has found his niche in Batman's world as a figure who is able to feed information to the Dark Knight while poking his beak into the sleazy goings-on of organized crime. His employees might do most of his dirty work now, but the Penguin is still an ice-cold killer.

TOP: Flanked by the Scarecrow, the Penguin plots to seize Gotham City. (Art by Peter Tomasi and Scot Eaton, *Forever Evil: Arkham War #1*)

LEFT: A jet-powered umbrella makes for a quick getaway. (Art by Carmine Infantino and Murphy Anderson, *Batman*, Vol. 1, #169)

OPPOSITE: Underestimating the Penguin can be a fatal mistake. (Art by Jason Fabok and Nathan Fairbairn, *Batman*, Vol. 2, #23.3: *The Penguin*)

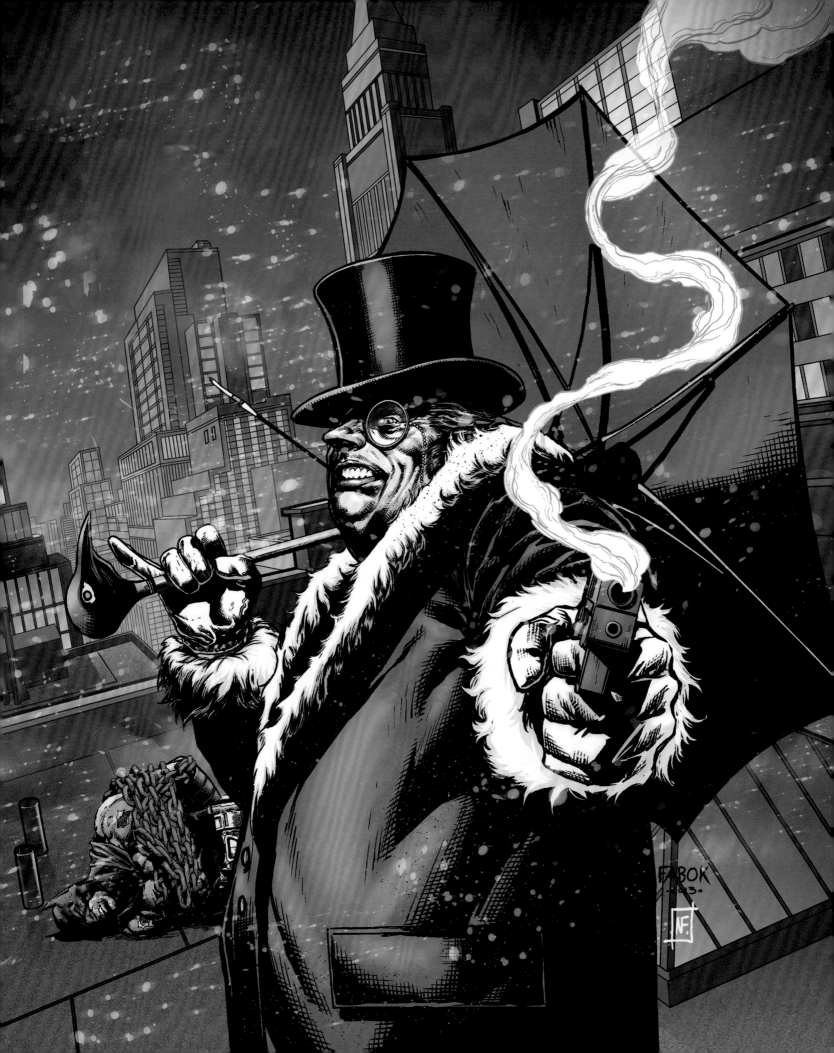

THE RIDDLER

Whether he's wearing a suit-and-hat ensemble or a form-fitting unitard dotted with question marks, the Riddler is one villain who always advertises. His gift for problem-solving makes him Batman's intellectual equal, but his compulsion to flaunt his smarts is his undoing.

"The Riddler is not a physical threat for Batman," says Mike Carlin. "He's obviously a mental threat, but he's always got that one flaw where he has to tip Batman off about what he's going to do. He's caught because he has a compulsion."

The Riddler first appeared in *Detective Comics* #140 (October 1948), though it was Frank Gorshin's manic performance in the 1960s *Batman* TV series that cemented his status as an iconic Bat villain. Born with the fitting name of Edward Nigma (Mr. E. Nigma, no less), the Riddler is fond of schemes that involve theatrically oversized props, like giant typewriters or colossal ears of corn. In 1995's *Batman Forever*, Jim Carrey turned in a larger-than-life performance as the cane-twirling crook.

"He likes to be THE GUY who KNOWS IT ALL, and he wants YOU TO *KNOW* he knows it..."

"Out of all of Batman's psycho-intellectual villains, the Riddler always fascinated me," says Chuck Dixon. "He likes to be the guy who knows it all, and he wants you to *know* he knows it, so he feels compelled to leave clues." But even this, Dixon notes, is often part of a larger con. "In a classic Riddler story, he doesn't leave clues to lead you toward his crimes. He does it to lead you *away* from them."

Batman: The Long Halloween found a role for the Riddler as an information resource, when mobster Carmine Falcone hired him to deduce the identity of the Holiday Killer. 2002's "Hush" storyline revealed that the Riddler had deduced Batman's identity—an ultimately hollow victory. Sharing the secret with others would cheapen its value, something the Riddler could not allow.

Writer Paul Dini discarded the Riddler's trademark conundrums entirely and found a fresh angle on the character in "E. Nigma, Consulting Detective," a story from *Detective Comics* #822 (October 2006). When a reformed Nigma hung out his shingle as a private investigator, he discovered a new way to beat Batman at his own game.

Recent New 52 tweaks to Batman's backstory have retroactively established Nigma as a former up-and-comer within Wayne Enterprises, who bumped off Bruce Wayne's uncle before embarking on a life of crime. His first Riddler caper, as told in Batman's "Zero Year" story arc, saw him black out the power grid and blow up a reservoir in an attempt to bring a flooded, paralyzed Gotham City to its knees.

The Dark Knight has mastered countless fields of study both physical and intellectual—the Riddler excels at only one. But to his credit, his peculiar obsession has brought him tantalizingly close to besting Batman.

Featuring "REMARKABLE RUSE of the RIDDLER!"

FAR LEFT: The Riddler stays on his toes in this early cover. (Art by Carmine Infantino and Murphy Anderson, *Batman*, Vol. 1, #171)
LEFT: With his suit, tie, and cane, the Riddler is a well-dressed rogue. (Art by Guillem March, *Batman*, Vol. 2, #23.2: *The Riddler*)
OPPOSITE: When deep in thought, Edward Nigma is a dangerous man. (Art by Jim Lee and Scott Williams, *Batman*, Vol. 1, #619)

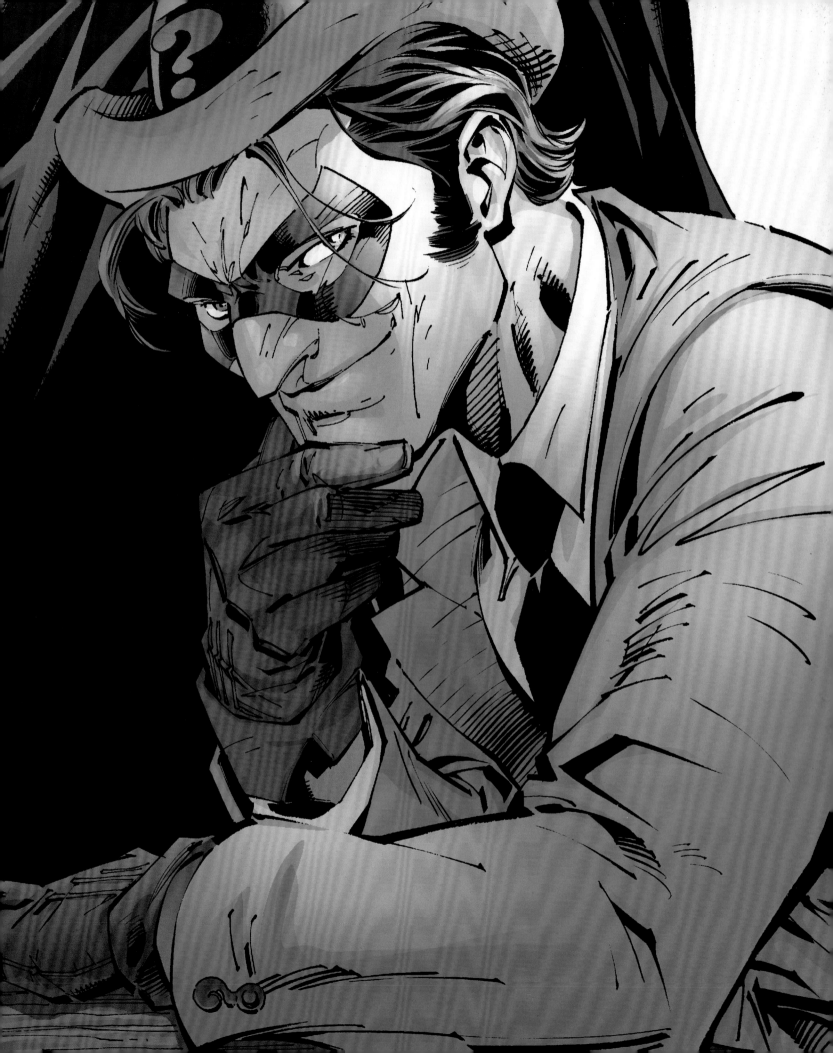

POISON IVY

Representing Mother Nature in all her serenity and savagery, Poison Ivy debuted in *Batman* #181 (June 1966) in a tale by Robert Kanigher and Sheldon Moldoff. Her costume resembled a bathing suit adorned with leafy garlands, and seduction was her weapon of choice. "She was the siren who could drive a wedge between Batman and Robin by luring Batman away," explains Batman writer Chuck Dixon.

Poison Ivy's wiles couldn't bewitch Batman, but over time she developed mind-controlling powers that went hand-in-hand with her affinity for growing things. Once known as Pamela Isley, she had been a botanist obsessed with ecological preservation. Now, as Poison Ivy, she could command plants to do her bidding and put all of Gotham City under her green thumb. Poison Ivy's body exudes chemicals that cast a spell on others, and the toxins on her lips are strong enough to kill with a kiss.

In DC Comics' New 52 continuity, Poison Ivy is afflicted with a skin condition that confined her to her family's garden as a girl. A chemical accident, sustained during her internship in the biochemistry division of Wayne Enterprises, opened her mind to telepathic communication with plants and allowed her to control their rate of growth. The Birds of Prey welcomed Poison Ivy as a member until she used her mind-fogging pheromones to seize command of the superpowered special-ops team.

Despite her history of backstabbing, Poison Ivy is motivated by her defense of the natural world, and as such she is rarely painted as irredeemable. She is close with Harley Quinn, their relationship originating in *Batman: The Animated Series*. Poison Ivy, Harley, and Catwoman starred in the series *Gotham City Sirens*, while the 1997 movie *Batman & Robin* saw the character captured through actress Uma Thurman's playful portrayal.

In the comics, Poison Ivy isn't entirely human and her motives only make sense to those who share her flora-hybridized DNA. After an earthquake leveled Gotham City, Poison Ivy claimed a patch of public greenery to grow food for the starving survivors. In the "Hush" storyline, she hypnotized Superman and sicced him on the Dark Knight.

Ivy got her turn in the spotlight in the six-issue solo series *Poison Ivy: Cycle of Life and Death*. Dr. Isley, hired by the Gotham Botanical Gardens for her PhD expertise, helped create three plant-human hybrids named Rose, Hazel, and Thorn. Ivy became a surrogate mother for the three children and helped them start new lives beyond Gotham.

Like the plants she loves so dearly, Poison Ivy cannot be contained. However, the creeping rot of her green empire will never comfortably take root in Gotham City—not as long as Batman continues to enforce his straight-edged view of law and order.

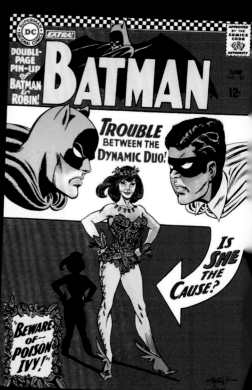

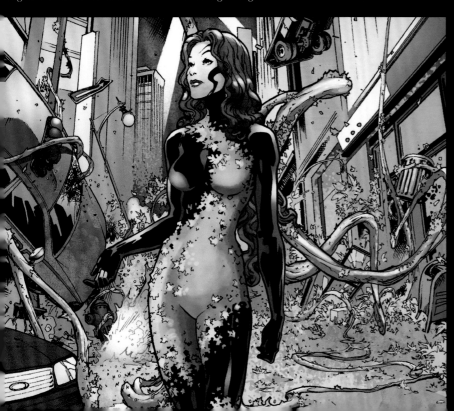

"Like the plants SHE LOVES so dearly, POISON IVY cannot be CONTAINED."

TOP: Plant pheromones are strong enough to bewitch even Superman. [Art by Jim Lee and Scott Williams, *Batman*, Vol. 1, #612]
ABOVE: Poison Ivy strikes a pose in her debut. [Art by Carmine Infantino and Murphy Anderson, *Batman*, Vol. 1, #181]
LEFT: Poison Ivy leaves botanical mayhem in her wake. [Art by Javier Pina, *Detective Comics*, Vol. 2, #23.1: *Poison Ivy*]
OPPOSITE: Poison Ivy, now more plant than human, luxuriates in the embrace of a chlorophyll partner. [Art by Clay Mann and Seth Mann, *Poison Ivy: Cycle of Life and Death* #1]

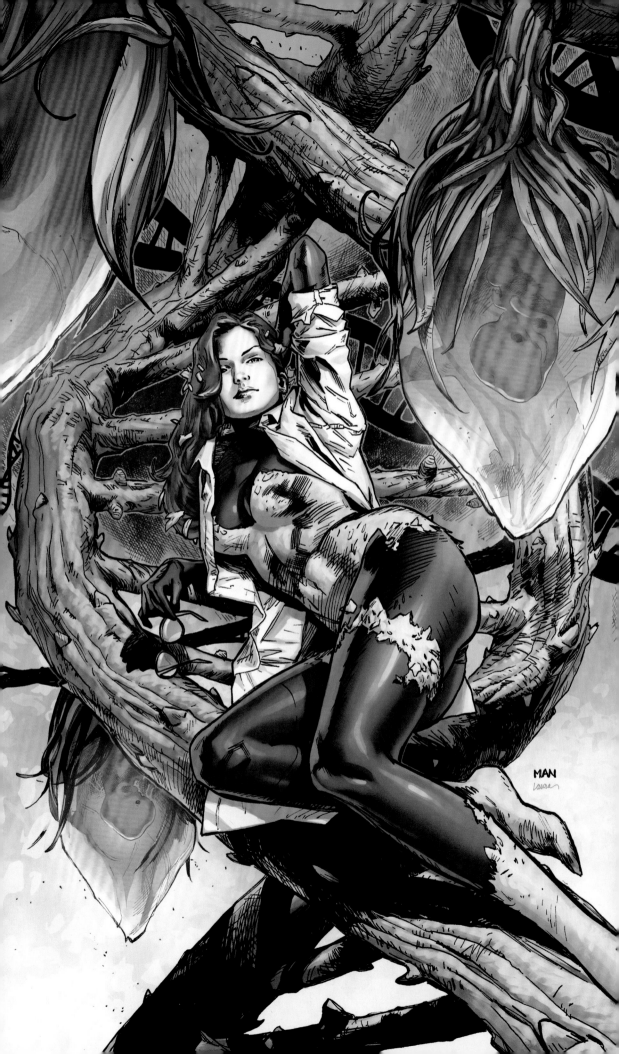

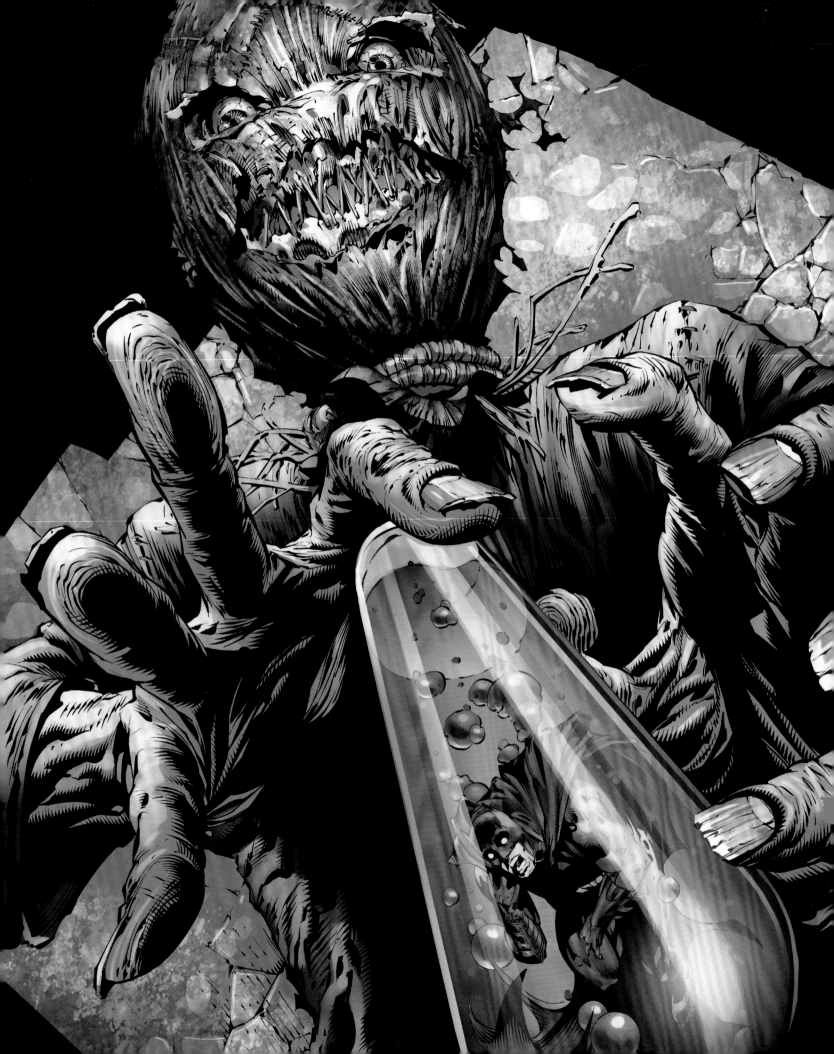

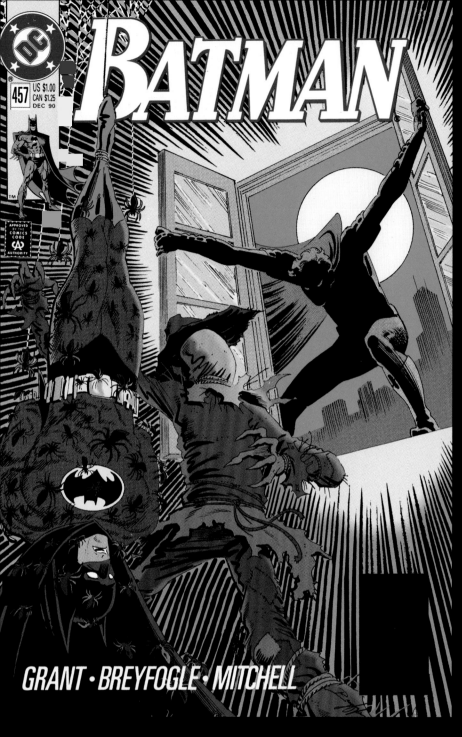

GRANT · BREYFOGLE · MITCHELL

SCARECROW

Batman writer Peter Milligan calls the Scarecrow "the tatterdemalion of crime," but beneath the patchwork costume is a gangly nerd who likes to play mind games. Jonathan Crane, fed up with others pushing him around, sought revenge by perfecting the science of fear. Crane's first outing as the Scarecrow dates back to the Golden Age, with *World's Finest Comics* #3 (Fall 1941) detailing Crane's use of psychological terror in "The Riddle of the Human Scarecrow."

With his raggedy farmer's field costume and a theme that's easy to grasp, the Scarecrow proved to be a durable Batman villain and finally received a movie outing in 2005's *Batman Begins* in a portrayal by actor Cillian Murphy.

Jonathan Crane's credentials are legitimate. He's a licensed psychiatrist specializing in phobias, and his past positions include a professorship at Gotham University and a role on the staff of Arkham Asylum. Crane's greatest invention is a hallucinogenic fear gas that triggers traumatic, incapacitating visions in those who breathe it. His Scarecrow mask contains air filters protecting him from the same effects—but when he does face his phobias, Scarecrow usually sees a swarm of bats.

"I like writing Scarecrow, because you just love to see him get his comeuppance," says Chuck Dixon. "He's such a cowardly little dweeb. It's fun to see the tables turned."

Batman #630 (September 2004) saw Crane's temporary transformation into the muscular mutated "Scarebeast." During the Green Lantern "Blackest Night" crossover event, the Scarecrow received a yellow power ring that deputized him into the Sinestro Corps on the strength of his history of instilling great fear in his victims.

In the New 52 reboot, the Scarecrow forged an alliance with Bane and combined his fear gas with Bane's Venom steroid to brew an even more potent concoction. He later turned on Bane, taking advantage of governmental chaos to seize control of Gotham City with a legion of mind-controlled followers. A later scheme saw Crane attempt to disperse aerosolized fear toxin across the city by unleashing a fleet of remote-controlled drones.

"Batman is a character who lives on fear, and who uses fear as a weapon," says Dan DiDio. "With Scarecrow, you see someone who also uses fear as a weapon, but in a different way."

OPPOSITE: The Scarecrow has brewed up a special batch of terror for Batman. [Art by David Finch, Richard Friend, and Sonia Oback, *Batman: The Dark Knight*, Vol. 2, #12]

TOP: Scarecrow's psychological torture of Batman is interrupted just in time. [Art by Norm Breyfogle, *Batman*, Vol. 1, #457]

LEFT: The Scarecrow preaches fear. [Art by Alex Ross and Doug Braithwaite, *Justice* #11]

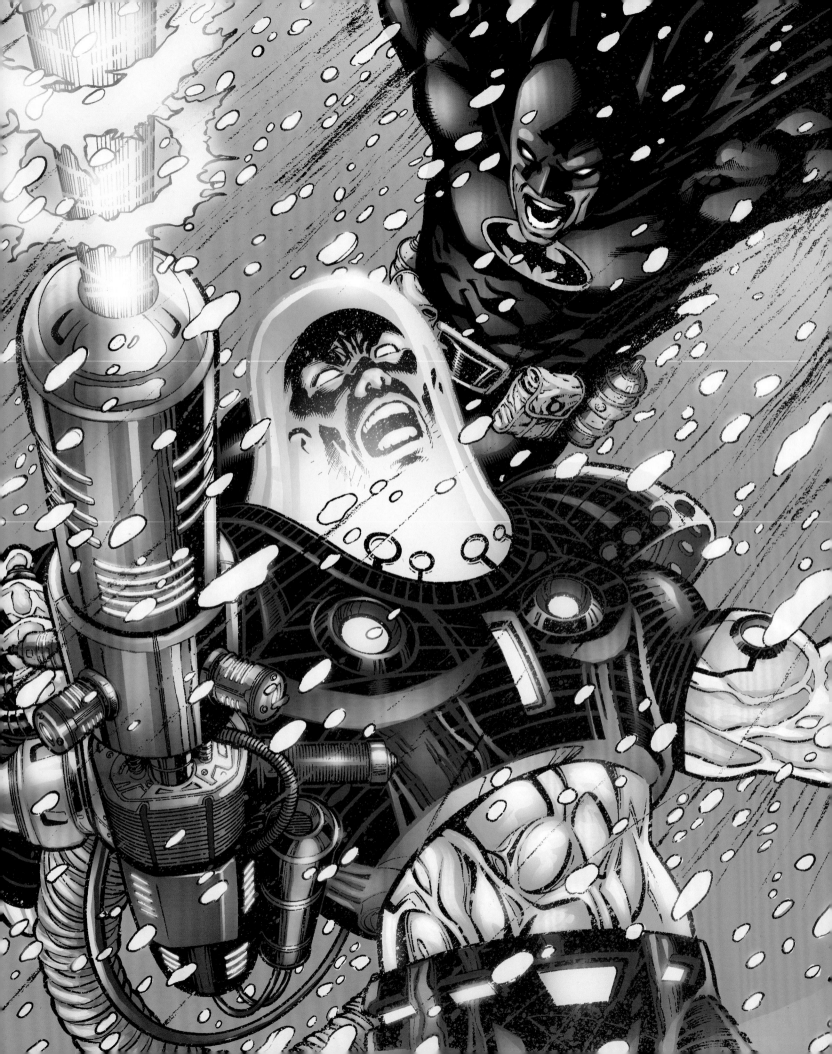

MR. FREEZE

Driven by his highly personal quest, Freeze is a sympathetic figure whose ice-blue aesthetic stands out against Gotham City's grimy streets. He's implacable, inflexible, emotionless—and unlike any other Batman foe.

The cover blurb advertised "The Ice Crimes of Mr. Zero," but the frozen foe of *Batman* #121 (February 1959) earned more fame under another name. The character's debut firmly established his criminal gimmick, as Mr. Zero sidelined the Dynamic Duo by putting them in ice-block isolation.

By the mid-1960s the *Batman* TV series had become a phenomenon. After the episode "Instant Freeze" introduced a villain similar to Mr. Zero but going by the name of Mr. Freeze, the Batman comics decided to fall in step. Mr. Freeze appeared in the comics throughout the 1970s and '80s, but it took a different TV outlet to give him a lasting dose of pathos.

The Emmy Award®–winning episode "Heart of Ice," written by Paul Dini and directed by Bruce Timm for *Batman: The Animated Series*, presented Mr. Freeze as a haunted figure desperate to save his terminally ill wife, Nora. Freeze's crimes helped fund his research, and he kept Nora's body in cryogenic stasis as he wistfully hoped for better days. Mr. Freeze got another injection of fame when Arnold Schwarzenegger took the role in 1997's *Batman & Robin*, delivering a string of frosty puns.

"He can be a tough character to write," says Batman writer Fabian Nicieza. "The fundamental reason for why he's a bad guy is kind of a noble one—to resurrect his wife, because he feels responsible for her condition. The idea that there's a drop of warmth inside this cold man is something you can play with. But the other side of the coin is that it can become a one-note aspect, so that there's nothing else *besides* that to the character that you can really mine."

In the New 52 continuity, Mr. Freeze started out as cryogenic scientist Dr. Victor Fries. He wrote his doctoral thesis on Nora, a patient who had existed in suspended animation for decades, and in time he grew to love the cold, silent figure.

When Bruce Wayne suggested the shutdown of his research, an enraged Fries accidentally exposed himself to super-cooling chemicals. Room temperatures could kill him in his new state, so Fries built a refrigeration suit to keep his blood pumping.

This mutated biology is occasionally a blessing. When the Joker infected Gotham with mind-controlling Joker venom, Mr. Freeze found that he possessed a natural resistance. This immunity made him one of the few people able to help Batman to restore order.

Mr. Freeze's signature weapon is his hand-held freeze gun. His armored suit provides bulletproof protection, but a broken seal can cause a coolant leak. If this happens, Freeze has only minutes before his body succumbs to the warm embrace of death.

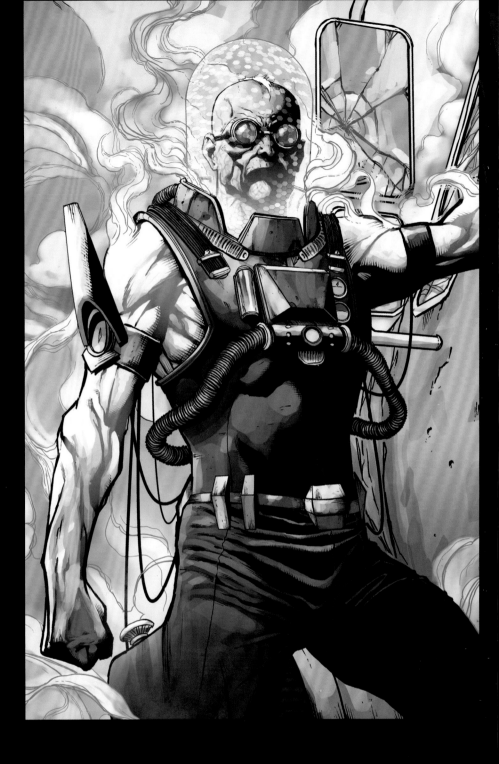

"The fundamental REASON for why he's A BAD GUY is kind of a NOBLE ONE— to RESURRECT his wife, because he FEELS RESPONSIBLE for her condition."

OPPOSITE: While battling Batman, Mr. Freeze brings on an early winter.
[Art by Greg Land and Drew Geraci, *Batman: No Man's Land Gallery* #1]
TOP RIGHT: Freeze's condition keeps him isolated from the rest of humanity.
[Art by Jason Fabok, *Batman Annual*, Vol. 2, #1]

RĀ'S AL GHŪL & TALIA AL GHŪL

ABOVE: Talia al Ghūl has plans for global domination. (Art by Chris Burnham and Cameron Stewart, *Batman Incorporated: Leviathan Strikes*) **BELOW:** Rā's al Ghūl is a master manipulator. (Art by Neal Adams, *Limited Collectors' Edition*, Vol. 1, C-51)

Rā's al Ghūl—"the Demon's Head" in Arabic—is an immortal ecoterrorist and the leader of the globe-spanning League of Assassins. As one of the most brilliant minds on the planet Earth, he is a fitting antagonist for the World's Greatest Detective.

In *Batman* #232 (June 1971), Dennis O'Neil and Neal Adams introduced the villain that O'Neil described as "so exotic and mysterious that neither we nor Batman were sure what to expect." Rā's al Ghūl enlisted Batman's help in locating his kidnapped daughter, Talia. After following the trail to a remote Himalayan stronghold, Batman realized the quest had merely been a test of his determination.

Batman angrily turned down Rā's offer to become his successor, but the stage had been set for the character's return. With each appearance, Rā's al Ghūl's popularity grew. In 2005, the villain broke into the mainstream with actor Liam Neeson's portrayal in the blockbuster *Batman Begins*.

"Rā's was Denny's idea for taking Batman global," explains Batman writer Chuck Dixon. "It was the spy era. Denny's thought was to give Batman a bad guy who's not out to rob the Gotham National Bank."

At least six hundred years old, Rā's al Ghūl's lifespan is sustained by mystical Lazarus Pits that reverse the effects of age and restore the dead to life. He has seen the rise and fall of countless kings, and has concluded that humanity's stupid, self-destructive actions will bring about the destruction of the natural world if left unchecked. Rā's al Ghūl believes he can restore the planet's ecological balance through plagues and natural disasters that exterminate most of the world's population.

"Rā's al Ghūl's actions are always meticulously planned around the precept that the world would be a better place if there were two-thirds fewer people living on it," says Fabian Nicieza, who contributed to the 2007–2008 storyline "The Resurrection of Rā's al Ghūl." He explains, "The beauty of it is, at its most heinous, there's still a fundamental logic and accuracy to his beliefs. If you want to be cold and clinical, he's probably right."

"His motivations are not necessarily off-base," agrees Mike Carlin. "He's not always wrong, and he's not out for personal gain. He's out to better the world, but the people who would be dead if Rā's had his way would probably disagree with him."

Rā's is a master martial artist and an expert with curved-bladed scimitars. His worldwide spy network ensures that nothing transpires on Earth of which he is unaware. Rā's is often shadowed by Ubu, his muscular bodyguard.

Because he regards Batman as the worthiest opponent he has ever faced, he respectfully addresses Batman as "Detective." Rā's is aware of the attraction between his opponent and his daughter Talia, and uses their bond as a bargaining chip to sway Batman to his faction.

In a 1990s Batman storyline, Rā's al Ghūl released the Ebola Gulf A virus into Gotham City, killing thousands. The 2004 storyline "Death and the Maidens" saw Rā's breathe his last breath, but he didn't stay in the grave for long.

The character returned in a new body in a storyline that began in *Batman* #670 (December 2007). Damian Wayne also debuted during this era, and the revelation that Damian was the biological son of Bruce Wayne and Talia al Ghūl set up a conflict around whether the boy would choose allegiance to his father or remain loyal to the League of Assassins.

The family ties represented by Talia and Damian got tangled up again in a 2013–2014 saga in which both characters perished. Their deaths became the tragic trigger that set Batman and Rā's al Ghūl back at each other's throats.

"The best Batman villains who have really stuck are Rā's al Ghūl and Talia," says Mike Carlin. "So much so that they have really become a major part of Batman's ongoing story. Damian is not a villain, but he is the product of villainy, and he is arguably the most important character to emerge in the last fifteen years."

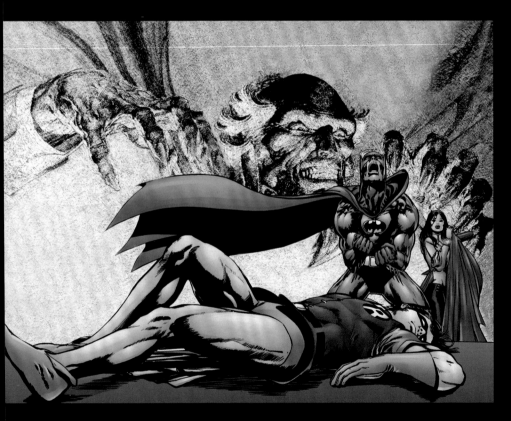

OPPOSITE: The head of the League of Assassins, Rā's al Ghūl is an unbeatable combatant. (Art by Patrick Gleason, Mick Gray, and John Kalisz, *Batman and Robin*, Vol. 2, #23.3: *Rā's al Ghūl and the League of Assassins*)

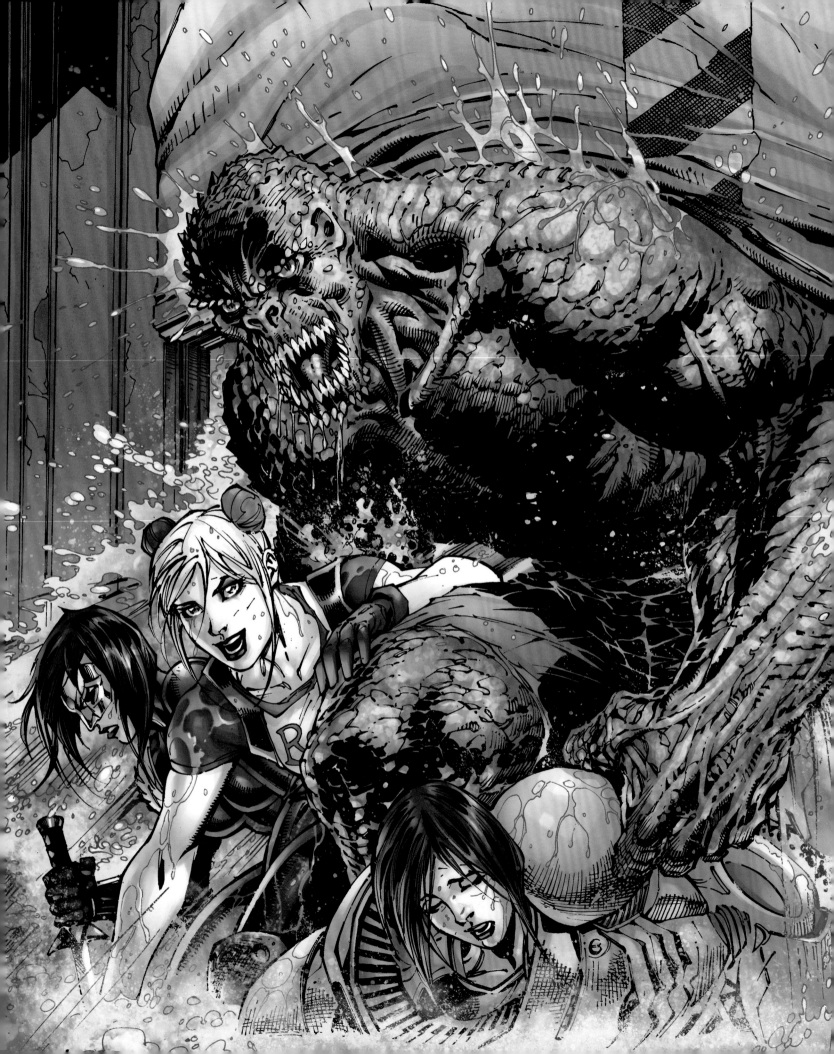

KILLER CROC

The cover of *Detective Comics #523* (February 1983) might have promised Solomon Grundy, but its pages had a surprise lurking inside. Killer Croc's debut, written by Gerry Conway and illustrated by Gene Colan, introduced the first villain of the 1980s who would earn a permanent spot among Batman's foes.

Glimpsed as a shadowy figure in a hat and trench coat, Killer Croc possessed a scaly hide that hinted at the monster within. Croc gradually worked his way up the hierarchy of Gotham City's underworld, and in a later appearance he murdered the parents of Jason Todd, the second Robin.

With each appearance, Killer Croc grew less calculating and more animalistic. His crocodilian traits soon encompassed far more than just his skin, until he resembled a hybridized reptile who acted on bestial impulses of rage, pain, and hunger. In the 2002 "Hush" storyline, Jim Lee rendered Killer Croc with a lashing tail and a long, tooth-filled snout.

"We mutated Croc to take him out of that standard humanoid shape, because we wanted each member of Batman's Rogues Gallery to have a striking silhouette and play off of Batman's shape," he says. "The villains like Croc weren't just men and women in costumes; they were monsters—Gotham's versions of nightmares."

Now a thick-hided leviathan, Killer Croc has all the muscular power one would expect from a creature of his size, along with jaws that can't be pried open once they clamp shut. His regenerative abilities let him grow back missing limbs. An excellent swimmer and a patient hunter, Croc stalks the sewers beneath Gotham City and hungrily devours human prey.

Newer storylines have given Croc a twinge of conscience by establishing him as the protector of Gotham's sewer dwellers. That being said, Croc's role as the biggest bruiser on the Suicide Squad is enough to shoot down any speculation that he's grown soft.

"He's dangerous," says Chuck Dixon. "He's an outcast from society. Croc is a monster."

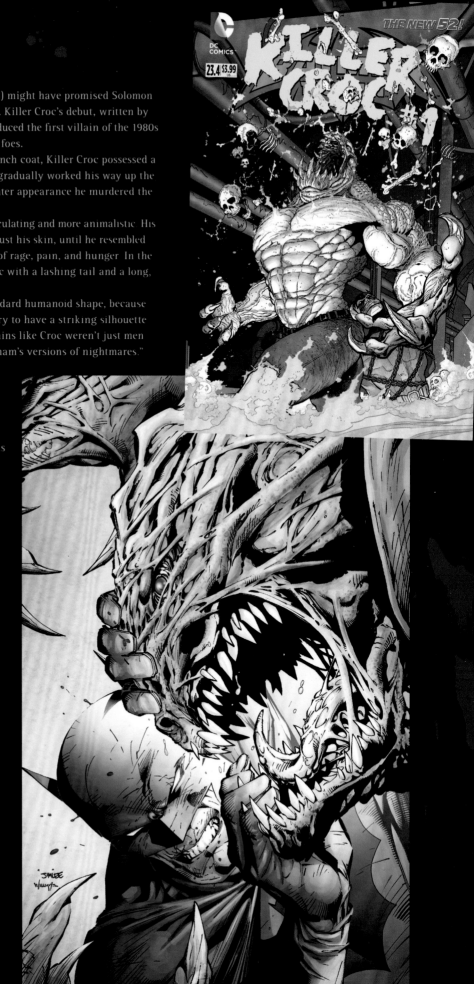

OPPOSITE: Killer Croc's enhanced strength and natural agility in submerged environments proves critical to his success as a member of the Suicide Squad. [Art by Scott Williams and Jim Lee, *Suicide Squad* #2]

TOP RIGHT: Killer Croc amid the skulls of his victims. [Art by Patrick Gleason, Mick Gray, and John Kalisz, *Batman and Robin*, Vol. 2, #23.4: *Killer Croc*]

RIGHT: Batman struggles to deflect Killer Croc's bite. [Art by Jim Lee and Scott Williams, *Batman*, Vol. 1, #610]

CLAYFACE

Clayface's shapeshifting seems like a miracle gift, but the character's story plays out as a grotesque tragedy. What does it matter if you can craft a beautiful exterior? It's a hollow victory when you're literally made of mud.

The first Clayface couldn't change his shape at all. *Detective Comics* #40 (June 1940) told the story of movie actor Basil Karlo, who sought revenge after learning that his part had been recast. Karlo put on a mask to become the murderous Clayface.

Detective Comics #298 (December 1961) resurrected the Clayface concept. Treasure hunter Matt Hagen transformed into a protoplasmic lump after a close encounter with radioactive glop. This Clayface possessed a familiar array of powers including facial mimicry and the ability to morph his limbs into clubs and hammers.

The third Clayface, Preston Payne, debuted in *Detective Comics* #478 (July/August 1978). Payne injected himself with Matt Hagen's blood to gain similar powers, only to watch in horror as his flesh sloughed from his body and his touch melted others into goo.

Clayface III's containment suit prevented Payne from accidentally harming others and kept his body from losing cohesion. In a memorable string of stories, a lonely Clayface fell in love with a mannequin named Helena, seeing her as the only woman who wouldn't fall apart under his caresses.

The New 52 continuity returned Basil Karlo to the role of Clayface but gave him the shapeshifting powers of his predecessors. Karlo's short temper ended his movie career and makes Clayface a hothead who explodes into action at the slightest provocation.

This new Clayface found surprising redemption in the pages of *Batwoman*, where he joined Ragman, Etrigan the Demon, Jason Blood, and Red Alice to form the Unknowns, a team of supernatural oddballs whose objective was to take down the resurrected Morgaine Le Fay. Clayface's short-lived heroic stint led to the shutdown of a dark magic plot cooked up by the witch.

However, Clayface got a new chance to play the hero when Batman recruited him to a team of Gotham-based champions led by Batwoman. The Dark Knight also discovered novel uses for Karlo's amazing powers, utilizing him as a bulletproof sphere to protect the team and even crafting the malleable Karlo into a form-fitting suit of Bat armor.

"AMORPHOUS and often AMORAL, CLAYFACE is one of the few BATMAN foes with true SUPERPOWERS."

TOP: Batman's blows pass right through Clayface.
(Art by Glen Orbik and Laurel Blechman, *Detective Comics*, Vol. 1, #735)

LEFT: By morphing his limbs, Clayface can become a walking arsenal.
(Art by Cliff Richards, *The Dark Knight*, Vol. 2, #23.3: *Clayface*)

OPPOSITE: Batwoman is consumed by an enveloping wall of Clayface. When deployed in friendly fashion, Clayface can serve as a shield against incoming fire.
(Art by Raúl Fernández and Alvaro Martinez, *Detective Comics* #936)

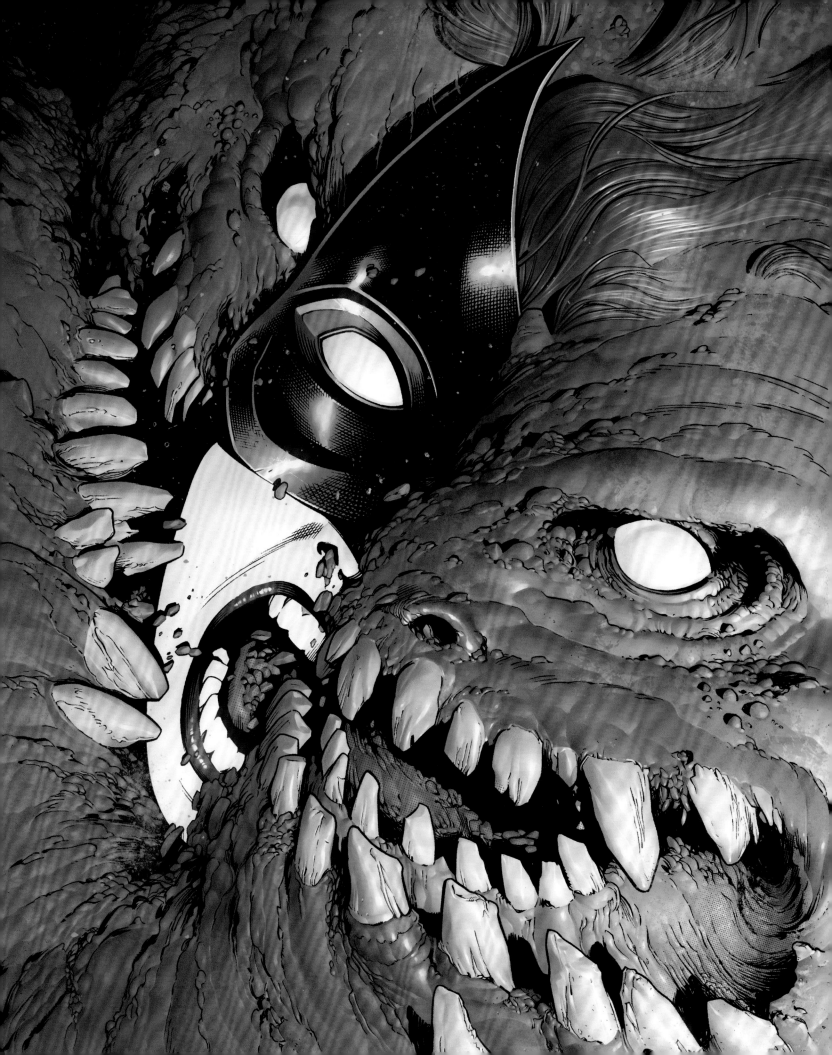

BANE

The definitive Batman foe of the 1990s burst onto the scene with a truly shocking finishing move. By snapping Batman's spine, Bane became infamous as the villain who finally "broke the Bat."

The nineteen-part "Knightfall" saga kicked off in *Batman* #492 (May 1993). As Batman faced a procession of enemies freed from their Arkham cells, Bane watched from the shadows. Finally, with the Dark Knight nearly dead from exhaustion, he delivered his famous move.

Batman: Vengeance of Bane (1993) provided Bane's backstory. Hailing from the island nation of Santa Prisca, he had grown up in the hellish prison of Peña Dura, fulfilling his father's life sentence. He became a leader among the convicts after learning multiple languages and bulking up in the prison's weight room, marking him as the next guinea pig for the test of an experimental serum. Given superhuman strength that relied on regular injections, Bane developed a costume that incorporated delivery tubes for the drug Venom.

"Most characters become popular by accident," says Chuck Dixon, writer of Bane's origin story. "I knew the difficulty in trying to create a character to be popular. We needed a villain who could disable Batman and knew he was going to use Venom to get an edge. My insistence was that he be Batman's intellectual and physical equal."

Bane kicked his addiction to Venom but kept his animosity toward Batman. A rematch between the two took place in *Detective Comics* #701, this time with Bruce Wayne coming out on top.

Bane's first movie role came in 1997's *Batman & Robin* with a portrayal by Robert Swenson. When 2012's *The Dark Knight Rises* arrived in theaters, Tom Hardy won over audiences with his interpretation of Bane as a soft-spoken but brutal anarchist.

Bane joined the cast of Gail Simone's *Secret Six* in 2008. Uncompromising and fearless, he served as the conscience in a team of reprobates. And his overprotectiveness of Scandal Savage indicated a surprising soft side.

In 2013, the *Forever Evil* event provided a new stage for Bane. After leading an army from Santa Prisca to Gotham City, Bane freed the criminals of Blackgate Prison to swell his ranks even further. He then launched a coordinated attack against the criminals who had seized Gotham for themselves, crushing and conquering their ragged city-block empires.

But Bane's experiences in Santa Prisca continued to haunt him. Once he seized control of his homeland, Bane kidnapped the Psycho Pirate and planned to use the emotion-manipulating super-villain's powers to ease the mental trauma left by his violent, prison upbringing. Batman, however, had his own plans for the Psycho Pirate and assembled a team of outcasts to assault Bane's prison fortress, giving the Dark Knight a chance to even the score with the masked villain.

"Bane caught on because other writers really hooked into him," says Mike Carlin. "So much so that he's been in two movies. Bane is a good physical threat. Someone who can beat Batman and break him, that's a pretty good villain."

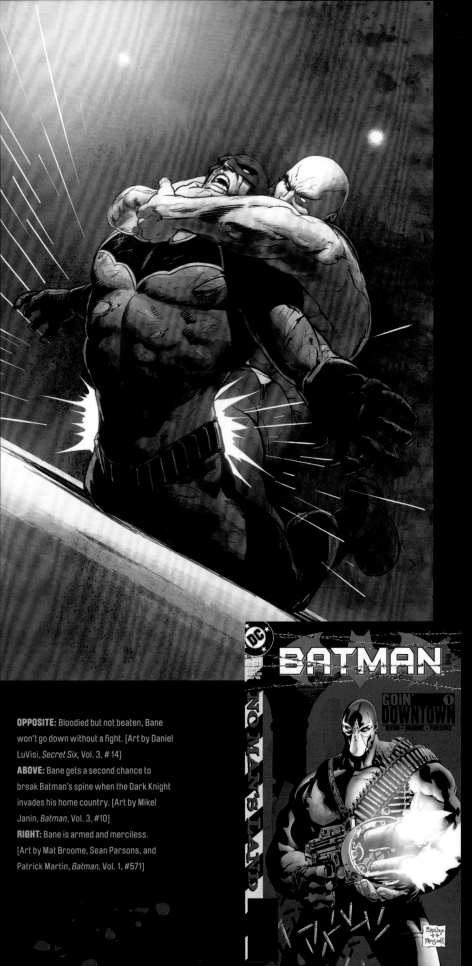

OPPOSITE: Bloodied but not beaten, Bane won't go down without a fight. [Art by Daniel LuVisi, *Secret Six*, Vol. 3, #14]

ABOVE: Bane gets a second chance to break Batman's spine when the Dark Knight invades his home country. [Art by Mikel Janin, *Batman*, Vol. 3, #10]

RIGHT: Bane is armed and merciless. [Art by Mat Broome, Sean Parsons, and Patrick Martin, *Batman*, Vol. 1, #571]

HARLEY QUINN

Most DC Comics villains came of age on the comic book page before making the leap into animation, movies, TV, or video games. Not Harley Quinn.

Writer Paul Dini and director Bruce Timm introduced Harley as the Joker's bell-wearing, madcap accomplice in a 1992 episode of *Batman: The Animated Series*. Her infectious glee and high-pitched, Brooklyn-accented voice (provided by Arleen Sorkin) made her a breakout star.

Never one to disappoint her audience, Harley expanded into comics that took place in the continuity of the animated series, including the Eisner award-winning *The Batman Adventures: Mad Love*. In 1999 she debuted in DC Comics' mainstream comic book universe. *Batman: Harley Quinn* unpacked the character's twisted history as an Arkham Asylum psychiatrist fascinated by the Joker's pathology. When therapy sessions turned to obsession, Dr. Harleen Quinzel plunged into madness in order to be close to her "puddin'."

Harley's weapons include a tough attitude and a heavy mallet. She is close friends with Poison Ivy and shares Ivy's immunity to poisons. Harley's greatest flaw is self-destructive love, for the Joker will happily toss her into traffic if it helps him make a clean getaway.

Scott Beatty cowrote *Joker: Last Laugh*, in which a terminally-ill Joker announced his intention to hook up with Harley and start a family. "One would think she'd be ga-ga over the Joker finally returning her affections, but I think her reluctance was completely in character," he says. "Harley was used to chasing the Joker, not being chased herself. Their relationship was always dysfunctional."

A *Harley Quinn* series debuted in 2001 and ran for thirty-eight issues. A later series, *Gotham City Sirens*, united Harley with Poison Ivy and Catwoman to protect their corner of the city.

Harley underwent an extreme makeover in the bestselling game *Batman: Arkham Asylum*, with the look carrying over into DC Comics' 2011 comics reboot. Ditching the red-and-white jumpsuit, a pale-skinned Harley sported multi-colored hair and a grab-bag wardrobe. In one story, Harley stole the skinned face of the Joker from police impound as a gruesome souvenir of her ex-lover.

Newer stories have allowed Poison Ivy and others to share the spotlight as objects of Harley's obsession. A six-issue 2015 miniseries teamed Harley with an amnesiac Power Girl, while 2016's ongoing *Harley Quinn* title set her up as the head of an eclectic criminal cabal. Given Margot Robbie's popular take on the character in 2016's big-screen *Suicide Squad*, Harley Quinn is one villain whose star is definitely on the rise.

"Harley is a sadistic killer with a wild streak of her own," says Sterling Gates, who used her to illustrate the ragtag but deadly nature of the villainous team the Suicide Squad. "And as such, she's the perfect complement to the Joker."

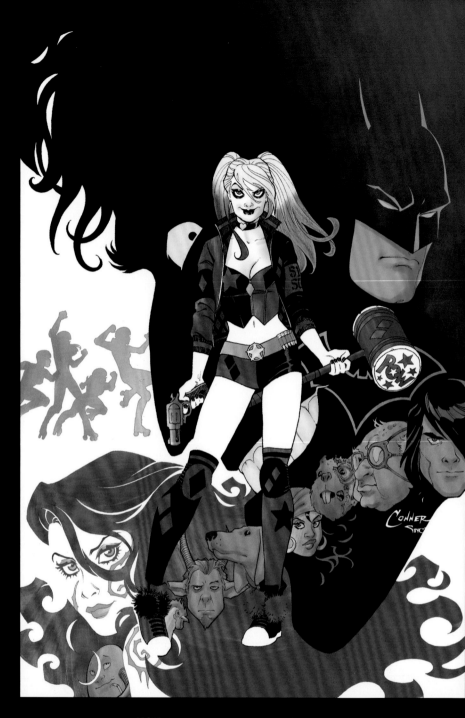

ABOVE: Harley Quinn sports her latest look in this composition, in which the competing influences of the Joker and Batman loom large. (Art by Chad Hardin, *Harley Quinn* #1)

THE TALONS

The Talons might be relative newcomers to Batman's Rogues Gallery, but their backstory spans centuries. Such longevity is par for the course, since the "Talon" name doesn't refer to any one person but rather a title passed between generations of assassins who serve Gotham's powerful secret society, the Court of Owls.

Only the oldest and wealthiest Gotham bloodlines are permitted entry into the Court of Owls, and the silence of their members is assured by the Talons. Each Talon is kept in subzero stasis until called upon, and the strange science employed by the Court allows these assassins to survive mortal wounds and even return from the dead. Talons exhibit enhanced strength and decreased pain sensitivity, are experts with knives and all forms of unarmed combat, and relentlessly stalk their targets until they fulfill their masters' orders with a killing strike.

Batman has tangled with many Talon villains since writer Scott Snyder introduced the concept in *Batman* #1 in 2011. The first, William Cobb, nearly killed the Dark Knight in retaliation for Bruce Wayne's plans to build a new, modernized Gotham. A later Talon, Calvin Rose, was a circus escape artist before joining the Court of Owls. He later turned on his employers and now seeks to ensure the Talon tradition ends with him.

TOP: Talons are experts in stealth combat, and even Batman isn't immune to their deadly abilities. (Art by Greg Capullo and Jonathan Glapion, *Batman*, Vol. 2, #5) **LEFT:** Each Talon wields a sharp-tipped arsenal that includes knives, swords, and weighted throwing blades. (Art by Greg Capullo and Jonathan Glapion, *Batman*, Vol. 2, #2)

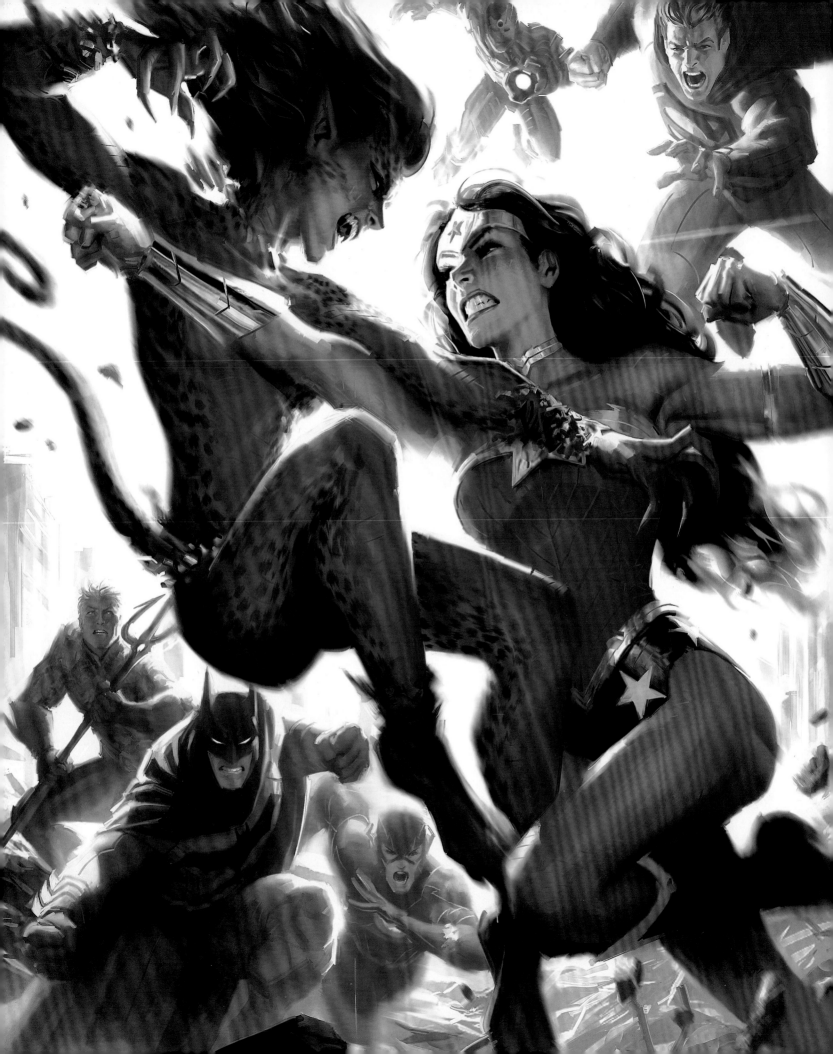

3

ADVERSARIES OF THE AMAZING AMAZON

Unusual for the era, Wonder Woman writer William Moulton Marston sought out female villains to challenge his Amazon heroine and cast male foes as agents of imbalance or gender subjugation. In the decades since her introduction, Wonder Woman has attracted an eclectic mix of enemies who come from the realms of mythology and weird science.

OPPOSITE: The Cheetah is on the hunt, and Wonder Woman is her prey. (Art by Tony S. Daniel, Richard Friend, and Tomeu Morey, *Justice League*, Vol. 2, #13)

THE CHEETAH

"The Cheetah is a counter to Wonder Woman's entire thematic structure," says writer Fabian Nicieza. "Wonder Woman is all about nobility and altruism and pacifism. The Cheetah is all about the opposite things: she's selfish, she acts on impulse, she acts aggressively and angrily, and her first impulse is to hurt rather than heal."

The Cheetah's first hunt came in *Wonder Woman* #6 (Fall 1943), featuring a memorable cover by Harry G. Peter. Dressed in a spotted cat-costume with only her face uncovered, the Cheetah practically popped off the page.

Wealthy heiress Priscilla Rich became the first Cheetah, making her costume from an animal-skin rug after taking an instant dislike to Wonder Woman at a charity event. TV audiences of the 1970s got to know the Cheetah through the animated series *Challenge of the Super Friends.*

After DC Comics reset the company's continuity with *Crisis on Infinite Earths* in 1985, Barbara Minerva became the new Cheetah. Businessman Sebastian Ballesteros had a brief run in the role beginning in 2001, becoming the first male Cheetah.

In the New 52 reboot, archaeologist Barbara Minerva grew up within a cult that worshipped the Amazon goddess of the hunt. By plunging the God-Slayer knife into her own heart, she came back from death as the Cheetah, possessed with a savagery that compels her to eat the hearts of her foes. Keen senses, sharp claws, and supernatural reflexes make the Cheetah a lurking danger for Wonder Woman.

DC Comics' 2016 Rebirth event cleared the way for fresh backstories and gave writer Greg Rucka the opportunity to wipe the slate clean for both Wonder Woman and her most infamous foe. According to Barbara Minerva's revised biography, her career as a globe-trotting archaeologist led to an encounter with the murderous Cult of Urzkartaga, after which she was cursed by their god to become the Cheetah. In Rucka's story, Dr. Minerva and Diana of Themyscira are friends, so long as the feral rage of the Cheetah can be kept at bay.

Keen senses, sharp claws, and supernatural reflexes make the Cheetah a lurking danger for Wonder Woman. Adds Nicieza, "The Cheetah makes a really good foil for Wonder Woman. Like Batman and the Joker, they're opposite sides of the same coin."

"The CHEETAH makes a really good foil for Wonder Woman."

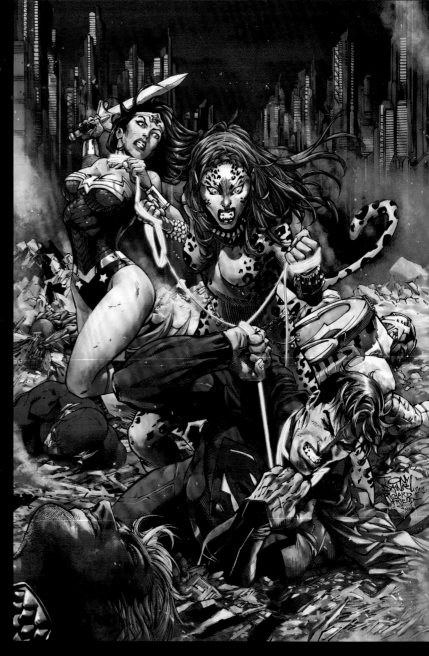

TOP: Mystical powers make the Cheetah a match for the Justice League. [Art by Tony S. Daniel, Richard Friend, and Tomeu Morey, *Justice League*, Vol. 2, #13]

LEFT: Mixing the best attributes of felines and humans, the Cheetah is a consummate predator. [Art by Terry Dodson and Rachel Dodson, *Wonder Woman*, Vol. 3, #2]

OPPOSITE: When her feral side is dominant, Cheetah will attack friends and foes alike. [Art by Liam Sharp, *Wonder Woman*, Vol. 5, #1]

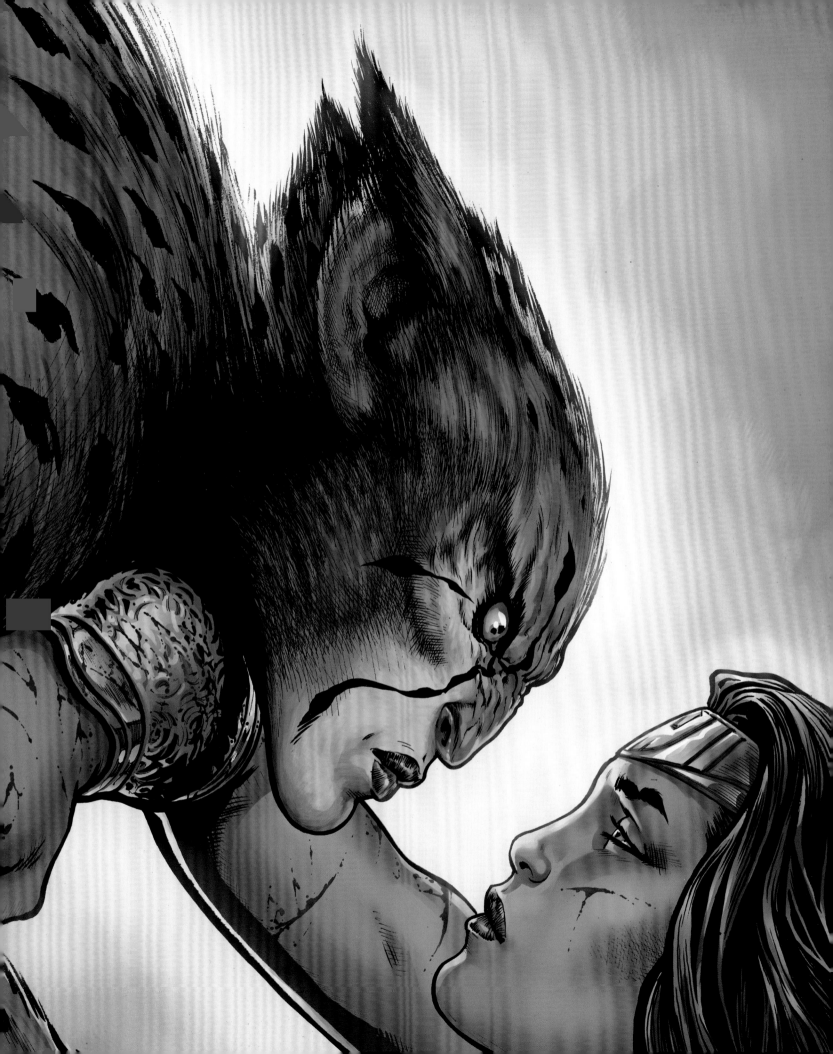

ARES

"Ares is a good villain for Wonder Woman," says Mike Carlin. "He's mythological and powerful. And there's a connection for her because of her mythological backstory."

The God of War has been a fixture of Greek and Roman mythology since antiquity, but in the DC Universe he crosses swords with modern-day Amazons and Titans. The warmongering son of Zeus debuted in *Wonder Woman* #1 (Summer 1942), and used his Roman name of Mars for most of his Golden Age appearances. He served as a natural foe for the peace-loving Amazons while World War II served as a real-world backdrop.

Ares possesses the gifts common to the gods of the Olympian pantheon, including immortality and shape-shifting. He is the avatar of violence and inspires hatred and bloodshed wherever he goes. He is at the peak of his powers during wartime.

The 1980s clean-slate reboot of Wonder Woman gave Ares a facelift. Illustrated by George Pérez in *Wonder Woman* #1 (February 1987), the muscular, armored Ares glared out at his foes from the depths of his face-shrouding hoplite helmet.

In time, Ares adopted a more insidious approach. He became the sharp-dressed arms supplier Ares Buchanan and favored boardrooms over battlefields. The 2013 video game *Injustice: Gods Among Us* went with the traditional Ares design, outfitting him with a whirling shield of swords and the ability to summon arrows from the heavens.

DC Comics' New 52 continuity recast Ares as an older, bearded mentor. He exhibited a fatherly protectiveness toward Diana but was angered when she showed mercy by sparing the life of the Minotaur. When Zeus's firstborn son tried to steal Ares's title, Wonder Woman had no choice but to kill them both—making her the new God of War.

But Diana's peaceful nature made her a poor avatar for the primal emotions of rage and bloodlust. Frustrated by the imbalance in the Olympian pantheon, the goddess Eirene resurrected Ares to lead humanity back into an epidemic of global violence.

His outward guise has changed over the years, but that's hardly a trick for a god of Olympus. What matters is that Ares still has a heart that is fed by wrathful conflict. And although Wonder Woman tries her best to be a symbol of peace, conflict is never hard to find in the DC Universe.

TOP RIGHT: The God of War returns from the dead wearing suitably militaristic garb. [Art by David Finch and Scott Hanna, *Wonder Woman*, Vol. 4, #46]

DOCTOR PSYCHO

During Wonder Woman's Golden Age beginnings, Doctor Psycho served as the embodiment of writer William Moulton Marston's central theme: hateful misogyny bested by womanly virtue.

Possessing the power to read minds and enter the dreams of others, Doctor Psycho did his best to keep women from contributing to the war effort—and took a particular dislike to Wonder Woman for presenting herself as a model of selfless service. His first tale, titled "Battle for Womanhood," played out in *Wonder Woman* #5 (June/July 1943), which revealed him as a bitter man who blamed others for humiliations rather than taking responsibility for his failings.

During the 2000s, Doctor Psycho rose to the status of one of the DC Universe's most powerful telepaths. He still played the foil to Wonder Woman, but he scored prominent supporting roles in crossovers such as *Villains United*, where he helped manage the Secret Society of Super Villains while secretly plotting to wrest control of it from Lex Luthor. By using his mind-controlling mojo on Doomsday, Doctor Psycho led the charge against Earth's assembled heroes in *Infinite Crisis* (2005).

More recently, Doctor Psycho costarred in *Superboy* as a telepath on the run from H.I.V.E. agents. As later revealed in 2013's "Trinity War," Doctor Psycho harbored an intense loathing for all other intelligent beings after reading minds led him to the conclusion that everyone is evil at their core. When the members of the Justice League burst in on Doctor Psycho's hideout, he was moments away from mentally forcing a roomful of innocents to slaughter one another.

Doctor Psycho's Superboy association has since been extended to Superboy's teammates in the Teen Titans. In a 2016 *Teen Titans* storyline, the villain orchestrated an illusory breakout of the maximum-security M.A.W. prison but bit off more than he could chew when he attempted a telepathic link with the demon sorceress Raven.

"Possessing the power to READ MINDS and enter the dreams of others, DOCTOR PSYCHO did his best to keep women from contributing to the war effort——and took a PARTICULAR DISLIKE to Wonder Woman for presenting herself as a model of selfless service."

ABOVE: Given that Doctor Psycho can control the mind of any prison guard, cell walls do not guarantee he will remain incarcerated. (Art by Ricken, Scott McDaniel, Paolo Pantalena, Noel Rodriguez, Trevor Scott, and Johnny Desjardins, *Teen Titans*, Vol. 5, #13)

LEFT: His telepathic powers have made Doctor Psycho hostile and paranoid. (Art by Eduardo Pansica, Jay Leisten, Mario Alquiza, Wayne Faucher, and Eber Ferreira, *Wonder Woman*, Vol. 1, #608)

GIGANTA

Despite her name, Giganta didn't acquire her size-changing power until decades after her introduction. When she debuted in *Wonder Woman* #9 (Summer 1944), her broad-shouldered build was the result of her mad-science evolution from an ape into a strongwoman. Wonder Woman referred to her as "gorilla girl."

It was the 1970s animated series *Challenge of the Super Friends* that popularized Giganta's colossal growth spurts. The character gained the ability to tower above skyscrapers when fully powered up, possessing levels of strength and toughness proportionate to her height. "Giganta is a good villain because she's a good visual," says Mike Carlin. "It's *Attack of the 50 Foot Woman*, and people still respond to that movie poster."

The post-*Crisis* Wonder Woman reboot provided a fresh take on Giganta. Suffering from a blood disease, Dr. Doris Zeul tried to transfer her mind into Wonder Woman's body, but it wound up inside a gorilla instead. However, after locating a human host with rapid-growth super-powers, Dr. Zeul had the brawn to back up her brilliance. She sought work as a villainous heavy hitter.

In the 2006 series *The All-New Atom*, Dr. Zeul taught at Ivy Town University and took an interest in physics professor Ryan Choi, the Atom. They were able to put their costumed lives on hold until their second date, when Zeul became suspicious of Choi and tore the roof off the restaurant.

After DC Comics' New 52 reboot, Giganta found employment as muscle for the superhuman enforcement agency S.H.A.D.E. While costarring with the magic-wielding Pandora in the series *Trinity of Sin: Pandora*, Giganta fought vampires and zombies in exchange for a governmental pardon of her past crimes.

"Giganta is a character who has had personalities grafted onto her in an attempt to create a character around the power," says writer Fabian Nicieza, who admits that the visual appeal of Giganta-as-colossus is a big part of her continued popularity. "Whenever she's hit and falls down, the artist gets a chance to draw a double-page spread!"

"Whenever she's hit and falls down, the ARTIST gets a chance to draw a DOUBLE-PAGE SPREAD!"

AS THE EVOLUTIONARY TRANS-FORMATION IS COMPLETED, A BEAUTIFUL GIRL OF AMAZONIAN PROPORTIONS STANDS IN PLACE OF THE GORILLA!

RIGHT: Giganta's origin. (Art by Harry G. Peter, *Wonder Woman*, Vol. 1, #9) **FAR RIGHT:** Giganta's scaled-up punches can pulverize buildings and embed enemies several feet into the pavement. (Art by Daniel Sampere and Vicente Cifuentes, *Trinity of Sin: Pandora* #2) **OPPOSITE:** Wearing a redesigned costume, Giganta wreaks havoc. (Art by Terry Dodson and Rachel Dodson, *Wonder Woman*, Vol. 3, #2)

EVIL OVERLORDS

If some Super Heroes have the abilities of gods, then these villains must be their arch demons. The most powerful beings in the DC Universe include extraterrestrial tyrants, ageless magic users, and puppeteers from other dimensions.

"Many of the writers who worked for DC in the 1950s later became science-fiction writers, and that's where their roots were," says Dan DiDio. "They started to explore the expansiveness of comic book stories and really take you off-planet to bring a new sense of excitement and fantasy into our books. And on these worlds that our heroes traveled to, it was right to have great villains to populate them."

OPPOSITE: Darkseid emerges on Earth, leading an army of Parademons. (Art by Jim Lee and Scott Williams, *Justice League*, Vol. 2, #4)

DARKSEID

Justice League #4 (February 2012) introduced Darkseid into DC Comics' updated continuity. By flushing squadrons of Parademons through a Boom Tube that connected Earth with the nightmarish planet Apokolips, the invincible alien god inadvertently provided the spark for Superman, Batman, Green Lantern, Wonder Woman, The Flash, and Cyborg to join forces.

"I love Darkseid, and I think he's the ultimate villain of the DC Universe," says Jim Lee, who redesigned the character for his New 52 debut. "The costume is majestic and powerful but also very sinister. It's the battle armor of a villain who has triumphed in battle after battle, universe after universe. I wanted to make it look like something that was battle-worn but also like it protected the power and dark legacy that Darkseid has in the DC Universe."

That legacy began when legendary comics creator Jack Kirby signed on with DC Comics in 1970, bringing with him the promise of an epic "Fourth World" saga of New Gods and

strange science. Kirby staked his claim to this mythology in issue #133 of *Superman's Pal Jimmy Olsen* (October 1970), and this ultimate villain made a shadowy appearance in the very next issue.

Darkseid was the iron-fisted ruler of Apokolips. Belching flame into space from the inexhaustible fire-pits on its surface, this martial planet labored under the yoke of fascism. Darkseid seemed carved from granite as he growled orders to his warriors and minions, massive hands clasped behind his back.

Absolute rule over Apokolips wasn't enough to satisfy Darkseid. He sought to obliterate the concept of free will by harnessing the Anti-Life Equation, and his pursuit of this prize brought him to Earth and into conflict with Earth's foremost defender, Superman.

"Darkseid is probably the only one of [Superman's villains] who is really far beyond Superman," says

ABOVE: Back from annihilation, the reconstituted Darkseid seizes power once more. (Art by Jason Fabok, *Justice League*, Vol. 2, #50)
OPPOSITE: As a New God, Darkseid seldom concerns himself with mortals. (Art by Ethan Van Sciver and Brian Miller, *Action Comics Annual*, Vol. 1, #13)

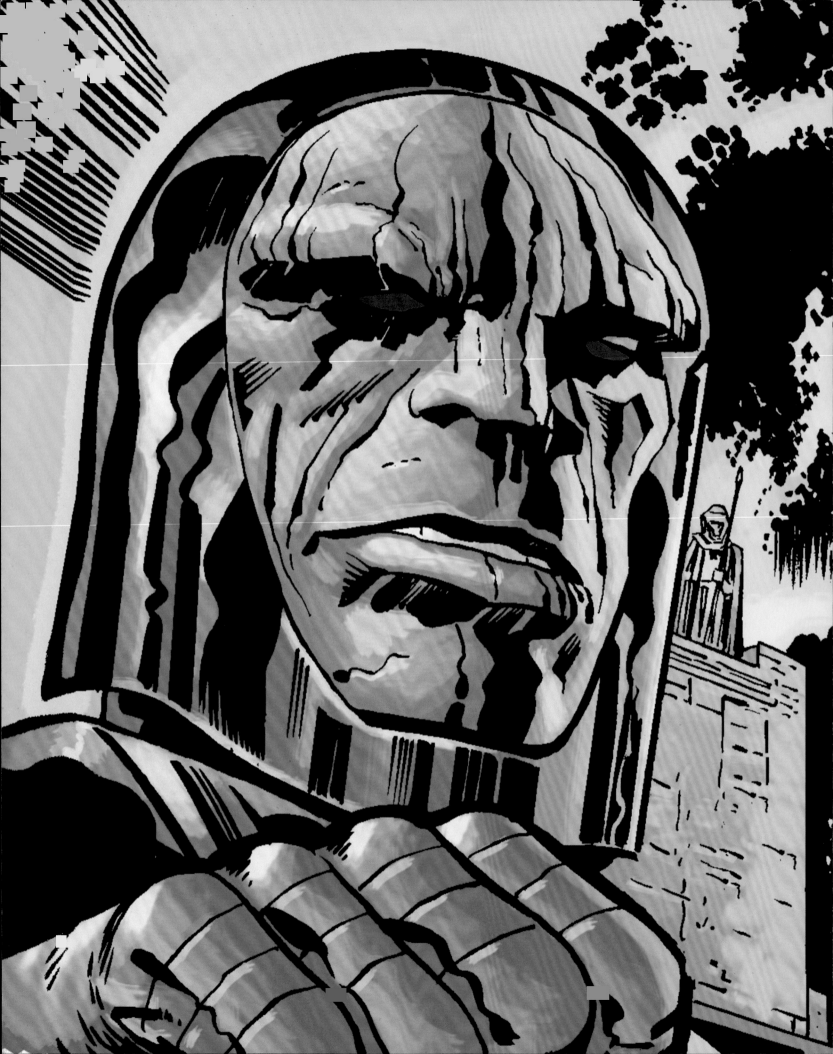

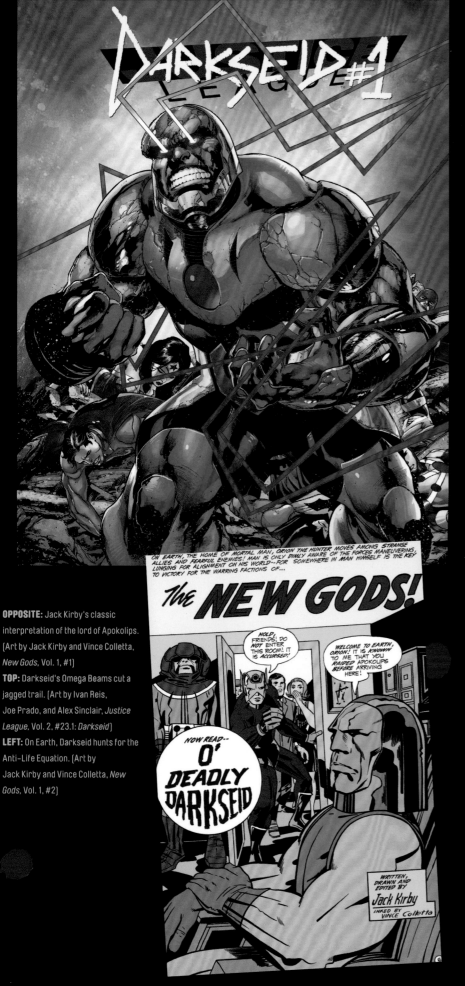

OPPOSITE: Jack Kirby's classic interpretation of the lord of Apokolips. (Art by Jack Kirby and Vince Colletta, *New Gods*, Vol. 1, #1)

TOP: Darkseid's Omega Beams cut a jagged trail. (Art by Ivan Reis, Joe Prado, and Alex Sinclair, *Justice League*, Vol. 2, #23.1: *Darkseid*)

LEFT: On Earth, Darkseid hunts for the Anti-Life Equation. (Art by Jack Kirby and Vince Colletta, *New Gods*, Vol. 1, #2)

Superman writer Marv Wolfman. "He's the lord of an entire dark dimension."

The lore behind Kirby's Fourth World solidified in the pages of *Forever People*, *New Gods*, and *Mister Miracle*. A state of détente existed between Darkseid's Apokolips and its paradisiacal sister world, New Genesis. A political exchange of offspring had resulted in Darkseid's son Orion growing up in the care of New Genesis's Highfather, while Scott Free—Highfather's son—had endured the hellish tortures of Apokolips to become escape artist Mister Miracle.

Darkseid's powers befitted his status as a literal god. Gifted with invulnerability, longevity, super strength, telepathy, and telekinesis, he could call upon a host of other powers as needed. But his signature weapons were his eye-blasting Omega Beams. Once fired, the Omega Beams tracked their target around corners and disintegrated their victims on contact.

"DARKSEID'S powers befitted his status as a LITERAL GOD."

The greatest hits of Darkseid's early years include his formation of the Secret Society of Super Villains and the "Great Darkness Saga," which nearly wiped the Legion of Super-Heroes from existence a thousand years in the future. During the 1986 crossover *Legends*, Darkseid authorized a propaganda campaign to drive a wedge between Earth's citizens and their costumed protectors.

But even the great Darkseid died—along with all of the New Gods—during the run-up to writer Grant Morrison's *Final Crisis* in 2008. This surprise move set the stage for the character's rebirth in human form. Now calling himself "Boss Dark Side," he activated the Anti-Life Equation and placed Earth's inhabitants under his heel. Batman fought back, and their showdown seemingly ended in mutual annihilation as Darkseid took a radion bullet and Batman stood in the path of Darkseid's Omega Beams.

The 2015 epic "The Darkseid War" saw the Lord of Apokolips square off against the reality-erasing Anti-Monitor, with the Justice League caught in the middle. By using the avatar of death, the Anti-Monitor actually slew Darkseid, sending the universe into chaos and temporarily leaving Lex Luthor in charge of the Apokoliptian hordes. Darkseid's daughter, Grail, soon resurrected her father, but she vowed to evolve him into a less malignant being.

"It's hard for me to even think of Darkseid as a villain," admits writer Ron Marz. "He simply is what he is. Darkseid is a monarch, and he works on a grand scale beyond humans. He's the pinnacle of the cosmic food chain—grand in every way."

MONGUL

"Given his power level, Mongul works best as a Superman villain," explains writer Dan Jurgens, who, during the 1990s, pitted Mongul against the Man of Steel in personal combat. In his debut, Mongul smashed his way onto the cover of *DC Comics Presents* #27 (November 1980), demanding the key that would make him "master of the universe." Len Wein and Jim Starlin proved the yellow-skinned brute wasn't just bluffing in their introduction to the cruelest despot to ever rule a galaxy.

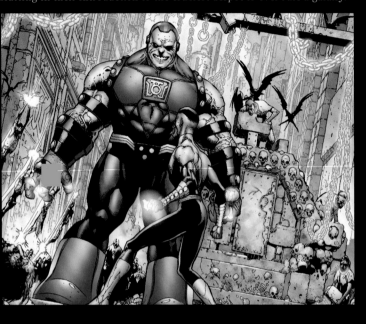

Mongul showed off overwhelming physical power and near-perfect invulnerability. He also invited readers to explore Warworld, an artificial planet designed only for battle. Mongul's aggressive physicality gave Superman another sparring partner in his weight class besides Darkseid.

The definitive Mongul story is often considered to be "The Man Who Has Everything," which appeared in *Superman Annual* #11 (1985) by Alan Moore and Dave Gibbons, the team behind *Watchmen*. Armed with a parasitic alien plant, Mongul breaks into the Fortress of Solitude and hypnotizes Superman into an endless It's left to Robin to turn the tables on Mongul. When the villain enters his own trance state, he sees an endless procession of pitiful, defeated enemies who beg for his mercy.

Mongul played a key role in Superman's 1990s continuity when he captured the Man of Steel and forced him to fight in Warworld's gladiator pits. Even the Cyborg Superman found common ground with Mongul, using Warworld to exterminate the seven million residents of Coast City.

The Coast City atrocity landed Mongul on the Green Lantern Corps' Most Wanted List, and he appeared in Lantern-related titles with increasing frequency in subsequent years. "I brought in Mongul very early in my *Green Lantern* run because I really wanted him," says writer Ron Marz. "You want your villains to be more powerful than the heroes they battle so the heroes face overwhelming odds. Mongul gives you that opportunity. Mongul is a powerhouse, and he really likes to break things."

After the emergence of the fear-powered Sinestro Corps, Mongul's son (also named Mongul) seized Sinestro's home planet of Korugar and named himself leader of the "Mongul Corps." With five yellow power rings on each bright yellow fist, Mongul certainly fit the color scheme.

Seeking to cement his claim as the rightful ruler of the Sinestro Corps, Mongul used the mind-manipulating plants known as "Black Mercies" to instill fear throughout the galaxy. But, despite this and similar schemes, he failed to permanently unseat Sinestro from his perch of power.

TOP LEFT: Mongul is even deadlier as a Yellow Lantern. (Art by Doug Mahnke, Christian Alamy, and Tom Nguyen, *Green Lantern*, Vol. 4, #46)

ABOVE: Mongul gloats in his conqueror's throne. (Art by Christian Alamy, Patrick Gleason, Wade Von Grawbadger, Howard Chaykin, Jamal Igle, Hi-Fi Design, Peter Stelgerwald, Michelle Madsen, Chris Sotomayor, and David Moran, *Green Lantern Secret Files and Origins*)

OPPOSITE: Mongul neutralizes the Dark Knight before moving on to his oldest foe. (Art by Brett Booth, Norm Rapmund, and Andrew Dalhouse, *Batman/Superman* #6)

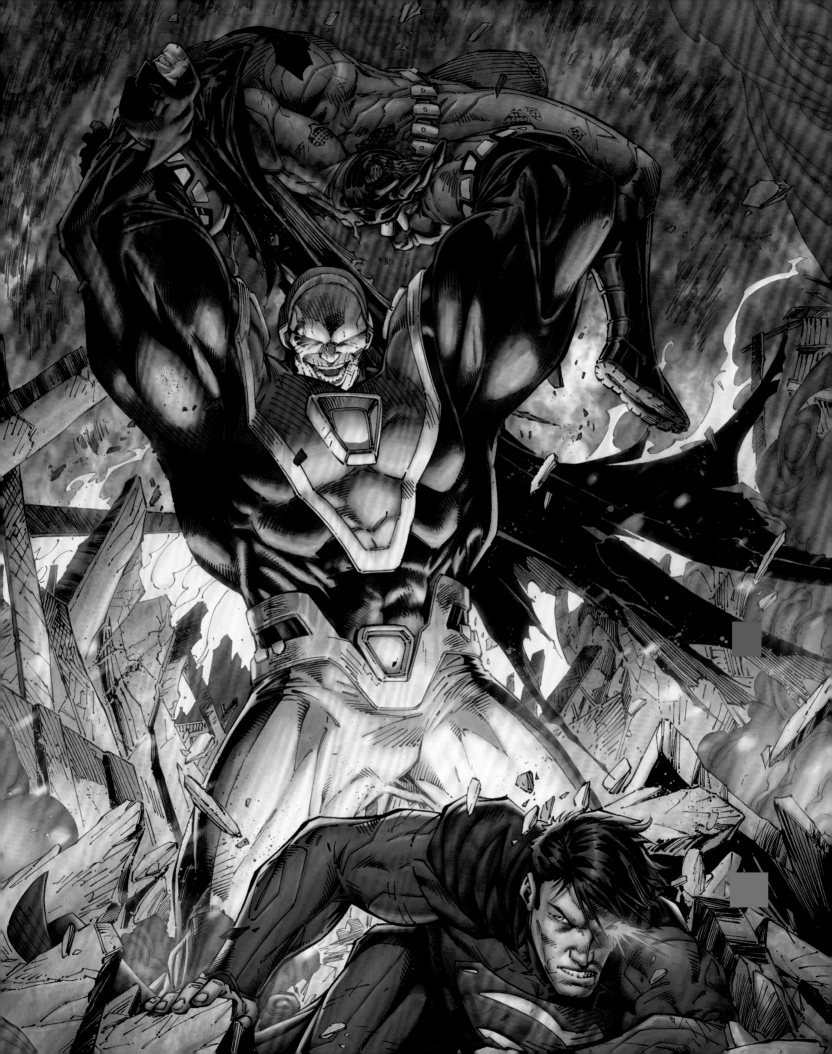

SOMEWHERE IN UPSTATE NEW YORK...

GET AWAY FROM HER, DESPERO. RIGHT NOW.

J'ONN?

COME TO WATCH GYPSY DIE, HAVE YOU, MARTIAN?

THERE'LL BE NO MORE DEATHS TODAY... EXCEPT PERHAPS--

--YOURS.

10¢

APPROVED BY THE COMICS CODE AUTHORITY

NOV

JUSTICE LEAGUE of AMERICA

I'VE GOT THIS GAME RIGGED SO THAT EVERY-TIME FLASH MAKES A MOVE, A MEMBER OF THE JUSTICE LEAGUE DISAPPEARS FROM THE FACE OF THE EARTH!

A STAR-STUDDED SPECTACULAR-- "WORLD OF NO RETURN!"

BLOW UP

GIFFEN, DeMATTEIS, HUGHES, RUBINSTEIN, LAPPAN, D'ANGELO, DOOLEY AND HELFER HAVE DONE IT AGAIN! (WE'RE NOT EXACTLY SURE WHAT THEY'VE DONE, BUT IF OUR LEGAL DEPARTMENT DOESN'T COMPLAIN, WE GUESS IT'S OKAY...)

OPPOSITE: A powered-up, enraged Despero is a global threat. [Art by Ivan Reis, Joe Prado, Oclair Albert, and Jonathan Glapion, *Justice League*, Vol. 2, #19]
LEFT: The Martian Manhunter's telepathy is one of the few things that can harm Despero. [Art by Adam Hughes and Joe Rubinstein, *Justice League America*, Vol. 1, #39] **ABOVE:** In his first appearance, Despero studies strategy. [Art by Murphy Anderson, *Justice League of America*, Vol. 1, #1]

DESPERO

Despero almost seemed like an intellectual in his first appearance. In a tale by Gardner Fox and Mike Sekowsky from *Justice League of America* #1 (October 1960), Despero challenged the members of the Justice League to a game of chess. He used the mental powers of his third eye to cheat and beamed the Leaguers into exile on distant worlds with a hidden dimensional transporter.

Despero's time as a cerebral gamemaster didn't last long. In later issues he grew into a sharp-toothed, muscle-bound monster, with shockingly advanced psychic abilities fueled by the Flame of Py'tar. In the early 1990s, Despero delivered a brutal beatdown to the Justice League in the middle of Times Square. In preparation for DC Comics' *Forever Evil* event in 2013, Despero assaulted the Justice League's satellite HQ.

Kurt Busiek wrote for Despero in 2008's *Trinity* and credits the character's design as a big factor in his popularity. "When he first appeared, he was a skinny pink guy with a weird fin, but he got revised into a massive alien powerhouse," he says. "He was still a pink guy with a weird fin. But now he looked great in battle against powerful heroes."

In *Trinity*, villains seeking to complete a mystic ritual are required to find a being whose power levels are in the same class as Superman's. Busiek knew Despero would fit the bill. "I like his attitude," he says. "As a conqueror, Despero wants a challenge. He lives for a good fight. He's fun to write; he's got a really strong, driving attitude; and he looks good on the page."

WARNING: Contains Bad Taste In The Form Of Ultra-Violence, Icon-Bashing, And "The Finger." More Offensive Than Christmas Usually Is.

LOBO

Translate his name from Czarnian and you'll get "He Who Devours Your Entrails and Thoroughly Enjoys It." Fortunately this lone-wolf character also answers to a shorter and snappier label. Debuting in *Omega Men* #3 (June 1983), the alien bounty hunter Lobo proved popular as an antagonist.

Repeat appearances ramped up Lobo's outlaw attitude to intentionally parodic levels. By the early 1990s, Lobo had become a biting commentary on the comics industry while simultaneously earning fame as one of its biggest stars.

"Lobo was out there when the antihero was very popular," says Mike Carlin. "He was outrageous. He was the heavy-metal character of the DC Universe."

Ultra-violence followed Lobo wherever he went, expressed as a mix of black comedy and audience shock. Lobo called himself the last Czarnian, a status he'd earned by exterminating every other Czarnian in the universe. Refreshingly selfish, his concerns included cigars, his flying motorcycle, the Space Hog, a pod of innocent space dolphins, and a vocabulary of colorful curses. Lobo's humorous appearances in *Justice League International* and *L.E.G.I.O.N.* cast him as an antihero. He even ascended to the status of religious leader as the Archbishop of the Church of the Triple-Fish God.

That didn't stop him from dishing out punishment. Lobo's preferred weapon was a titanium chain ending in a wicked hook, which he kept wrapped around his right arm when not in use. He was practically indestructible and could restore himself to full health from a single drop of blood.

A self-titled *Lobo* miniseries hit shelves in 1990, uniting the talents of Keith Giffen, Alan Grant, and Simon Bisley. The storyline opened with Lobo agreeing to escort his hated fourth-grade teacher to safety, struggling to suppress his violent urges in what proves to be a temporary stay of execution for Miss Tribb.

The Lobo of the New 52 made his debut during 2013's "Villains Month" crossover. Not nearly as rough around the edges, this Lobo has the sleek, lean appearance of a sophisti-cated killer-for-hire. After facing off against a stand-in who represented his old self and killing the "imposter," he was next seen in a monthly *Lobo* series that ran for 13 issues. In 2017, Lobo joined the relaunched *Justice League of America* with issue #1.

"I think what made Lobo work when he was created was that he was this ultimate biker guy, and in a lot of ways that visual is played out," says Jim Lee. "What's important to the character? Is it that he's a biker, or that he's an alien bounty hunter, or that he's essentially unkillable? This is an interesting take, and allows us to explore a different distillation of the character."

OPPOSITE: Mayhem delivered, courtesy of Lobo. [Art by Simon Bisley, *Lobo*, Vol. 1, #2]

TOP LEFT: Holiday cheer means little to this Czarnian. [Art by Simon Bisley, *Lobo Paramilitary Christmas Special*]

ABOVE: Lobo is angry all over again. [Art by Simon Bisley and Kieth Giffen, *Lobo: The Last Czarnian*]

BLACK ADAM

The shadow opposite of Shazam (Captain Marvel), Black Adam has variously starred as villain, hero, and war criminal. But his rock-solid code of honor keeps him in the good graces of comics fans.

Unlike Shazam, who derives his abilities from the Greek pantheon, Black Adam mainlines his powers from the ancient gods of Egypt. He possesses the stamina of Shu, the swiftness of Horus, the strength of Amon, the wisdom of Zehuti, the power of Aton, and the courage of Mehen. The initials of his benefactors spell out SHAZAM, the same word that calls lightning from the sky to infuse him with magical might.

Of course, that's Shazam's magic word too, and Black Adam's early stories—beginning with *The Marvel Family* #1 (December 1945)—laid out the connection. As explained by Otto Binder and C. C. Beck, Teth-Adam served as a heroic magical champion five thousand years in the past until he killed the pharaoh in a bid for power. With that act of corruption, Teth-Adam became Black Adam.

After a long absence from comics, Black Adam reappeared starting in 1977 and finally found an ongoing stage with the 1994 *The Power of Shazam* series by Jerry Ordway. The character's nobility didn't fully emerge until Black Adam encountered the Justice Society of America in the 2000s in the pages of their book, *JSA*. Under the presumption that Black Adam had reformed, the Justice Society welcomed him as a full member.

Ultimately, Black Adam's "eye for an eye" outlook proved far harsher than the Justice Society could permit, and Adam left the team to seize control of his ancestral homeland of Kahndaq. He gained a loving queen in the superpowered Isis, but her murder inspired Black Adam to launch a revenge-fueled raid on the neighboring nation of Bialya.

In the New 52, Black Adam is a powerful member of Lex Luthor's resistance force assembled to fight the world-conquering Crime Syndicate. Though he fared badly in a brawl with Ultraman, he swallowed his pride to wait for a rematch.

A later storyline saw Sinestro visit Khandaq and recruit Black Adam into the ranks of the Sinestro Corps. Adam's magical power set, now augmented by the hard-light constructs generated by a yellow power ring, made him an unstoppable force when facing the anti-emotion cultists of the Paling—a deep-space cult that threatened all power-ring wielders by rejecting the validity of the feelings fueling the emotional spectrum.

"He's the perfect example of a character who is literally the dark opposite of the hero," says Mike Carlin. "He has the same powers and abilities but different motivations. Black Adam is a strong character for his beliefs. He's not doing things only for personal gain. He's doing some things that are admirable; but going about it in a rougher way."

OPPOSITE: Wreathed with his trademark mystical lightning, Black Adam tosses vehicles with careless disregard for any civilians who might suffer amid the carnage. [Art by Joe Prado and Ivan Reis, *Justice League* #18]
ABOVE: Black Adam wields the lightning of the gods. [Art by Alex Ross, *Justice Society of America*, Vol. 3, #23] **RIGHT:** Black Adam's magical power has unlimited intensity. [Art by Tony S. Daniel, Matt Banning, and Tomeu Morey, *Justice League of America*, Vol. 3, #7.4: *Black Adam*]

5

ENEMIES OF THE EMERALD KNIGHT

Green Lantern is more than a Super Hero—he's also a space cop. Duly appointed by the Guardians of the Universe, he protects Earth and its neighbors within the jurisdiction of Sector 2814. His villains are often galactic-level threats that can't be put down without the pooled resources of the entire Green Lantern Corps.

"Green Lantern has his share of super-crooks, but his series is a science-fiction space opera at its heart," says writer Kurt Busiek. "He needs a foe with a lot of sci-fi scope. His villains have a broader range and don't look as focused at first glance, but they have a lot of richness and variety, and that suits Green Lantern well."

OPPOSITE: Sinestro leads the Sinestro Corps members—including the Cyborg Superman—into combat. [Art by Ivan Reis, Oclair Albert, and Moose Baumann, *Green Lantern*, Vol. 4, #21]

SINESTRO

"The ring-bearers aren't just heroes," points out Dan DiDio. "With Sinestro, we can see that they're people, and that they might use the rings for their own personal gain."

Fallen hero Sinestro debuted in *Green Lantern* #7 (July–August 1961) by John Broome and Gil Kane. The character's Luciferian trajectory serves as both a cautionary tale and an ongoing temptation for those still committed to the straight and narrow.

"Green Lantern is a cop whose job is to make things right," says Marv Wolfman, who wrote the *Green Lantern* series during the early 1980s. "Sinestro was also one of those cops, and that makes him interesting. He comes from the same background, but he thinks his bosses, the Guardians, are wrong. He's not crazy. He has a purpose."

Born on the planet Korugar in sector 1417, Sinestro excelled as a Green Lantern and used his status to install himself as dictator of his homeworld. He trained Hal Jordan after the Earthman joined the Green Lantern Corps, but when Sinestro's abuses of power came to light, the Guardians banished him to the antimatter world of Qward. In exile he nursed his hatred of the Guardians and plotted their downfall.

Sinestro's weapon is indeed his yellow power ring. Similar to the rings of the Green Lantern Corps, it can generate hard-light constructs in the shape of whatever the wielder imagines. Originally Sinestro's ring exploited Green Lantern's classic vulnerability to the color yellow, but over time the hue took on a larger meaning. The establishment of a multihued "emotional spectrum" encompassing the rainbow colors of red, orange, yellow, green, blue, indigo, and violet, retroactively established Sinestro's yellow ring as a talisman of pure fear.

In 1994, DC Comics retired both Hal Jordan and Sinestro and made a fresh start with its Green Lantern titles. Jordan went crazy after the annihilation of his hometown of Coast City, and the Guardians pitted him against Sinestro in an effort to halt his rampage. The battle between the two enemies ended with Sinestro dead from a broken neck.

"The standout Green Lantern villain was always Sinestro, as he literally embodied the weakness of Hal's power ring," says Ron Marz, who took over as *Green Lantern* writer following Hal's retirement. "The decision to have Hal take out Sinestro was obviously a big deal. It removed the best villain from the playing field, but it also signaled that the new status quo was going to be a radical departure from what had gone before."

2004's *Green Lantern: Rebirth* restored Hal Jordan to the Green Lantern role after a long publishing absence. Sinestro came back too, and the reveal of the emotional spectrum as the source of Lantern powers gave Sinestro the opportunity to raise his own army. The Sinestro

Corps sought to instill order by force, and its warriors packed the yellow ammo of fear.

Sinestro became a White Lantern during the "Blackest Night" event, the embodiment of life energy and—in his words—the "greatest Lantern of them all." The condition didn't stick, but that did nothing to lessen Sinestro's ego. A later storyline saw him return to his old green uniform, working to undermine a Sinestro Corps that had gone rogue.

He eventually returned to his familiar yellow duds. Following a battle with the Paling, Sinestro established a new home for his Corps on the artificial planetoid of Warworld.

"Sinestro seemed to have such untapped potential as a truly deadly foe for Hal Jordan, and as a poisonous political enemy for Oa," says Green Lantern artist Ethan Van Sciver. "His embrace of the yellow energy, fear, and our understanding of Sinestro as a fascist political tyrant informed everything about our reworking of him. It gave him arrogance. Sinestro is cold, angry, bitter, but wise. He was always destined to be the greatest of the Green Lanterns, but he fell astray, like Lucifer. Perhaps he just believed he had better ideas."

ABOVE: Sinestro takes aim with a hard-light construct. (Art by Ethan Van Sciver and Prentis Rollins, *Green Lantern: Rebirth* #3)
LEFT: Star Sapphire and Sinestro do battle. (Art by Doug Mahnke, Christian Alamy, and Tom Nguyen, *Green Lantern*, Vol. 4, #45)
OPPOSITE: Sinestro triumphant. (Art by Ethan Van Sciver and Moose Baumann, *Green Lantern: Sinestro Corps Special* #1)

THE FIRST LANTERN

The Green Lantern Corps is trained to tackle threats on a reality-warping scale, but no foe proved more dangerous to its existence than Volthoom. As the First Lantern, Volthoom wields unlimited control over the emotional spectrum—and he knows secrets that the Guardians of the Universe would prefer to keep buried.

DC's Chief Creative Officer Geoff Johns introduced the character during "Rise of the Third Army," a 2012–2013 Green Lantern story arc that marked the start of Johns' farewell to a series he had written for nearly a decade.

Though the story introduced Volthoom as the original bearer of Lantern energy, longtime comics fans recognized that the character's name had a history. During the 1960s' debut of the Crime Syndicate of America, an evil, parallel-universe version of Green Lantern drew his energy from a mystical figure he called Volthoom. Johns worked this minor piece of lore into a cornerstone of Green Lantern mythology.

As a *Green Lantern* writer, Johns had established an "emotional spectrum"—ranging from red to violet—and the existence of seven different Lantern Corps, each deriving power from a different color in the spectrum. It stood to reason that a single entity that could channel every emotional color at once would be one of the most powerful beings in existence.

That figure proved to be Volthoom, who acquired the First Ring after the Guardians of the Universe divorced themselves from emotion and locked their abandoned feelings in the Great Heart. By tapping into this power battery, the First Lantern could feast at will from the reservoirs of rage, greed, fear, willpower, hope, compassion, and love.

At first the Guardians hoped Volthoom would be their champion, but he quickly became an emotional sadist. Locked away for billions of years, Volthoom escaped when several Guardians siphoned his strength to raise a Third Army and eradicate emotion and free will.

In the heavens-shaking crescendo of the "Wrath of the First Lantern" saga, heroic Hal Jordan rose from the dead as a Black Lantern, and Sinestro ascended to become the omnipotent host of the fear entity Parallax. This epic clash of wills guest-starred many personalities from Green Lantern history in a testament to Johns' creative legacy.

In the end, Volthoom met defeat—but readers know this may not be the last time they see the First Lantern.

ATROCITUS

The "R-O-Y-G-B-I-V" emotional spectrum underpinning Green Lantern mythology is said to grow unstable at each end, with the obsessive passion of violet love counterbalanced at the opposite extreme by the red savagery of rage. Atrocitus, introduced by Geoff Johns in *Green Lantern* #29 (May 2008), is the embodiment of fury who leads the Red Lantern Corps.

"Atrocitus was designed to be a bully with his large shoulders and small, needle-sharp teeth," says *Green Lantern* artist Ethan Van Sciver. "I wanted Atrocitus to seethe. To always look like he was on edge, boiling inside. Leaking red energy like blood from every pore."

In the backstory provided by Johns, Atrocitus is the fiend responsible for the death of Abin Sur, Hal Jordan's predecessor as Green Lantern. Enraged by the death of his wife and children during an attack by the robotic Manhunters, Atrocitus had formed a terrorist cell to fight the Manhunters and their creators, the Guardians of the Universe. Imprisoned with his fellow plotters as the "Five Inversions," Atrocitus later became a captive aboard Abin Sur's starship and triggered his fatal crash on Earth.

"Atrocitus is in many ways the embodiment of evil in the Green Lantern mythos," says Van Jensen, writer on *Green Lantern Corps*. "He's a cosmic devil tracing back to the ancient evil of the Empire of Tears. His powers are grounded in rage, particularly in the deaths of his people, and that makes him a compelling counterpoint to the Corps. He is truly unleashed—what the Green Lantern Corps won't allow themselves to be. And, like any great villain, his history is so compelling that at times you can't help but root for him."

Through blood sacrifice, Atrocitus forged the Red Lantern Power Battery. Beings who reveled in violence and vengeance received invitations to join this new Corps. Among Atrocitus's first recruits was fan-favorite Dex-Starr, a vicious housecat who wore his ring on his tail.

Atrocitus's red power ring duplicates many of the functions of a Green Lantern ring but supersedes his body's circulatory system in order to pump acidic, rage-fouled blood through his veins. Atrocitus can spew hot blood from his mouth to blind and melt his enemies.

"What makes this guy tick? That was the question I asked myself," says Peter Milligan, writer of the *Red Lanterns* series centered on Atrocitus. "My first thought was that he had been full of rage for so long, his entire people wiped out. He can never forgive, but I couldn't see how he'd maintain the same pitch. So my first story was about how Atrocitus keeps stoking up his rage. And what if the rage dies down a little—is he scared of that? It seems to me that as long as he's spitting molten fire, he doesn't have to deal with his feelings."

OPPOSITE: The First Lantern stands alone against the assembled might of the Lantern Corps. [Art by Doug Mahnke and Alex Sinclair, *Green Lantern*, Vol. 5, #20]
LEFT: Atrocitus uses red energy to channel his pain. [Art by Doug Mahnke, *Green Lantern*, Vol. 4, #51]
ABOVE: The embodiment of rage charges a terrified Larfleeze. [Art by Doug Mahnke, Christian Alamy, Tom Nguyen, and Mark Irwin, *Green Lantern*, Vol. 4, #47]

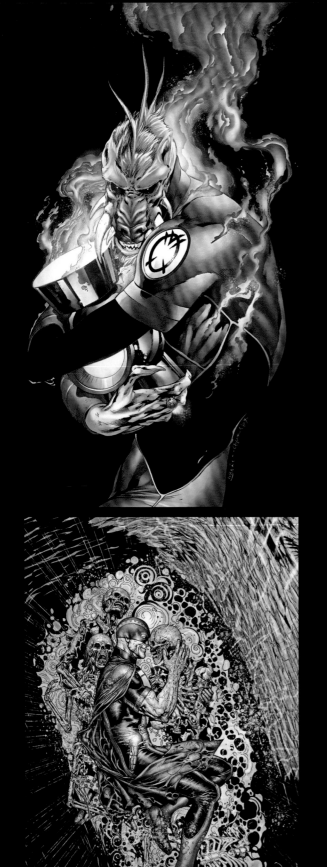

LARFLEEZE

If the color orange corresponds to avarice on the emotional spectrum, how could its champions ever share their power as part of a Lantern Corps? Writer Geoff Johns recognized this puzzle by giving the orange power to just one being: Larfleeze.

This hunched, tusk-faced alien grew up as a slave, hoarding his food rations to survive. After casting his lot with a gang of thieves he came across the Orange Power Battery in the Vega system. The Guardians of the Universe agreed to leave Larfleeze in possession of the battery in exchange for the return of a stolen artifact, but quarantined the Vega system against outsiders.

After eons, Green Lantern agents breached the Vega system and Larfleeze renounced his treaty with the Guardians. A war between the Orange Lantern and the Green Lantern Corps ended in a cease-fire. The Guardians decided Larfleeze was more irritating than dangerous.

The idea of sharing power is unthinkable to Larfleeze, though he can create obedient soldiers out of orange light, patterned after those whom he has slain. He is sometimes called Agent Orange, after the toxic defoliant used in the Vietnam War.

"Larfleeze is just a filthy rat," says *Green Lantern* artist Ethan Van Sciver. "He cares about acquisition, and that's it. I described him as having dirty, matted fur and hair, and perhaps insects buzzing around him at all times. Slender, long limbs. He's an interesting shape. I was thinking about Wile E. Coyote when I drew him."

During the fight against Black Hand in the "Blackest Night" crossover, Larfleeze had no choice but to permit another being to wear an orange lantern ring. For twenty-four hours, Lex Luthor became a deputy Orange Lantern.

In 2013 Larfleeze received a comic book series all to himself by Keith Giffen, J. M. DeMatteis, and Scott Kolins. On the cover of the first issue, the ostensible hero snarls, "*This book's all mine!*"

"My favorite Larfleeze moment was when he visited Earth and composed a letter to Santa," says *Green Lantern Corps* writer Van Jensen. "It's a brilliant moment that gets at his core. He's a terrified, compulsive, self-obsessed child, who just happens to be insanely powerful. His greed has left a trail of destruction through the galaxy, and yet Larfleeze is never able to fill the hole inside himself."

BLACK HAND

Black Hand debuted in *Green Lantern* #29 (June 1964)—a smart crook with zero connection to the Green Lantern Corps' cosmic mythos. William Hand had invented a device to collect the stray energies of Green Lantern's power ring, and used it to split Hal Jordan's body between two separate dimensions.

The villain got an upgrade in 2009's "Blackest Night" event as scripted by Geoff Johns. With the revelation that colored power rings tapped into an emotional spectrum, Black Hand dealt with the question of what the *absence* of light might induce. He became the first Black Lantern, the avatar of Death, and raised fallen heroes and villains from the grave as ring-wielding zombies.

"Black Hand spent years craving power," says Green Lantern Corps writer Van Jensen. "When he finally rose to prominence during 'Blackest Night,' it seemed as if he hadn't anticipated what true power would look like and how ill-prepared he was to wield it. Ever since, he's struggled to find his place in the universe."

The villain's subsequent schemes have remained characteristically epic, including the necromantic reanimation of the Source Wall—a barrier at the edge of the universe, composed of the bodies of the foolish beings who have attempted to cross it.

"He now knows just how much damage he can inflict," says Jensen, "and that might be the most dangerous thing of all."

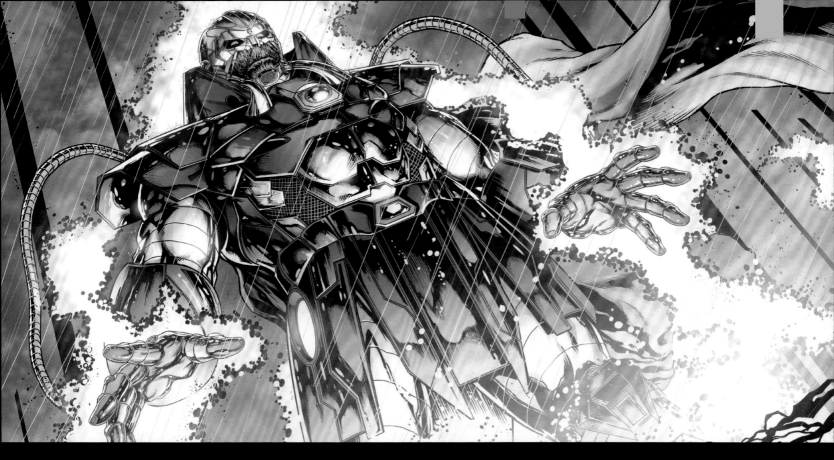

ANTI-MONITOR

Many of DC Comics' villains are unrepentant killers, but only the Anti-Monitor has a death count so high it can never be calculated. The embodiment of entropy, the Anti-Monitor has erased entire universes from existence.

In 1985, *Crisis on Infinite Earths* cleared the way for a ground-floor rebuild of DC Comics' continuity, and the Anti-Monitor served as the in-story explanation for the change. One of two immortal beings created at the beginning of time (counterbalanced by the Monitor), the Anti-Monitor symbolized evil but remained safely isolated in an anti-matter universe. When at last the Anti-Monitor made his move to destroy reality, heroes fought back from all eras of history.

"The Anti-Monitor was created to be the most powerful villain in the DC Universe and probably the most powerful character in any comic universe," says *Crisis* writer Marv Wolfman. "I needed someone who, with little more than a wave of his hand, could destroy Superman, Wonder Woman, Green Lantern, and all the other DC powerhouses."

The Anti-Monitor wore an armored shell to contain his life force, and could release energy to change his size or generate waves of power. During the Crisis, the Anti-Monitor unleashed armies of shadow demons to terrorize his enemies and annihilated countless parallel dimensions.

"For the longest time I didn't have a name for him," admits Wolfman. "He was the character who was going up against the Monitor, so for the sake of my plots I just called him the Anti-Monitor, fully intending to change it. I used to joke that, by having his mother name him Anti-Monitor, it sort of limited his job description."

Crisis on Infinite Earths ended with the Anti-Monitor's death—though in truth the villain had succeeded in 99 percent of his goal. Only a single universe remained. Every parallel Earth that had once populated the multiverse had fallen to the Anti-Monitor's schemes.

In 2005 *Infinite Crisis* revisited the themes of the original Crisis and even found a role for the Anti-Monitor's corpse. It became part of a vibrational tuning fork, recreating a multiverse consisting of 52 new dimensions.

The Anti-Monitor returned in *Green Lantern: Sinestro Corps Special* #1 (August 2007) as the Guardian of Fear for Sinestro's yellow ring-wielders. The Cyborg Superman served as the Anti-Monitor's herald during his attack on Earth. Defeated, the Anti-Monitor found new life as an avatar of Death. By supplying the energy to fuel the Black Power Battery, the Anti-Monitor was revived as the ultimate Black Lantern.

DC Comics' New 52 continuity shed new light on the Anti-Monitor, revealing his origin as a scientist named Mobius and his ties to the cosmic pantheon of New Gods. His plot to unleash the Anti-Life Equation as part of the "Darkseid War" resulted in Darkseid's death—and, apparently, the annihilation of the Anti-Monitor himself.

"Once you introduce a villain that powerful, you know the threat is serious," says Wolfman. "With the Anti-Monitor, heroes are forced to become underdog Davids against a much more powerful Goliath."

OPPOSITE TOP: Larfleeze isn't letting go of his Orange Power Battery without a fight. [Art by Doug Mahnke, Christian Alamy, and Tom Nguyen, *Green Lantern*, Vol. 4, #48]

OPPOSITE BOTTOM: As the avatar of Death, Black Hand brought about the Blackest Night. [Art by Doug Mahnke and Christian Alamy, *Green Lantern*, Vol. 4, #43]

ABOVE: After destroying entire universes during DC's Crisis event, the Anti-Monitor gears up for his next challenge: Darkseid. [Art by Jason Fabok, *Justice League*, Vol. 2, #41]

LIVES OF CRIME

Not everybody wants to rule the world. Some super-villains are in it for the money. They might not have superpowers, but something compels these crooks to don costumes. Even if they enjoy testing their skills against Super Heroes, at the end of the day it's just another job.

"These characters can straddle the line between good and evil on a consistent basis," says Dan DiDio. "The thing that determines which side they'll align with is a very personal need. They always put their own priorities above the priorities of others, and that's why they usually fall on the villain side of the fence."

OPPOSITE: Deathstroke is the mercenary to call when villains like Doctor Light need a bodyguard. (Art by Rags Morales and Michael Bair, *Identity Crisis #2*)

DEATHSTROKE

Deathstroke, unbeatable soldier of fortune, sliced his way into comics beginning with *The New Teen Titans* #2 (December 1980) by Marv Wolfman and George Pérez. Armed to the teeth and boasting mastery of every combat style, Deathstroke became so popular as an antagonist he soon made the jump to morally neutral antihero.

"I never saw him as a villain," explains Wolfman. "I saw him as a character who had his own goals and his own morality, but he made a bad deal and found himself having to deal with this group, the Titans. He didn't want to fight, but he had to."

Slade Wilson, who originally went by Deathstroke the Terminator before shortening his *nom de guerre*, was a mercenary and assassin whose loyalties ended with the terms of his contract. In his first appearance, Deathstroke tried to complete a job on behalf of the evil organization H.I.V.E. by bumping off the Teen Titans.

Deathstroke's "nothing personal" morality made him compelling to fans. "I think people can understand a character who sometimes has to go against his own desires," says Wolfman. "He's not after supreme domination, or even crime. He's someone who has been forced, and it has turned him into this dark and deadly character."

The backstory provided to Slade Wilson established him as a U.S. Army veteran who gained a superhuman edge through classified military experiments. Despite augmented strength, speed, agility, stamina, and an accelerated healing factor, he was unable to restore his damaged right eye. The asymmetrical mask of Deathstroke is one of the character's trademarks.

For Deathstroke, adventuring is a family affair. His son Grant became the first Ravager. His other son, Joseph, later joined the Titans under the code name Jericho. Slade's daughter Rose followed in his mercenary footsteps as the second Ravager. Deathstroke is aided in his efforts by his servant, Wintergreen, a former mentor and comrade-in-arms.

Few are as skilled as Deathstroke when it comes to swords, firearms, or energy-blasting power staffs. But his true asset is his number-crunching brain, which is constantly calculating battle tactics. Only Batman rivals Deathstroke for always-prepared perfection, and the white-haired Wilson has years of experience on the Dark Knight.

"He was very much an anti-Batman, right down to his own Alfred, who was Wintergreen," says Wolfman. "I saw him in his mid- to late-40s, older than any Super Hero out there. Nobody was doing characters that were that age, especially action characters."

A standalone series, *Deathstroke the Terminator*, launched in 1991 and ran for sixty-one issues. In 2004's *Identity Crisis*, Deathstroke took out the Justice League's members one by one, with The Flash accidentally impaling himself on Deathstroke's sword.

After DC Comics' New 52 reboot in 2011, Deathstroke received his own series and an updated backstory. A decorated member of the black-ops unit Team 7, Slade Wilson traveled to Somalia and used his enhanced reflexes to rescue Wintergreen. His merciless execution of Wintergreen's captors gave rise to the legend of Deathstroke the Terminator.

In 2013's *Forever Evil* event, Deathstroke led a team of villains into the heart of the White House to kidnap the president. Fortunately for the commander in chief, agent Steve Trevor—who once served with Slade Wilson on Team 7—shut down the surprise raid.

In the following tales, Deathstroke forged a close bond with his daughter, Ravager. When she became the target of an assassin, Deathstroke even enlisted the help of Batman and Robin to protect her.

"Deathstroke is a contract killer and one of the most dangerous figures in the DC Universe," says Sterling Gates, who wrote Deathstroke's White House attack in *Forever Evil*. "Every breath he takes is another breath he can use to kill someone. The only way you survive once you're in his sights

PRANKSTER

If you can't beat Superman, humiliate him!
That seemed to be the Prankster's motto
when he showed up in *Action Comics* #51
(August 1942). Armed with a water pistol and
a foolproof scheme to get inside a bank vault,
the Prankster's silly appearance disguised a
cunning mind.

The character got an update in *Superman* #16 (April 1988), as reconceived by John
Byrne. After his firing as the host of TV's *The Uncle Oswald Show*, Oswald Loomis exacted
revenge on the network's executives using the same childish gags that had once been his stock
in trade.

An artistic makeover in *Adventures of Superman* #579 (June 2000) saw the Prankster
ditch his tubby, buck-toothed image for a new look that rendered him charmingly suave.

"I do like the idea of the traditionally comic Superman villains finding the right kind of
role," says Kurt Busiek, who penned one of the Prankster's memorable tales in *Superman* #660
(March 2007). "I focused on the Prankster by turning him into a distraction-for-hire. This
made good use of his obsessions by having him act as part of someone else's villainous plan.
He's a service provider more than the main villain."

After DC Comics' New 52 reboot, a new Prankster emerged: a hacker, cyber-criminal, and
one of the world's foremost code-breakers. Wearing a mask to preserve his anonymity, this
Prankster chose Nightwing as his nemesis.

No matter how many times he changes his face, the Prankster's motivations remain the
same: He wants mayhem of his own design and isn't about to let any hero get in his way.

OPPOSITE TOP: Superman catches up with the Prankster and the Toyman. [Art by Curt Swan and George Pérez, *Superman*, Vol. 1, #423] **OPPOSITE BOTTOM:** The Prankster is a gag-driven villain. [Art by Mike McKone and Marlo Alquiza, *Adventures of Superman*, Vol. 1, #579] **ABOVE:** The new Prankster draws Nightwing into a nightmare. [Art by Brett Booth, Norm Rapmund, and Andrew Dalhouse, *Nightwing*, Vol. 3, #19]

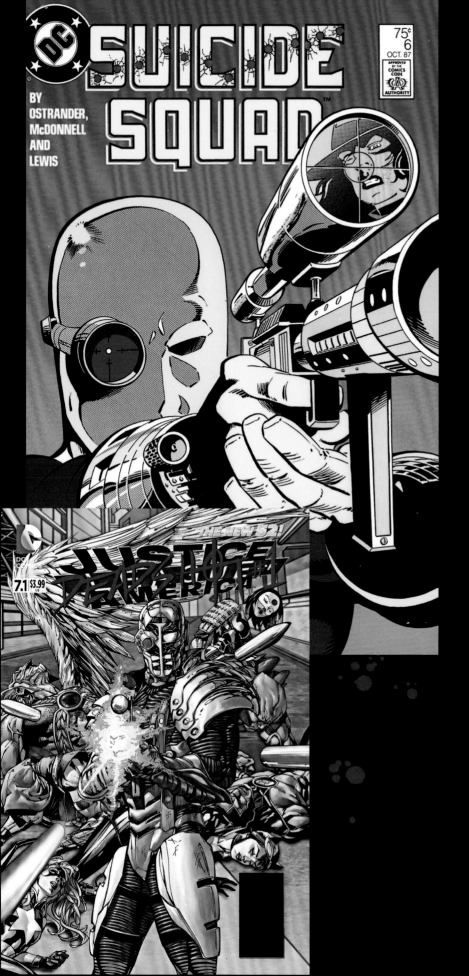

DEADSHOT

The assassin who never misses, Deadshot took aim in *Batman* #59 (June/July 1950). But his distinctive targeting-sight mask and his wrist-mounted guns didn't come until 1977, and it wasn't until the 1980s—and the fatalistic series *Suicide Squad*—that Deadshot came into his own as an antihero with a death wish.

Writer Steve Englehart and artist Marshall Rogers gave Deadshot new life when they reworked the character in *Detective Comics* #474 (December 1977). The character had previously worn a tuxedo and carried a pair of six-shooters, but Rogers gave him a streamlined makeover. With a sniper's scope over one eye and machine guns strapped to each wrist, Deadshot became a living weapon.

As a boy, Floyd Lawton tried to take out his abusive father with a rifle shot. He failed and killed his brother instead. Lawton worked out his guilt as the hired killer Deadshot, hiding his pain behind a façade of smart-alecky nihilism. Clients were wowed by his marksmanship, but his skill was Deadshot's way of ensuring he would never again fire a bullet that didn't hit its target.

The government-funded Suicide Squad provided Deadshot and other criminals with the opportunity to commute their prison sentences in exchange for running black-ops missions. Deadshot became the team's field leader.

Deadshot #1 (March 2005) provided the gunman with a daughter and a reason to go on living. As Deadshot morphed into a reluctant hero, the time seemed right for him to put in a starring turn. In the limited series *Villains United*, writer Gail Simone matched Deadshot with Catman, Parademon, Ragdoll, Cheshire, and Scandal Savage to form an all-new Secret Six. An ongoing *Secret Six* series followed, with Deadshot as the wry backbone of a highly dysfunctional team.

In the New 52, Deadshot landed behind bars after Batman broke up his planned assassination of a U.S. senator. Enticed by the prospect of an early release, Deadshot resumed his familiar role as the head of the Suicide Squad.

The 2016 blockbuster *Suicide Squad*, in which actor Will Smith brought the character to life, raised Deadshot's profile even further. DC Comics also launched an all-new *Suicide Squad* series featuring Deadshot (as well as his fellow movie standout, Harley Quinn) as part of the Rebirth publishing initiative.

OPPOSITE: No target walks away once Deadshot has taken aim. (Art by Jim Lee and Scott Williams, *Suicide Squad*, Vol. 5, #1) **TOP:** Deadshot puts a fellow villain in his sights. (Art by Luke McDonnell and Bob Lewis, *Suicide Squad*, Vol. 1, #6) **LEFT:** Deadshot unloads on his enemies. (Art by Tony S. Daniel and Matt Banning, *Justice League of America*, Vol. 3, #7.1: *Deadshot*)

BLACK MANTA

His UFO helmet hints at an outer-space pedigree, but this is one villain who lurks in the deepest depths of the sea. Introduced in *Aquaman* #35 (September/October 1967), Black Manta initially played an unremarkable role, filling in as a rival for Aquaman's nemesis Ocean Master.

"That helmet, and that silhouette, is what really defines the character," says Jim Lee. "Why that shape? It can be hard to explain at times. Things that might look silly from the '50s or '60s can work if you refine them in a visually striking way. Look at car design. Cars that have been around for fifty years, like the Porsche 911, have certain elements that you just have to have. But they're able to refine the edges to make it look modern. And at the same time, retro."

The distinctive costume made him a memorable enemy, and in his repeat appearances Black Manta hatched plots to kidnap Aquaman's son. In *Adventure Comics* #452 (July/August 1977), Black Manta finally fulfilled his vendetta and killed young Arthur Jr.

TV audiences got to know Black Manta starting with the animated *Superman/Aquaman Hour of Adventure*, which ran from 1967 to 1968, and the villain later graduated to full membership in the Legion of Doom in *Challenge of the Super Friends*. Originally voiced by Ted Knight and later by Ted Cassidy, Black Manta's lines issued from his oversized helmet in an eerie, modulated tone.

"The thing that sticks in my brain the most about Black Manta is his voice on the cartoon," says writer Ron Marz. "That bottom-of-the-well echo is still ringing in my mind. Even if he wasn't a Darkseid-level threat, he sounded great."

Black Manta's costume is essentially a diver's wetsuit; his helmet is a giant SCUBA rebreather. Unlike Aquaman, he can't survive the pressures of the sea without technological assistance. Jets in his boots allow him to move quickly underwater, and his reinforced gear gives him boosted strength at sea-level elevations. Black Manta sometimes employs a telepathic scrambler that nullifies Aquaman's control over sea creatures.

Always ready to fight, Black Manta can be found with a weapon in his fist: a trident, spear gun, electrified net, or torpedo launcher. He can fire energy blasts from his helmet's lenses, and his vehicle of choice is a submarine patterned after a manta ray.

DC Comics' *Forever Evil* crossover event in 2013 made Black Manta a surprising star. After the Crime Syndicate seized control of Earth—seemingly killing Aquaman in the process—Black Manta blamed them for stealing his revenge. He joined Lex Luthor, Bizarro, Black Adam, and Captain Cold to form a resistance cell and take the fight to the new ruling elite.

When Aquaman reappeared alive and well, Black Manta resumed his vendetta by sinking an Atlantean embassy and torpedoing hopes of cooperation between the undersea and surface worlds. Manta is now the head of N.E.M.O., a terrorist organization devoted to the downfall of Atlantis and its people.

"He's a great arch-villain for Aquaman," says writer Dan Jurgens. "Black Manta has a great name and one of the all-time great designs. It's both simple and threatening—as cool as it gets."

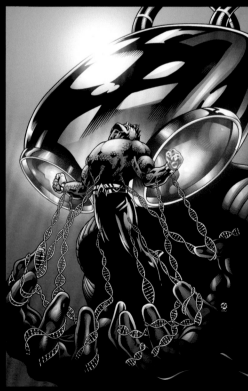

TOP: Aquaman and Black Manta engage in an underwater duel. [Art by Ivan Reis, Joe Prado, and Rod Reis, *Aquaman*, Vol. 7, #10] **ABOVE:** A rare image of Black Manta without his helmet. [Art by Ivan Reis and Joe Prado. *Aquaman*, Vol. 7, #7] **RIGHT:** The villain plots his revenge. [Art by Patrick Gleason, Christian Alamy, and Nathan Eyring, *Aquaman*, Vol. 6, #32] **OPPOSITE:** He's not an Atlantean, but Black Manta is at home beneath the waves. [Art by Ivan Reis, Joe Prado, and Rod Reis, *Aquaman*, Vol. 7, #12]

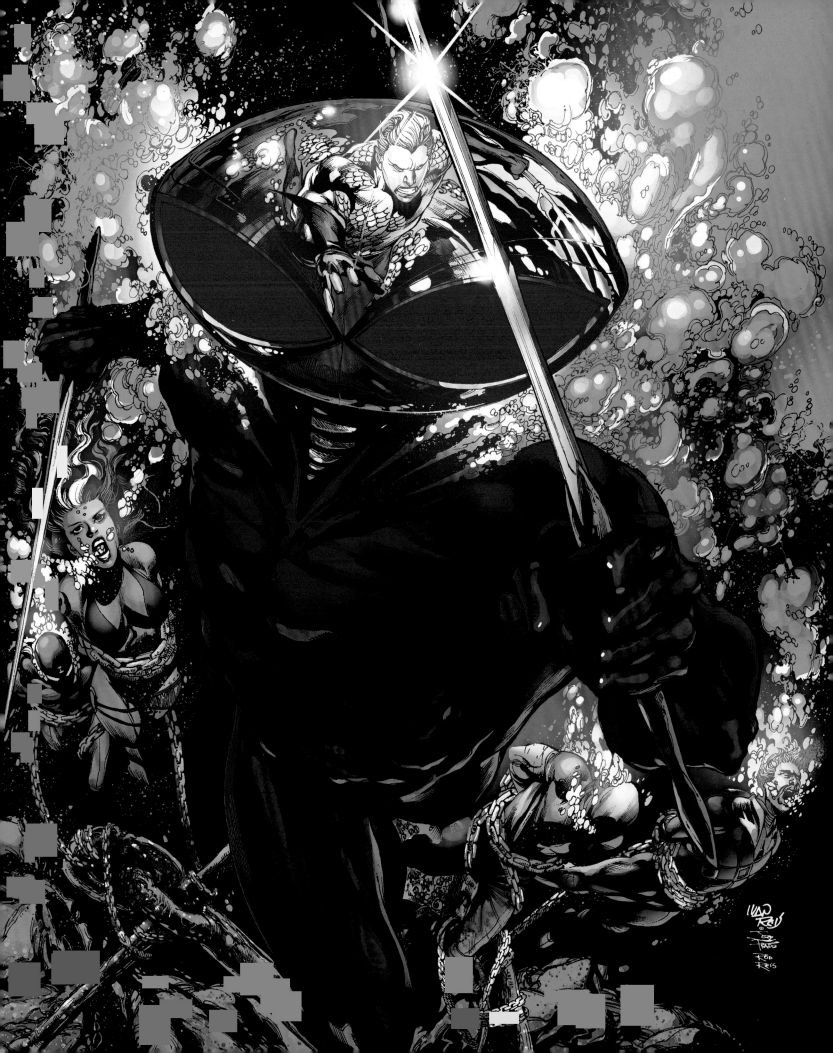

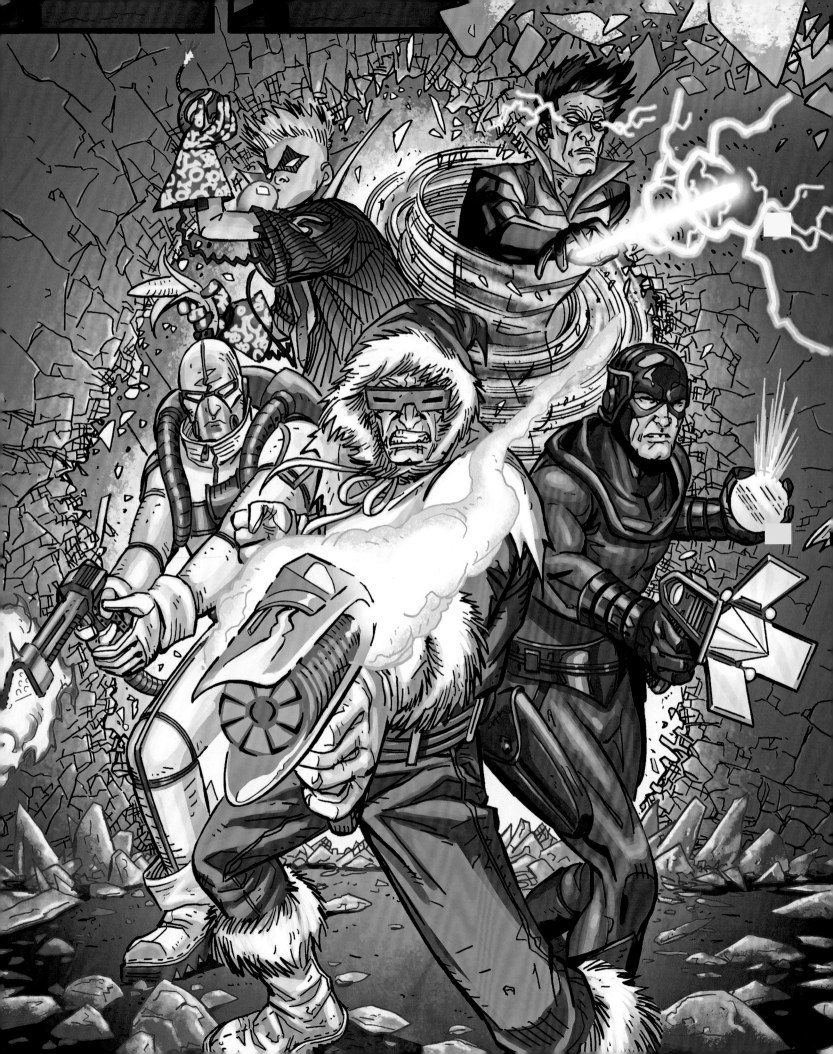

FOES OF THE FASTEST MAN ALIVE

Most of The Flash's villains joined his cast in the late 1950s and early 1960s in a remarkable burst of creativity that is even more notable for its sheer longevity. Characters like Captain Cold, Mirror Master, and Captain Boomerang are as popular as ever, especially in their team-up mode when they are known simply as the Rogues.

"Because these characters became so popular as individuals, the decision to put them together was one of the highlights of Flash storytelling," says Dan DiDio. "People react very positively whenever they see the Rogues side by side, because they have as much personality together as they do by themselves."

Writer Kurt Busiek declines to compare The Flash's villains to those of Batman or Superman. "It's almost apples, oranges, and walnuts to compare them," he says, "but The Flash's Rogues are so distinctive that they're practically supporting characters. They're generally out for the same kind of thing, which is why they team up so well together. They're crooks, and they're fun crooks."

THE REVERSE-FLASH

Whether he's called the Reverse-Flash or Professor Zoom, Eobard Thawne is a light-speed killer unhindered by the laws of space and time.

John Broome and Carmine Infantino unveiled the character in *The Flash* #139 (September 1963). A resident of the 25th century, Eobard Thawne traveled into the past to meet The Flash and to meddle in the life of his alter ego, police scientist Barry Allen. Though he possessed the same abilities as his target—able to run faster than thought and phase through solids by vibrating his body's molecules—Thawne's color-swapped costume marked him as a true "Reverse-Flash."

"There is a simplicity to the Reverse-Flash," says writer Fabian Nicieza. "Barry Allen is a detail-oriented guy who moves at the speed of near-light. That's when details should be lost, and as a police scientist he needs to see the details. The Reverse-Flash is the opposite—he doesn't think about the details; he thinks about the big picture. The Flash is, in some ways, grounded in the now, but as a time traveler the Reverse-Flash comes from everywhere and invades the now."

Thawne's obsession with Barry Allen's wife, Iris, took an ugly turn after she rejected his advances. He attacked and seemingly killed her, forcing The Flash to snap his enemy's neck in order to save a second victim. In the subsequent trial, a jury found The Flash innocent of all charges.

"The Reverse-Flash's murder of Iris was one of the most captivating narratives of my childhood," remembers writer Sterling Gates. "The fact that Barry Allen broke his neck and was put on trial for it? It made for one of the best and most dramatic comic book sagas of the 1980s."

The Reverse-Flash didn't stay dead for long. During the early 2000s he became the unhinged nemesis of Wally West, Barry Allen's replacement as The Flash. When Barry took up the costume once more, the Reverse-Flash orchestrated a revenge scheme so thorough it rewove the fabric of existence.

This occurred in *Flashpoint*, a 2011 crossover in which the Reverse-Flash mangled the timeline and brought about an Earth with an alternate history. In a bleak new reality of warring Amazons and vengeful Atlanteans, the Reverse-Flash gloated over his creation. But letting his guard down proved fatal for Thawne when the Flashpoint-Batman stabbed him through the heart with a sword.

The Reverse-Flash of DC Comics' rebooted continuity is Daniel West. After the Rogues forced him into a Mirror World and robbed him of his possessions, he escaped by crashing an experimental monorail into a battery fueled by the Speed Force. The explosion gave him super-speed but fused his body with the monorail's shrapnel.

While serving with the Suicide Squad, this Reverse-Flash went out like a hero, saving innocents from a bomb blast but apparently perishing in the explosion. However, given the character's connection to the Speed Force, he is unlikely to stay down for long.

"Barry Allen is a problem solver, and the Reverse-Flash is a problem maker," says Nicieza. "That simple dynamic is how the characters come into conflict, thematically as well as physically."

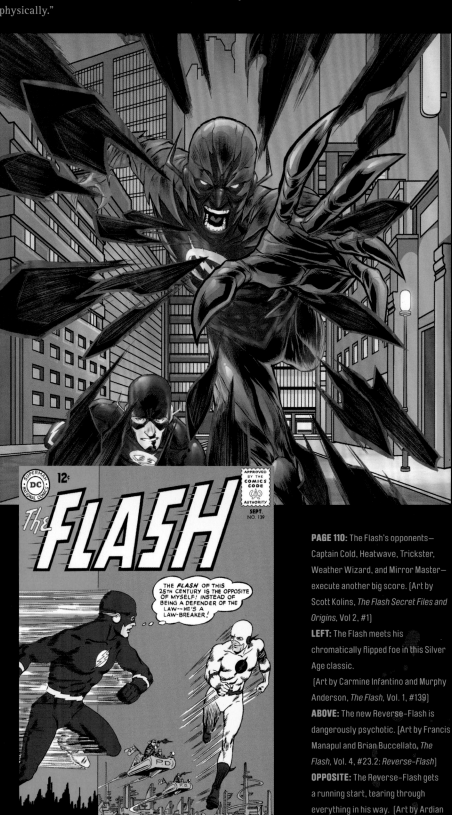

PAGE 110: The Flash's opponents—Captain Cold, Heatwave, Trickster, Weather Wizard, and Mirror Master—execute another big score. [Art by Scott Kolins, *The Flash Secret Files and Origins*, Vol 2, #1]

LEFT: The Flash meets his chromatically flipped foe in this Silver Age classic.
[Art by Carmine Infantino and Murphy Anderson, *The Flash*, Vol. 1, #139]

ABOVE: The new Reverse-Flash is dangerously psychotic. [Art by Francis Manapul and Brian Buccellato, *The Flash*, Vol. 4, #23.2: *Reverse-Flash*]

OPPOSITE: The Reverse-Flash gets a running start, tearing through everything in his way. [Art by Ardian Syaf and Vicente Cifuentes, *Flashpoint: Reverse-Flash* #1]

GORILLA GRODD

Grodd had to settle for joint billing with the Pied Piper as the villain of *The Flash* #106 (April/May 1959). But the story "Menace of the Super-Gorilla," by John Broome and Carmine Infantino, made it clear that Grodd really isn't a character who likes to share.

Hailing from the evolutionary anomaly of Gorilla City in Africa, Grodd tried to wrest control of the kingdom from Solovar, its wise ruler. After The Flash put a stop to his scheme, Grodd expanded his conqueror's scope to encompass the entire planet and the humans who infested it.

Grodd's gifts include genius-level intelligence, supercharged ape-like strength, and frighteningly advanced powers of telepathy and telekinesis. He can project mental force beams and manipulate others like puppets. His loyal simian soldiers frequently attack The Flash's hometown of Central City, and Grodd's savagery is so absolute that he has been known to eat his victims alive.

"Grodd is a hyper-intelligent scientist, and he desperately wants to lead his people in an uprising to overtake the Earth," says writer Sterling Gates. "Grodd's psionic powers make him an even deadlier foe, since he can even use them to transfer his consciousness into a human body."

In the 2007 series *Salvation Run*, Gorilla Grodd is one of the villains banished to a distant world, where he kills his fellow ape Monsieur Mallah in a ruthless display of dominance. During 2013's "Forever Evil" event, Grodd crowns himself ruler of Central City and mounts the heads of his victims on pikes.

Adds Gates, "Gorilla Grodd is both brains and brawn."

CAPTAIN COLD

The leader of the Rogues, Leonard Snart is one cool customer. He put in his first appearance as Captain Cold in *Showcase* #8 (June 1957) by John Broome and Carmine Infantino.

Traditionally the most "grown-up" member of the Rogues, Captain Cold keeps a level head and has the smarts to combine the powers of the Rogues for maximum strategic effect. Under his watch, the Rogues have become a rare thing in the DC Universe—a team of villains that doesn't crumble into feuding factions.

That *esprit de corps* can be chalked up to Captain Cold's rules of order. He controls the purse strings—ensuring that each member gets their fair share of the loot from a heist—and demands that opponents be treated with respect. His sister, Lisa, sometimes known as the Golden Glider, is one of the few people who can melt his heart.

"Cold acts as the moral flag for the Rogues, never allowing them to cross certain lines," says *Kid Flash* writer Sterling Gates. "His code of honor is what keeps the Rogues from killing women and children. Cold encourages them to respect themselves and even respect the heroes of the DC Universe."

Captain Cold's freeze gun inhibits molecular motion to a point close to absolute zero. This can coat the ground with ice and cause The Flash to lose his footing, or generate a zone of supercooled inertia and force The Flash to exit super-speed. Cold wears a polar-blue costume accessorized with Inuit-inspired snow goggles.

In the New 52, Captain Cold leads the Rogues despite the distraction of his sister Lisa's battle with cancer. Blaming The Flash for Lisa's lack of treatment, he sets out to kill his foe until the Crime Syndicate takes over the world. Cold joins a resistance movement, fighting the Crime Syndicate overlords alongside Lex Luthor, Black Adam, Bizarro, and Black Manta. Captain Cold's actions won him a governmental pardon, and following that he gratefully signed on to be Lex Luthor's new head of security.

Says Gates, "Captain Cold might seem cold-hearted to some, but underneath that layer of ice there's a little bit of gold."

OPPOSITE TOP LEFT: Gorilla Grodd holds the skull of a human weakling. (Art by Francis Manapul and Brian Buccellato, *Flashpoint: Grodd of War* #1)

OPPOSITE TOP RIGHT: Grodd and the Speed Force is a dangerous combination. (Art by Francis Manapul and Brian Buccellato, *The Flash*, Vol. 4, #14)

TOP LEFT: Captain Cold will freeze anyone who opposes him. (Art by Francis Manapul, *The Flash*, Vol. 4, #6)

LEFT: Cold takes command of the gang. (Art by Sean Chen and Walden Wong, *Salvation Run* #1)

MIRROR MASTER

Mirror Master debuted in *The Flash* #105 (February/March 1959), the first new issue of the series to appear on newsstands in a decade. His villainous turn proved popular enough to warrant repeat appearances, continuing Barry Allen's pattern of collecting a lineup of familiar foes.

Ex-con Sam Scudder became the Mirror Master through his mastery of reflective technology. He could generate illusions and make decoys of himself, but his most fantastic gift was the ability to teleport between two mirrors—or trap his enemies inside the mirror dimension with no way out.

In the 1990s, the identity of the Mirror Master fell to foul-mouthed Scottish mercenary Evan McCulloch, as seen in Grant Morrison's run on *Animal Man*. McCulloch targeted Animal Man while working for a shadowy government agency. He went on to harass the third Flash, Wally West, as the newest member of the Rogues.

Sam Scudder returned as Mirror Master in the New 52. Together with familiar Flash rogues Captain Cold, Heatwave, and Weather Wizard, he went on the run after Gorilla Grodd ran rampant over his Central City home.

TOP LEFT: Mirror Master makes a connection with Golden Glider. (Art by Patrick Zircher, *The Flash*, Vol. 4, #23.3: *The Rogues*) **TOP RIGHT:** Animal Man shatters a mirror duplicate. (Art by Chaz Truog and Doug Hazelwood, *Animal Man*, Vol. 1, #8) **LEFT:** The Hall of Mirrors trick rarely fails. (Art by Carmine Infantino and Joe Giella, *The Flash*, Vol. 1, #105)

CAPTAIN BOOMERANG

George "Digger" Harkness is an Australian with an unforget-
table shtick. Introduced in *The Flash* #117 (December 1960),
Harkness adopted the identity of Captain Boomerang while
working for a toy company. But his skill with razor-edged
and exploding boomerangs led him to his true calling as a
costumed thief.

Captain Boomerang fared surprisingly well against the
supersonic Flash, relying on trick boomerangs to provide
the element of surprise. In his first adventure, he strapped
the Scarlet Speedster to a giant, rocket-propelled boomerang
and launched him on a potentially fatal trajectory into the
upper atmosphere.

The 1987 series *Suicide Squad* found a recurring role
for Captain Boomerang. He proved unpopular among the
murderers and madmen who filled out the rest of the Squad's
ranks, thanks to his inability to keep his mouth shut.

"With Captain Boomerang, I drew more from John
Ostrander's *Suicide Squad* than from anything in the
Silver Age," says writer Fabian Nicieza, who brought in
the character as a guest villain on *Red Robin*. "What I like
about Boomerang is that he's a self-centered, self-righteous,
arrogant jerk—but there's this tiny drop that sometimes
makes him do the right thing. As a writer, that one drop is
what you squeeze as much as you can."

Digger Harkness died in 2004's *Identity Crisis*. His son
Owen Mercer (conceived by Harkness with the villainess
Golden Glider) briefly replaced him, having inherited both his
father's throwing talents and his mother's super-speed.

The "Brightest Day" event brought the original Captain
Boomerang back from the grave. In the New 52, Digger
Harkness resumed his role as a recurring Flash villain and a
bothersome Suicide Squad recruit.

"It's great to have a villain like Captain Boomerang,"
says Nicieza. "When push comes to shove, he's a villain who
might actually do the right thing."

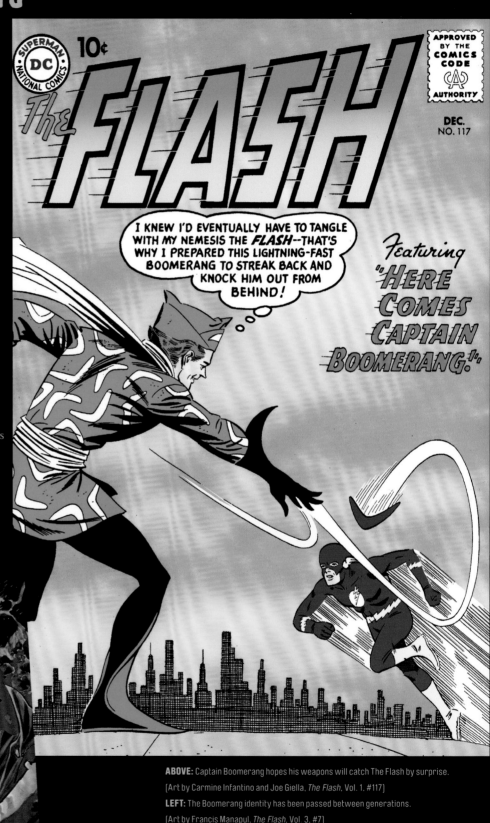

ABOVE: Captain Boomerang hopes his weapons will catch The Flash by surprise.
[Art by Carmine Infantino and Joe Giella, *The Flash*, Vol. 1, #117]
LEFT: The Boomerang identity has been passed between generations.
[Art by Francis Manapul, *The Flash*, Vol. 3, #7]

TRICKSTER

Like Superman's foes Toyman and Prankster, the Trickster is a practical
joker who relies on criminal stunts to get the attention he craves.
Bowing in *The Flash* #113 (June/July 1960), James Jesse abandoned life
as a circus acrobat for a career as an outlaw.

With the Trickster, it's all about the bag of tricks. His shoes let
him walk on air. His itching powder can incapacitate armed guards.
His exploding yo-yos are powerful enough to blast open bank vaults,
and razor-sharp jacks are enough to foil pursuit as the Trickster makes
his getaway.

James Jesse's run as the Trickster ended in a 2008 issue of the
weekly series *Countdown to Final Crisis*, after he took a bullet to save
the life of his former comrade-in-crime, the Pied Piper. This opened the
door for teenager Axel Walker (a character first introduced in 2002)
to become the Trickster full time.

Axel Walker is still the Trickster in DC Comics' New 52 continuity.
His overconfidence and his dangerously smart mouth led to the loss of
his right hand during Gorilla Grodd's takeover of Central City.

After fashioning a robotic replacement limb, the Trickster returned
to the joys of crime. He briefly joined forces with the Riddler but
rebelled against his new partner when the alliance turned sour.

TOP LEFT: The Trickster pulls a fast one on the fastest man alive. (Art by Brian
Bolland, *The Flash*, Vol. 2, #183)
TOP RIGHT: Hover-shoes are just one of the surprises the Trickster is eager to
spring. (Art by Francis Manapul and Brian Buccellato, *The Flash*, Vol. 4, #18)

"With the **TRICKSTER**, it's all
about the bag of **TRICKS.**"

WEATHER WIZARD

Says writer Sterling Gates, "Who hasn't wanted to shuffle away a rainy day with the wave of a magic wand?" Yet despite his name, the Weather Wizard's powers come not from magic, but science—a grounded trait that he shares with most of The Flash's Rogues.

Arriving in 1959's *The Flash* #110, the Weather Wizard stole the designs of his scientist brother to build a wand and harness the atmospheric energy of wind and storms. He proved a versatile member of the Rogues with his power to summon blizzards, zap victims with lightning, or carry himself aloft on air currents.

In DC Comics' New 52 continuity the Weather Wizard is Marco Mardon, who headed a crime family alongside his brother Claudio before signing on with the Rogues. His brother's death forced Marco to once again get involved in the family business.

"Weather Wizard is simply a crook who stumbled across a great idea and became a super-powered crook in its usage," says *The Flash* artist Ethan Van Sciver. "I love the Rogues, because they're so down-to-earth. Geoff [Johns] and I would talk about how important it was to humanize them and give them real weaknesses, but also to explain that they were evil men. Weather Wizard is not a funny thief with a gimmick. He's a hardened criminal who belongs behind bars."

HEATWAVE

Fascinated by flames since childhood, Mick Rory set his own home ablaze before going into business as a full-time costumed arsonist.

Debuting in *The Flash* #140 (November 1963), Heatwave quickly became a rival of Captain Cold's. The two criminals specialize in opposite ends of the thermometer, but their ability to pack a punch of fire and ice is an effective combo against their supersonic nemesis.

Heatwave originally wore a temperature-controlled suit made from asbestos. The New 52 version of the character chooses to leave his charred skin exposed to the elements. He packs flamethrower gauntlets on each wrist, wears a flame sprayer in the center of his chest, and carries a firefighter's axe.

TOP: Weather Wizard whips up a whirlwind. [Art by Francis Manapul and Scott Kolins, *Flash Secret Files and Origins*, Vol 2 #1]
LEFT: Heatwave prepares to ignite another inferno. [Art by Howard Porter, *The Flash*, Vol. 2, #218]

MAD SCIENCE

Following in the footsteps of masterminds in popular fiction, from Moriarty to Doctor Frankenstein, these villains share a fierce intelligence and a sneering disregard for the ethical consequences of their experiments. Arrogance is their universal flaw.

"They come from the atomic age, and the idea of science going horribly wrong," says Dan DiDio. "Our 'lab coat villains' is what I like to call them. They are characters who represent the downside of science and how it changes the world."

DOCTOR SIVANA

The cackling Dr. Sivana has been hatching schemes since 1940, when he debuted in *Whiz Comics* #2 in a story by Bill Parker and C. C. Beck. Sivana's nemesis is Shazam (Captain Marvel), who, along with Black Adam, is one of the longest-running foes of the "Big Red Cheese." He appeared in an amazing 134 stories between 1940 and 1953.

Thaddeus Bodog Sivana is the quintessential mad genius, peering out at his inferiors from behind the lenses of his pupil-masking spectacles. His children include Beautia, Magnificus, Georgia, and Thaddeus Jr., and, during the Golden Age, the Sivana family visited the planet Venus in a rocket ship of Sivana's own design.

Dr. Sivana dropped out of comics for two decades but returned in various revivals. Jerry Ordway's 1994 series *The Power of Shazam* cast the scientist as a corporate threat in his position as CEO of Sivana Industries.

Among Sivana's notable adventures is his creation of the Fearsome Five in 2004's *Outsiders*. In 2006's limited series *52*, Sivana was among the geniuses who found themselves abducted, transported to Oolong Island, and tasked with creating terrifying inventions for a mysterious benefactor.

In DC Comics' New 52 continuity, Dr. Sivana is a man of science who turns to the occult to save his family from tragedy. His brush with magic leads to a brief alliance with Black Adam, until he finds a superior partner in the tiny, telepathic worm that calls itself Mister Mind.

Grant Morrison, in the 2014 limited series *Multiversity*, brought back the classic Sivana of the Golden and Silver Ages via the parallel world of Earth-5. In this tale, multiple interpretations of the mad doctor formed the Legion of Sivanas to wreak havoc on the multiverse.

OPPOSITE: Doctor Sivana, zapped by Black Adam's magic, gains a new perspective on the world of magic. [Art by Gary Frank, *Justice League*, Vol. 2, #9]

TOP RIGHT: Sivana adds his brainpower to that of his multiversal counterparts, forming a mental menace greater than the sum of its parts. [Art by Cameron Stewart, *The Multiversity: Thunderworld Adventures*]

"Thaddeus Bodog Sivana is the quintessential

MAD GENIUS, peering out at his inferiors from

behind the lenses of his pupil-masking spectacles."

PROFESSOR IVO

Professor Ivo hatched his first scheme in *The Brave and the Bold* #30 (June/July 1960), where he took a backseat to his android creation Amazo. Terrified of dying, Ivo had devoted years to the production of a nearly-indestructible life-form with which he hoped to defeat the Justice League and obtain the resources for a life-extending serum.

But Amazo failed, forcing the increasingly desperate Ivo to new battles against DC Comics' costumed heroes. Ivo scored a rare triumph for villainy in *Justice League of America* #258 (January 1987), marking a four-issue story arc that finished off the series' original run. Now disfigured with reptilian skin and pointy teeth, Ivo sent his androids against the Justice League and killed two of their members, Steel and Vibe.

"Anyone as brilliant and lunatic enough to create a maniac like Amazo would have the ability to manufacture some other pretty nasty entities," says writer Peter Milligan, who introduced a next-gen version of the android in the "Kid Amazo" story arc from *JLA Classified*.

Ivo matched wits against the Justice League once again in *JLA* #5 (May 1997) when he built the robotic Tomorrow Woman in a bet against fellow scientist T. O. Morrow. Ivo's creation was little more than a living bomb, designed to infiltrate the League and explode. But Ivo realized he built the Tomorrow Woman *too* well when her programmed heroism superseded her prime directive.

In the New 52, Professor Ivo made early appearances as one of the directors of the S.T.A.R. Labs facility in Detroit. With his villainy not yet apparent, Ivo gained authority over the Red Room, where S.T.A.R. Labs reverse-engineers alien technology.

Eventually Ivo unleashed his Amazo creation upon the Justice League, but he escaped retribution by faking his own death in an explosion.

ABOVE: T.O. Morrow and Professor Ivo share a toast. [Art by Howard Porter and John Dell, *JLA*, Vol. 1, #5]

TOP RIGHT: An institutionalized Ivo proves no threat to Vixen. [Art by Luke McDonnell and Bob Lewis, *Justice League of America*, Vol. 1, #261]

RIGHT: Professor Ivo is a disciple of science. [Art by Brett Booth and Norm Rapmund, *Justice League of America*, Vol. 3, #4]

OPPOSITE: Ivo, his appearance still unblemished, pits his greatest scientific creation against the Justice League. [Art by Mike Sekowsky and Murphy Anderson, *The Brave and the Bold*, Vol. 1, #30]

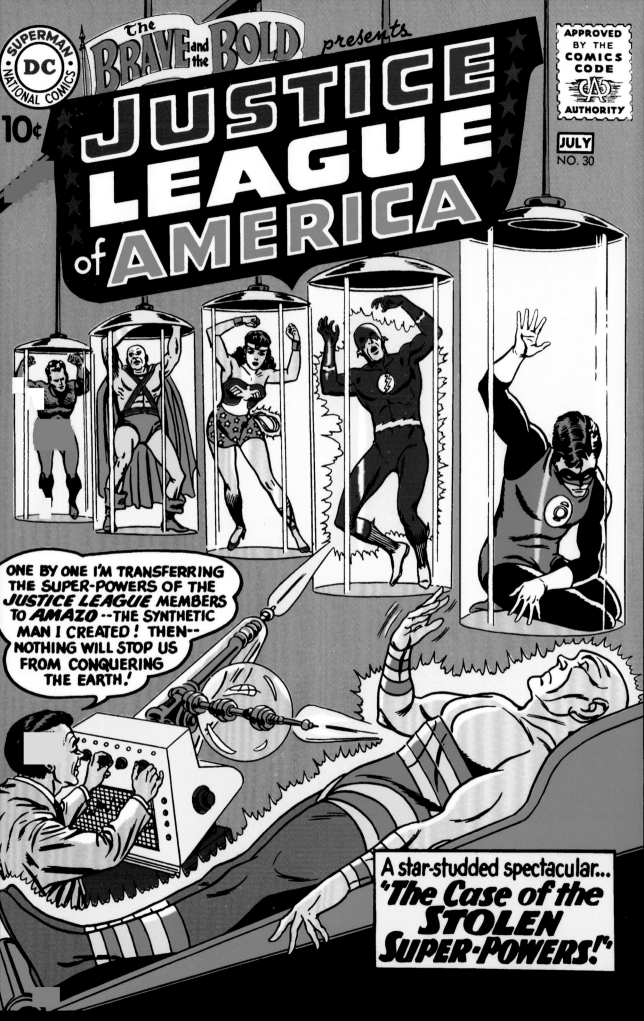

TOYMAN

Combine a gift for invention with a love of playthings and you get the Toyman—a Superman villain whose stories tend toward the silly.

Action Comics #64 (September 1943) heralded the new character as "the terrible Toyman," and Winslow Schott certainly tried to raise mayhem with his miniature devices. The villain planned to rob an armored car by using toy soldiers that sprayed knockout gas, and miniature fire engines packed with bombs.

After DC Comics' *Crisis on Infinite Earths* reboot in the mid-1980s, an all-new Toyman surfaced in *Superman* #13 (January 1988). This version of Winslow Schott blamed corporate kingpin Lex Luthor for the loss of his job, dispatching an army of explosive action figures on Metropolis and forcing the Man of Steel to intervene.

Can a character like the Toyman be dark and gritty? The Superman comics gave it a shot in the 1990s when Winslow Schott shaved his head and dressed in black. His character arc culminated with the kidnapping and murder of *Daily Planet* reporter Cat Grant's young son.

"When creators bring back characters like Toyman, we consciously try to put an edge on it," explains Mike Carlin. "The readers of today tend to not gravitate toward humorous material, especially in the action/adventure comics. We probably wouldn't have done a Toyman story at all if it was going to be just for jokes."

Action Comics #865 (July 2008) by Geoff Johns and Jesus Merino restored the Toyman's lighter roots, portraying a heartbroken inventor outraged by the revelation that his toy blueprints had been misappropriated by arms manufacturers. The Toyman's revenge took the form of an explosive teddy bear.

Other "Toymen" occasionally pop up in the comics. Twelve-year old Hiro Okamura of Japan used the Toyman name, and constructed a giant rocket shaped like an amalgam of Superman and Batman to destroy a kryptonite asteroid. *Action Comics* #837 (May 2006) introduced the child-sized doll Toyboy, which followed the ventriloquist-dummy design originally used in *Superman: The Animated Series.*

OPPOSITE: The Toyman relaxes amid the evidence of his obsession. (Art by Jesús Merino, *Action Comics*, Vol. 1, #865)

ABOVE: A pensive Toyman seems conflicted by his role as a bringer of mirth and a bringer of mayhem. (Art by Jesús Merino, *Action Comics*, Vol. 1, #865)

LEFT: United with other gimmick-driven villains, the Toyman makes his move. (Art by Kevin Maguire and Brad Anderson, *Action Comics*, Vol. 1, #865)

VANDAL SAVAGE

A caveman who can't die. That's the basic premise behind Vandal Savage, a character who muscled his way into comics in *Green Lantern* #10 (Winter 1943) by Alfred Bester and Martin Nodell.

His Cro-Magnon heritage—and his surname—suggest a violent brute, but in truth Vandal Savage exhibits a keen intellect that has been honed over more than 50,000 birthdays. He received his longevity from a fallen meteorite during his days as Vandar Adg, leader of the Blood Tribe. His rival in the Bear Tribe also received a meteorite power, gaining the ability to resurrect himself every time he died and becoming the Immortal Man.

In the DC Universe, Vandal Savage is one of history's most infamous figures. It is he who destroyed the lost city of Atlantis, and he claims to have conquered the ancient world while using the names Alexander the Great and Genghis Khan. Savage gained a taste for bloodshed during his stints as Vlad

ABOVE: Vandal Savage solidifies his hold over the Old West. [Art by Glenn Fabry and Adam Brown, *All-Star Western*, Vol. 3, #18]

TOP RIGHT: Lex Luthor faces opposition from an immortal rival. [Art by David Finch, Matt Banning, and Peter Steigerwald, *Action Comics*, Vol. 1, #895]

OPPOSITE: In ancient Egypt, Vandal Savage carves out his own kingdom. [Art by Leonard Kirk and Keith Champagne, *JSA* #42]

the Impaler and Jack the Ripper. His daughter, Scandal Savage of the Secret Six, is the heir to his grim legacy.

"I love the idea of a character who has lived for so long and seen so much that he brings with him a very different perspective," says writer Fabian Nicieza. "Your average Super Hero has to solve the problem of the month, in each issue of a monthly comic. But Vandal Savage is thinking in centuries. It's a completely different way to think, how a person would plan over the course of centuries rather than minutes or days. And it might be part of the reason why he's not more popular. If it's going to take years to enact a plan, you may not see a full story printed in your lifetime!"

The 2008 miniseries *Salvation Run* opened with scores of DC Comics' most notorious super-villains exiled to a distant jungle planet. Lex Luthor and the Joker formed competing factions, but the more level-headed Vandal Savage headed off into the wilds to create his own society. In the 2010 storyline "The Return of Bruce Wayne," a time-displaced Batman fought Vandar Adg during the time of the Blood Tribe, only to experience a rematch in the gunslinging era of the Old West.

DC Comics' New 52 reboot found an appropriate role for Vandal Savage in *Demon Knights*, a series set during the Middle Ages. Savage starred alongside other period-appropriate characters including Etrigan the Demon, Madame Xanadu, and the Shining Knight.

Back in modern times, Savage launched one of his most ambitious schemes to date and managed to nullify Superman's powers. With the Man of Steel sidelined, he hoped to bestow asteroid-fueled immortality upon all of his genetic descendants.

Says Nicieza, "Vandal Savage is more than just a vicious caveman. There are plenty of characters who will snarl and hit. It's much more interesting to use Vandal Savage as a character who sees a bigger picture than the hero is capable of seeing."

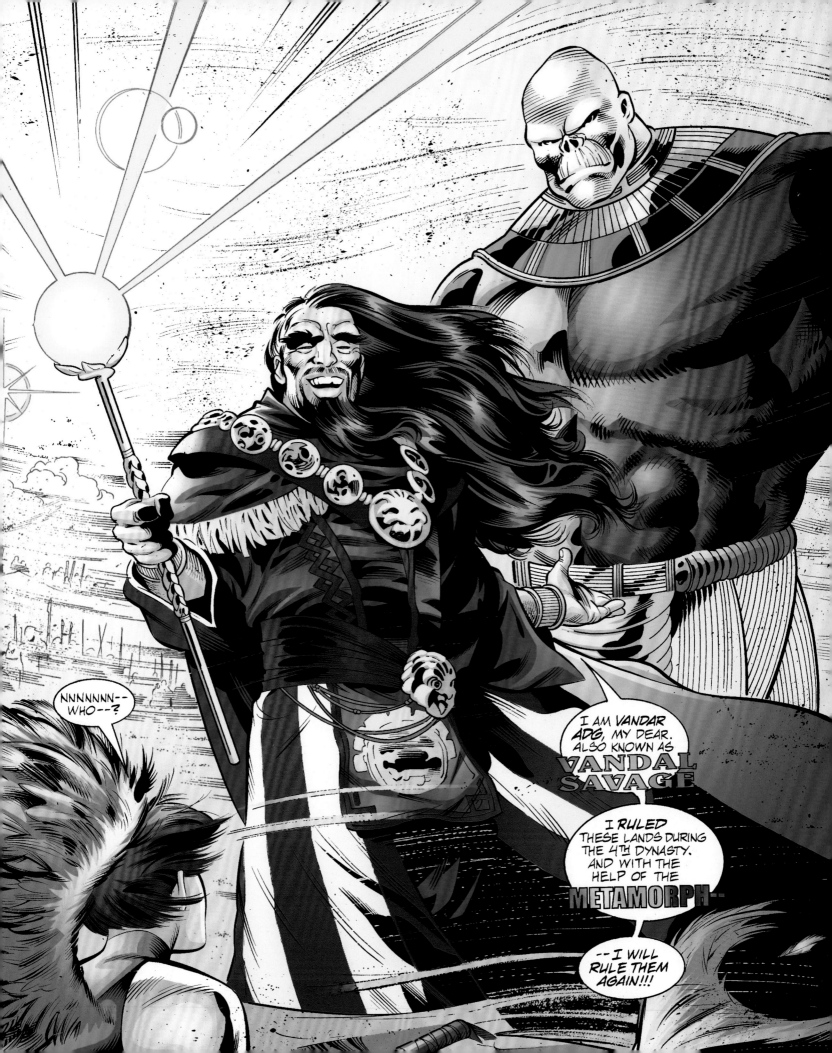

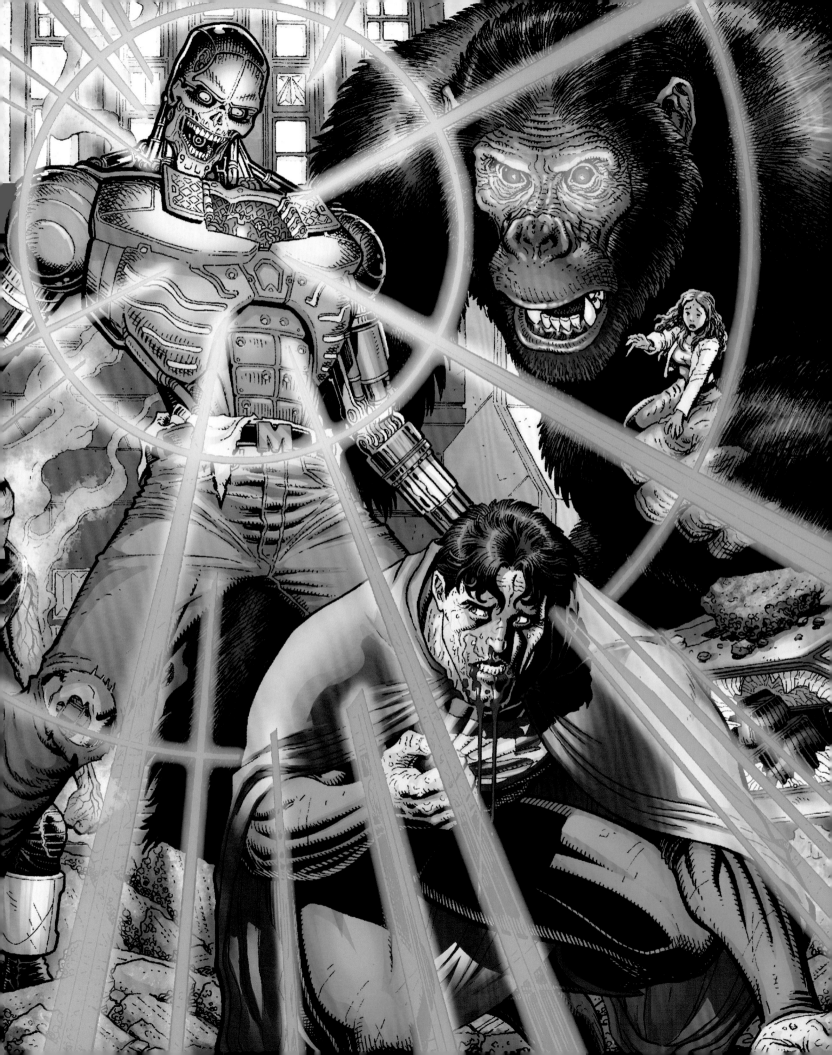

MONSTERS, EXPERIMENTS, AND FREAKS

Some villains have a tough time blending into normal society. For most of them, that suits them just fine. Among this crew, lab accidents and genetic mutations are common conditions. Others are the horrific by-products of mad scientists unencumbered by conscience.

OPPOSITE: With the super-ape Titano as his audience, Metallo bathes Superman in the toxic radiaton of kryptonite. (Art by Art Adams, *Action Comics Annual*, Vol. 1, #10)

METALLO

Depending on the storyline, Metallo's appearance has ranged from mostly human to completely mechanical. He can morph his metallic components into cutting blades and plasma cannons, while his tough alloys protect him from damage. And underneath all that metal is a glowing heart of toxic kryptonite.

Action Comics #252 (May 1959) famously introduced Supergirl to the world. Metallo, overlooked in the issue's opening pages, struggled through a second-billing story that barely hinted at the character's future importance.

For John Corben, the switch from common crook to unstoppable cyborg occurred when a scientist offered to heal the injuries Corben had received in a recent crime with a robotic rebuild. Because no battery had enough juice to power his new prosthetics, Metallo received a chunk of Kryptonite as a crystalline battery.

"Kryptonite is a bit of a gimmicky thing to go to all the time," says Mike Carlin, "but when Metallo appeared he gave Superman someone that he didn't have to hold back on. He was a robot, for the most part, so Superman could really go toe-to-toe with him."

After DC Comics' *Crisis on Infinite Earths* reboot, an all new Metallo loomed over Superman on the cover of *Superman* #1 (January 1987). This Metallo had a similar power set to the hero, and his Kryptonite reactor provided the Man of Steel with a fatal risk to his health.

In DC Comics' New 52 continuity, John Corben appeared as a soldier under the command of General Sam Lane and shared a romantic history with the general's daughter, Lois. After Superman fled government custody, Corben volunteered to pursue him while wearing the U.S. Army's experimental "Metal 0" armor. The cyborg interface proved too much for him to handle, and Metallo became a threat to both Superman and the U.S. military.

Metallo combines a cyborg's unstoppability with the lethality of Kryptonite. And even though Metallo no longer has a human heart, Superman can see beneath his metal shell to perceive the good person that John Corben once was.

ABOVE: Metallo will kill anyone who stands in his way. (Art by Gary Frank and Jon Sibal, *Superman: Secret Origin* #6)

OPPOSITE: An enraged Metallo fights the U.S. Army. (Art by Steve Pugh, *Action Comics*, Vol. 2, #23.4: *Metallo*)

"METALLO combines a cyborg's unstoppability with the lethality of KRYPTONITE."

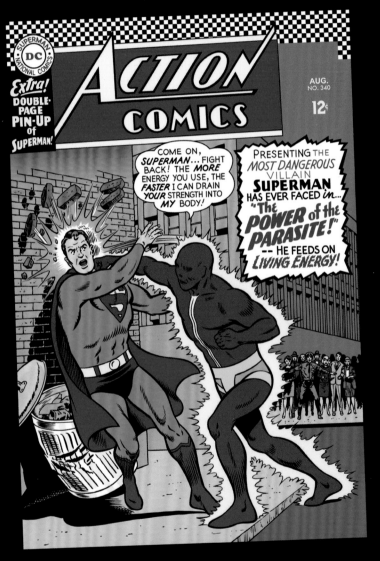

PARASITE

"Parasite's a great villain," says Mike Carlin. "He's all about sucking the power and the life force out of his victims. He has a power that is a genuine danger to Superman, and putting a character's exact opposite against them is what many, many villains are all about."

Jim Shooter and Al Plastino unveiled the Parasite in *Action Comics #340* (August 1966), presenting a ravenous foe for Superman who could never satiate his own hunger. Lab assistant Maxwell Jensen got too close to a dangerous isotope, accidentally becoming the purple-skinned, blank-faced Parasite and being forced to drain the energies from living beings. For the Parasite, the power levels possessed by the Man of Steel were the equivalent of an all-you-can-eat buffet.

The Parasite suffered an explosive overload when he gorged too deeply on Superman's bounty but eventually recovered and crawled back as a recurring foe. After 1985's *Crisis on Infinite Earths*, DC Comics reworked the character from scratch, with janitor Rudy Jones replacing Jensen in the role. The Rudy Jones Parasite had a murderous edge. His victims crumbled into skeletons after giving up their bio-energies, and over time the Parasite devolved into a shapeless, lamprey-mouthed mass. Every time he absorbed the powers of Superman, the Parasite became just as strong as the Man of Steel.

In 2009, *Superman: Secret Origin* added a touch of tragedy to the tale of Rudy Jones. Here, the unlucky janitor won the "LexCorp Lottery" and the promise of a handout from a billionaire. Instead, Jones accidentally ate an irradiated donut and doomed himself to perpetual famine.

In the New 52, the Parasite was reworked a third time. After bike messenger Joshua Michael Allen ran into a mutated blob virus on the streets of Metropolis, he walked away with an infection that triggered his transformation.

With his powers in high demand from the criminal elite, the Parasite found roles within the Secret Society of Super Villains and the Suicide Squad. The severity of the Parasite's hunger can be seen at a glance by his size and bulk.

"It's tough to find villains who can give Superman a real run for his money," says Superman writer Dan Jurgens, "but the Parasite is one of the few."

OPPOSITE: Having fed on Superman, Parasite looks for fresh prey. [Art by Dan Brown, *Superman*, Vol. 3, #23.4: *Parasite*]

TOP: Superman's heat vision is a temporary acquisition for Parasite [Art by Aaron Kuder, *Superman*, Vol. 3, #23.4: *Parasite*]

ABOVE: Parasite has always been a challenge for the Man of Steel. [Art by Curt Swan and George Klein, *Action Comics*, Vol. 1, #340]

"It's tough to find VILLAINS who can give SUPERMAN a real run for his money, but the PARASITE is one of the few."

SOLOMON GRUNDY

The undead Solomon Grundy rose from his grave in *All-American Comics* #61 (October 1944) by Alfred Bester and Paul Reinman. The corpse of the murdered Cyrus Gold was reanimated as an unkillable monster in the depths of Slaughter Swamp. Hobos at a campsite gave the muscle-bound zombie a name, inspired by a line from a nursery rhyme: "Solomon Grundy, born on a Monday."

"Grundy helps showcase the 'id' side of our heroes," says writer Fabian Nicieza. "With a certain amount of pathos and tragedy behind him, Grundy shows uncontrolled power and anger. That's good, because your hero gets the opportunity to see themselves through dark-colored glasses. It's a 'there but for the grace of God go I' situation."

Throughout the Golden Age, Solomon Grundy filled the role of antagonist for Alan Scott, the Green Lantern of the era. Because Scott's Green Lantern power ring had a weakness against wood, Grundy's body—which was partially composed of swamp detritus—proved resistant to the ring's effects.

Solomon Grundy got some TV visibility as a member of the Legion of Doom in the 1970s animated series *Challenge of the Super Friends*, and he is one of the toughest combatants in the 2013 fighting game *Injustice: Gods Among Us*. In the 1996 comics series *Batman: The Long Halloween*, Grundy prowled the sewers beneath Gotham until Batman left him a turkey dinner in an act of Thanksgiving kindness.

Heroes don't always need superpowers to take out Solomon Grundy. In *Green Arrow* #18 (December 2002), the Emerald Archer discovers that his arrows only leave Grundy bristling like a pincushion. He finally puts down the monster by choking him with his bowstring.

However, Solomon Grundy is capable of taking punches from the likes of Superman. Each time he is defeated he rises again. If he is at peace, Grundy can be a gentle giant, but he is easily angered and will attack friends and foes alike in a fugue of rage. A few kindhearted women have brought out Grundy's affectionate side, including Alan Scott's daughter, Jade.

Grundy continues to play the role of an unstoppable force. In a recent *Batman* story called "I Am Gotham" Solomon Grundy slapped down attacks from the super-powered heroes Gotham and Gotham Girl, and could only be stopped by the tactical precision of the Dark Knight himself.

"Solomon Grundy was a zombie before zombies were big," says Nicieza. "And as with all zombie stories, a good Grundy story should say more about the living than it does about the dead."

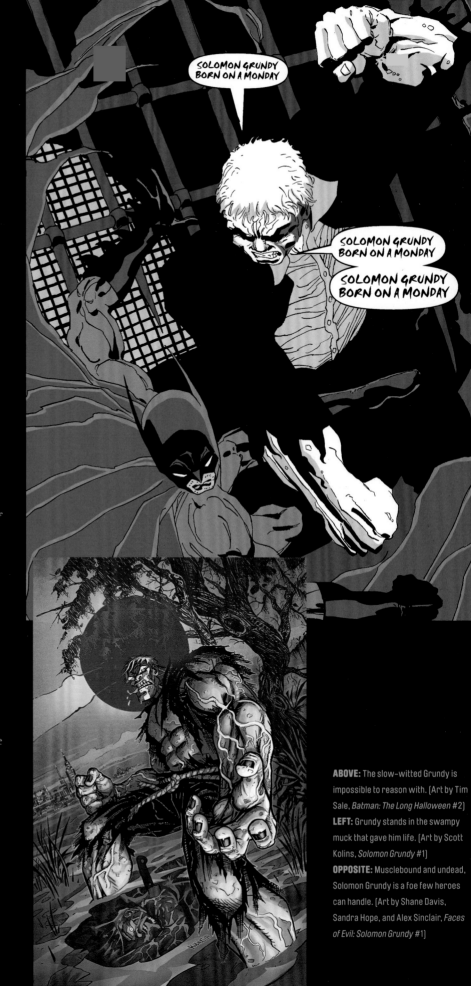

ABOVE: The slow-witted Grundy is impossible to reason with. (Art by Tim Sale, *Batman: The Long Halloween* #2)
LEFT: Grundy stands in the swampy muck that gave him life. (Art by Scott Kolins, *Solomon Grundy* #1)
OPPOSITE: Musclebound and undead, Solomon Grundy is a foe few heroes can handle. (Art by Shane Davis, Sandra Hope, and Alex Sinclair, *Faces of Evil: Solomon Grundy* #1)

AMAZO

Amazo is an android with an array of powers and a name that would sound at home in the circus. Built by Professor Ivo, Amazo can drain the superpowers from the members of the Justice League of America and use those powers against his now-helpless victims. Chalk this one up to "absorption cells," which at various times have allowed Amazo to duplicate Superman's strength and Batman's tactical brilliance.

Gardner Fox and Mike Sekowsky introduced Amazo in *The Brave and the Bold* #30 (June/July 1960), in which Professor Ivo unleashed his robot in his scheme to brew an immortality serum. Amazo easily matched the powers of Aquaman, Wonder Woman, the Martian Manhunter, The Flash, and Green Lantern, but ultimately fell prey to the teamwork of the assembled heroes.

Amazo returned in *Justice League of America* #27 (May 1964) and remained a foe of the League for decades. In *Batman* #637 (April 2005) he wound up in a Gotham City shipping crate, fighting Batman and Nightwing the instant he emerged. The Dark Knight and his former sidekick incapacitated the android by blinding him with explosive putty and disabling his gyroscopic balance with a batarang stab to the ears.

In the New 52, Amazo got a nod as the "A-Maze Operating System," part of Professor Ivo's backstory with S.T.A.R. Labs. A proto-Amazo, already smashed to pieces at the start of the issue, made his first appearance in *Justice League* #8.

The character finally received a multi-issue saga with 2015's "Amazo Virus" storyline, in which a genetically engineered LexCorp plague spread across Metropolis, triggering randomized superpowers in its citizens. Dr. Armen Ikarus, the "Patient Zero" of the outbreak, retained his power-copying abilities after the event and christened himself the new Amazo.

OPPOSITE: Infected by the Amazo virus, Dr. Ikarus becomes the biological incarnation of the classic, power-copying villain. (Art by Jason Fabok, *Justice League*, Vol. 2, #39) **LEFT:** Amazo uses every Leaguer's powers at once. (Art by Chuck Patton and Romeo Tanghal, *Justice League of America*, Vol. 1, #241) **ABOVE:** Other villains play backup when Amazo leads the charge. (Art by Mikel Janin, *Justice League*, Vol. 2, #23.4: *Secret Society*)

CYBORG SUPERMAN

Wearing a much less familiar face, the future Cyborg Superman debuted as astronaut Hank Henshaw in *The Adventures of Superman* #466 (May 1990). This self-aware take on the origin of the Fantastic Four by Dan Jurgens showed a space shuttle crew getting a lethal dose of radiation after reaching orbit. Shuttle commander Henshaw didn't escape that fate, but his ability to transfer his consciousness into computer networks left the door open for his return.

That opportunity came in 1993's "Reign of the Supermen" saga, published in the wake of Superman's death. With the Man of Steel filling a grave, four new characters took his place. Henshaw, as the Cyborg Superman, shared top billing with the hardworking hero Steel, the emotionless alien Eradicator, and the teenaged clone Superboy.

"When I created Hank Henshaw we thought it was a one-shot story, but I liked the potential so much I brought him back," explains Jurgens. "Later, when we had decided to have characters claiming to be the real Superman come back from the dead, I thought it would be a great idea if one was actually a villain who was using Superman's identity to worm his way into the hero community and betray them."

"I'm always surprised at which characters actually stick," says Mike Carlin, editor of the Superman titles during "Reign of the Supermen!" "Hank Henshaw was a one-issue storyline that was just our take on what the Fantastic Four's origin would be if it was played out a little more realistically. But for 'Reign,' everyone came in with a version of what they would do for a new Superman, and Dan Jurgens wanted to do a cyborg hybrid. We came up with the visuals before the backstories, and Hank Henshaw's ability is what led us to go back to him."

In "Reign of the Supermen," the people of Metropolis believed the Cyborg Superman might be the real deal. His metallic parts corresponded with the injuries Superman had suffered in battle with Doomsday. Henshaw, who blamed Superman for the shuttle accident that had caused his condition, encouraged the delusion and teamed up with the intergalactic tyrant Mongul to destroy Coast City.

Because Coast City was also the hometown of Green Lantern Hal Jordan, the Cyborg Superman became a Green Lantern villain too. The Cyborg Superman eventually became the Grandmaster of the android Manhunters and signed up with the Sinestro Corps to wield multiple power rings of yellow. "The Cyborg Superman has got powers on the cosmic level where the Green Lantern Corps operates," says Mike Carlin. "But because [*Green Lantern* writer] Geoff Johns liked the character and thought he could fit into the universe he was working in, that was what validated that villain."

The Cyborg Superman believes he is indestructible, and the thought terrifies him. His fervent wish is the peace of self-obliteration. His electronic immortality allows him to transfer himself into any machine, while his metallic components can morph into grasping tendrils or energy cannons. The organic sections of his body share Superman's DNA, allowing him to fly and ignore the sting of bullets.

DC Comics' New 52 continuity reboot added a shocking twist to the Cyborg Superman's origin. Brainiac, seeking a perfect instrument of his will, constructed a robotic servant after using the corpse of Zor-El—Supergirl's father—as his starting point. The new Cyborg Superman referred to itself with a single phrase: "I am perfection."

Supergirl packed her bags and moved to National City during DC's 2016 Rebirth event. The Cyborg Superman, obsessed with restoring Krypton by sacrificing the people of Earth, followed his daughter in an effort to recruit her. In a story arc titled "Reign of the Cyborg Supermen," Kara Zor-El battled her fallen father from Argo City to the Fortress of Solitude.

"There's something visually powerful about taking the Superman design—which is about hope—and subverting it to be a reflection of evil," says *Green Lantern* writer Ron Marz. "Cyborg Superman deserves not just to be in the pantheon of the great Superman villains, but of the great DC villains."

TOP LEFT: The new Cyborg Superman has even less humanity than his predecessor. [Art by Aaron Kuder, *Action Comics*, Vol. 2, #23.1: *Cyborg Superman*] **LEFT:** Never wholly organic, the Cyborg Superman is an unsettling sight. [Art by David Lapham and Mike Machlan, *Superman Annual*, Vol. 2, #5] **OPPOSITE:** Kryptonian biology and alien circuitry give the Cyborg Superman a remarkably unique power set. [Art by Brian Ching, *Supergirl*, Vol. 7, #1]

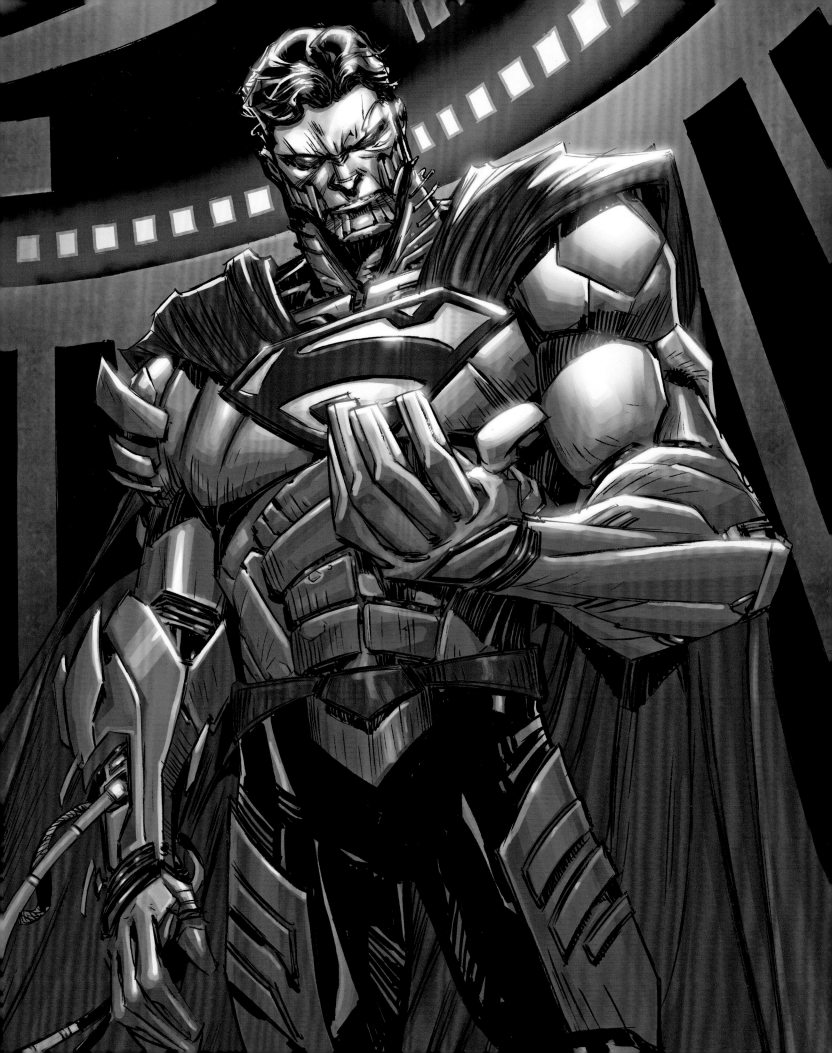

KILLER FROST

Killer Frost is a heat vampire who drains the life forces of others to sustain a body that is in a perpetual state of hypothermia. Several women have played the part of Killer Frost, but all of them have polar-blue skin and lips that can freeze with a kiss.

"She has a great, classic look, as she appears to be made of frost and ice," says *Fury of Firestorm* writer Dan Jurgens. "There's also the idea that opposites attract. When it comes to Firestorm, that becomes a case of fire and ice." Killer Frost's unique power set made her a natural choice for inclusion in the 2013 video game *Injustice: Gods Among Us*.

The original Killer Frost debuted in *Firestorm #3* (June 1978). Crystal Frost, a lovesick student accidentally locked inside a thermafrost chamber, perfected the ability to absorb heat from her victims and fire barrages of piercing icicles. Firestorm faced a second Killer Frost, Dr. Louise Lincoln, in *Fury of Firestorm #35* (May 1985).

In the New 52, Dr. Caitlin Snow was a S.T.A.R. Labs scientist assigned to work on a perpetual energy generator at a remote arctic outpost. Her colleagues finally revealed themselves as H.I.V.E. agents and arranged for her death in a reactor explosion. Instead, Dr. Snow emerged as Killer Frost, killing her tormenters before returning home to Pittsburgh in a quest to satiate her hunger.

Firestorm is the only being in the universe who can generate enough energy to keep Killer Frost satisfied. Dr. Snow has tried to duplicate the effect artificially, but for now the battles between Killer Frost and the Nuclear Man are essential to her survival.

"Caitlin Snow was a brilliant scientist until the accident," says Sterling Gates, who wrote "Freezing to Death," a Killer Frost spotlight issue of *Justice League of America*. "Now all she has are her cryokinetic powers. That's how she takes the hunger away and warms the chill in her heart."

ABOVE: By using icicles as daggers, Killer Frost remains a formidable foe. [Art by Derlis Santacruz, *Justice League of America*, Vol. 3, #7.2: *Killer Frost*]

OPPOSITE: Killer Frost's touch is incompatible with life's vital heat. [Art by Derlis Santacruz. *Justice League of America* #7.2: *Killer Frost*]

"FIRESTORM is the only being in the universe who can generate enough **ENERGY** to keep Killer Frost **SATISFIED."**

ABOVE: A mindless Chemo attempts to squash Superman. [Art by Mike Wieringo and Jose Marzan Jr., *Adventures of Superman*, Vol. 1, #593]

OPPOSITE TOP: The gurgling chemical stew that is Chemo holds its shape through the use of clear containment modules. [Art by Ivan Reis, Joe Prado, and Scott Hanna, *Justice League*, Vol. 2, #28]

OPPOSITE BOTTOM: Chemo is the secret weapon for this group of villains. [Art by George Pérez and Jerry Ordway, *Crisis on Infinite Earths* #9]

CHEMO

The lurching embodiment of environmental disaster, Chemo came of age during an era of rapid scientific advancement. Debuting in *Showcase* #39 (July/August 1962), Chemo seemed to be a fitting foe for the similarly artificial Metal Men.

"He's a jar with chemicals in him," Mike Carlin points out. "They were trying to come up with a science background for everything in the [Metal Men] series to go up against the robots, who were a new technology themselves. They were going through the periodic table for villains. The Metal Men were going up against gasses, or robots from outer space who were made of different metals than we have on Earth. So chemicals vs. robotics? It was just a different area of science."

Chemo came to life when a scientist used a human-shaped plastic container to hold discarded laboratory brews. The strange liquids sloshing around inside Chemo's interior allowed him to change his size or spew a toxic spray at his foes. With negligible intelligence, Chemo couldn't be reasoned with and could take a tremendous beating before cracking.

In 1985, *Crisis on Infinite Earths* showed just how big a natural disaster Chemo could cause. Brainiac and Lex Luthor unleashed Chemo on the New York City of a parallel world, where he poisoned the land and fouled the harbor within minutes.

"Chemo got nasty when he poisoned the ocean during *Crisis*," says Scott Beatty, writer of *Joker: Last Laugh* in which the world's super-villains become the Joker's chemically-altered lackeys. "During *Last Laugh*, Chemo was a convenient plot contrivance. He's a giant jar full of toxic chemicals, and while we couldn't "Jokerize" Chemo like he did the other villains, we could use him to spread the Joker love."

Infinite Crisis (2005) found a similar role for Chemo. The Secret Society of Super Villains dropped the liquid golem on Gotham City's neighboring Blüdhaven. Radioactive sludge rendered everything inside the Blüdhaven city limits unfit for human habitation.

Chemo got a new origin in a 2014 issue of *Justice League*, which also introduced the Metal Men—robotic shape-shifters who first appeared in 1962's *Showcase #37*—into DC's New 52 continuity. In this tale, Chemo emerged from a vat of toxic waste after a thief tossed a "responsometer" (the same device that animates the Metal Men) into its murky depths.

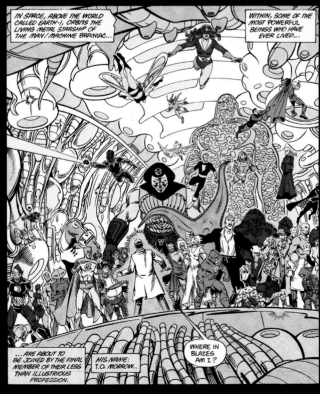

10) STRENGTH IN NUMBERS

If a single villain is enough to pose a threat, how can any hero handle a horde? In response to the Justice League and other super-heroic team-ups, villains have formed their own cabals of might and menace. Fortunately for the side of law and order, feuding egos often lead to self-sabotage.

"We want to create challenges that are greater than the heroes can face on their own," says Dan DiDio. "When you put a lot of villains together it becomes more fun. Plus, when you have a villain who normally fights a particular hero, and match the villain with somebody else, in those mix-and-matches you see how unique the characters are regardless of who they fight."

OPPOSITE: Ultraman and the Crime Syndicate—Johnny Quick, Owlman, Deathstorm, Power Ring, and Superwoman—conquer another planet. (Art by Ivan Reis, Joe Prado, Oclair Albert, and Eber Ferreira, *Justice League*, Vol. 2, #23)

CRIME SYNDICATE

In a dark reflection of our own universe, parallel versions of Superman and Batman serve as global dictators while heroes such as Luthor and the Joker lead the resistance against their rule. The concept has proven popular since *Justice League of America* #29 (August 1964) introduced the Crime Syndicate as the evil Justice League of this mirror Earth.

Its members are doppelgangers of familiar heroes, but with their qualities inverted or exaggerated to frightening extremes. Ultraman, Superman's counterpart, is a merciless tyrant. Superwoman is his cold-hearted queen and serves as Wonder Woman's duplicate. Owlman stands in for Batman and wages war against the police. The Flash of their world is Johnny Quick, a morally bankrupt thrill-killer. Power Ring proves himself to be Green Lantern's opposite with his terror at the prospect of wielding cosmic energy.

"I think the Crime Syndicate is a rich source of stories," says Kurt Busiek, who brought in the antagonists to star in "Syndicate Rules," a 2004–2005 run on *JLA*. "A lot of villain team-ups feel like a random collection of bad guys, but the Crime Syndicate is a strong, powerful, resonant concept."

The original Crime Syndicate came from a world that disappeared from DC Comics' continuity following 1985's *Crisis on Infinite Earths*. A 1999 restart for the Crime Syndicate placed them on an antimatter Earth.

In the New 52, the Crime Syndicate found a way to escape the corrupt Earth-3 thanks to the magical energies of Pandora's Box. After eliminating the Justice League, the Crime Syndicate emerged from the dimensional portal and laid claim to Prime Earth as their new kingdom. This kicked off *Forever Evil*, the crossover event of 2013–2014.

Their scheme failed, and the Crime Syndicate's members scattered. During 2016's "Darkseid War" event, Superwoman, Owlman, and a few remaining Syndicate loyalists joined forces to stop the Anti-Monitor from erasing all of existence.

"They're twisted mirror versions of the Justice League, coming from a world where crime is king," says writer Sterling Gates. "And it seems nothing can stop their reign."

BELOW: The Crime Syndicate prepares for its takeover of Earth. (Art by Ivan Reis, Joe Prado, Oclair Albert, and Eber Ferreira, *Justice League*, Vol. 2, #23)

OPPOSITE: Tensions between the members of the Crime Syndicate run high. (Art by David Finch and Richard Friend, *Forever Evil* #1)

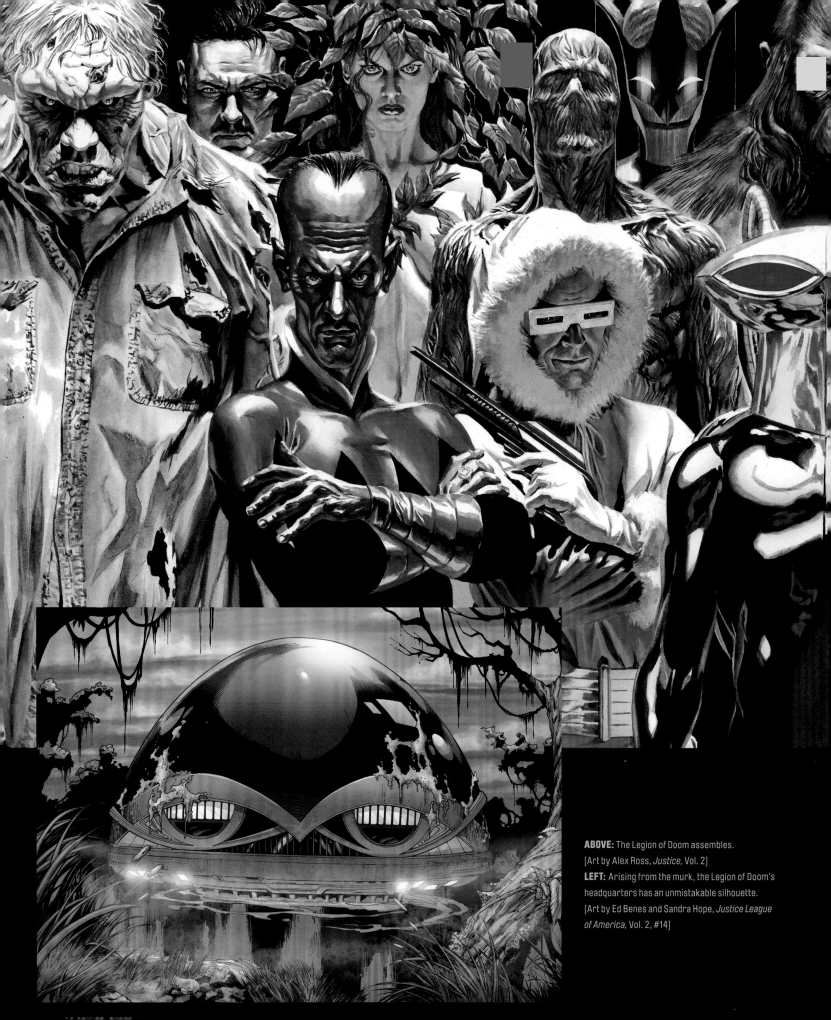

ABOVE: The Legion of Doom assembles.
[Art by Alex Ross, *Justice*, Vol. 2]

LEFT: Arising from the murk, the Legion of Doom's headquarters has an unmistakable silhouette.
[Art by Ed Benes and Sandra Hope, *Justice League of America*, Vol. 2, #14]

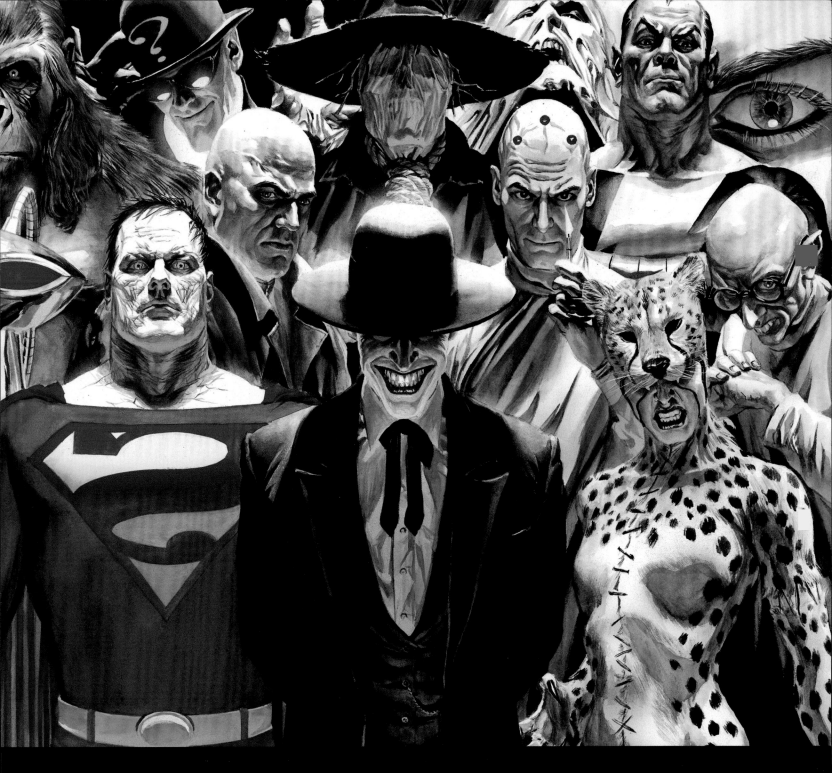

LEGION OF DOOM

The 1970s animated series *Challenge of the Super Friends* popularized the Legion of Doom, and since then the grouping has made sporadic appearances in comics. A notable reinterpretation of the Legion of Doom came in the 2005 miniseries *Justice*, written and illustrated by Alex Ross.

The Legion of Doom's headquarters is the menacing Hall of Doom, a skull-shaped edifice that rises from the murky waters of a remote swamp.

Membership in the Legion is given to some of the most recognizable villains of the DC Universe: Lex Luthor, Sinestro, Solomon Grundy, Bizarro, Giganta, the Riddler, Brainiac, Captain Cold, Toyman, Scarecrow, Cheetah, and Black Manta. In *Justice*, the extended roster included Clayface, Parasite, Poison Ivy, Metallo, and Black Adam.

INJUSTICE LEAGUE

As the Justice League's titular opposite, this grouping of villains defines itself by the ideological distance from its counterparts. As the Injustice Gang, the team took shape in *JLA* #10 (September 1997) under the joint leadership of Lex Luthor and the Joker.

Luthor gave it another go in *Justice League of America* #13 (November 2007), uniting dozens of villains under his command by offering mutual protection from Super Hero harassment. The Joker served as second-in-command, with prominent leadership roles offered up to Cheetah, Gorilla Grodd, Parasite, Poison Ivy, and Killer Frost.

More crooks signed on to the team, which now called itself Injustice League Unlimited, but Luthor's power play didn't last. The U.S. government sent operatives to round up most of the villains and ship them into exile on a jungle planet, an ordeal chronicled in the series *Salvation Run*.

LEFT: Lex Luthor's Injustice Gang. (Art by Howard Porter and John Dell, *JLA* #11)

BOTTOM: Luthor leads the expanded Injustice League. (Art by Joe Benitez and Victor Llamas, *Justice League of America*, Vol. 2, #13)

OPPOSITE: Luthor's latest team, assembled to oppose the Crime Syndicate. (Art by David Finch and Richard Friend, *Forever Evil* #3)

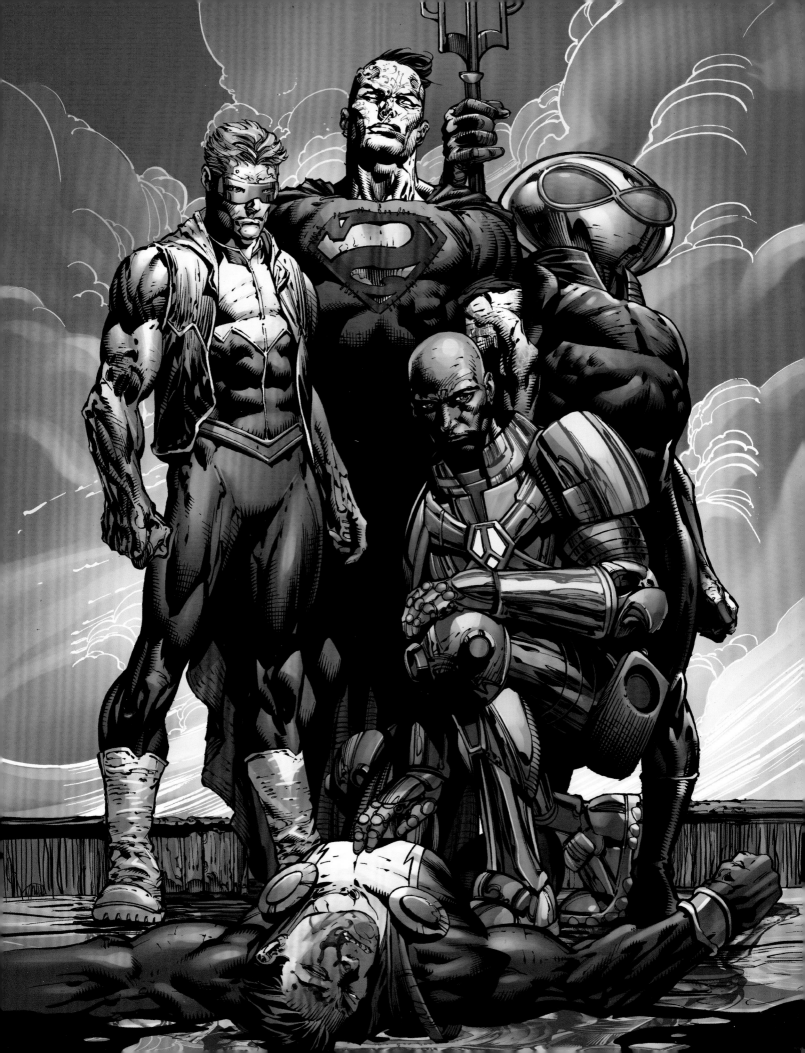

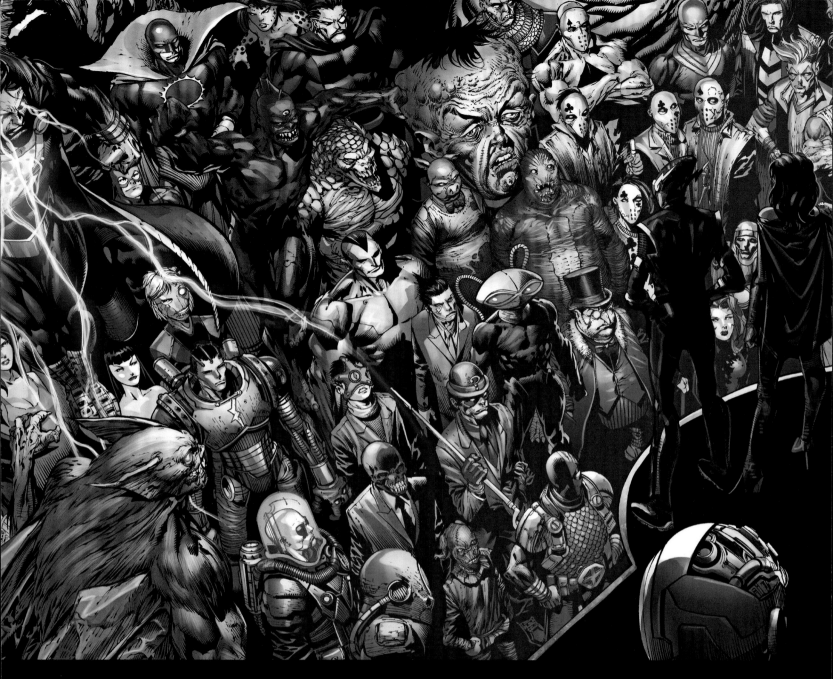

THE SECRET SOCIETY OF SUPER VILLAINS

This criminal consortium got a series of its own with *Secret Society of Super Villains* #1 (May/June 1976). Founded by Darkseid to enact mayhem on a global scale, the assemblage included members such as Captain Cold, Gorilla Grodd, Star Sapphire, and Sinestro.

"Fans react very positively when you put characters together you normally wouldn't see working together," says Dan DiDio. "I was a big fan of *Secret Society of Super Villains* when that book was introduced in the '70s. When I got to DC, that was one of the things I wanted to do: reintroduce the Society. And we did it during the lead-in to *Infinite Crisis.*"

The new Society counted nearly every villain on Earth among its number. Its directors included Doctor Psycho, Deathstroke, Talia al Ghūl, Black Adam, and a Lex Luthor later revealed to be the alternate-universe imposter Alexander Luthor Jr. The Society showed off its stuff in 2005's *Villains United*. In the subsequent series *Infinite Crisis*, the Society clashed with an army of heroes in a knockdown brawl set amid downtown Metropolis.

In the New 52 continuity, the Society is the name by which the Crime Syndicate refers to its legion of loyalists. Villains who pledge to serve the Crime Syndicate receive a coin as a token of their membership, while those who refuse their invitations are hunted down as traitors.

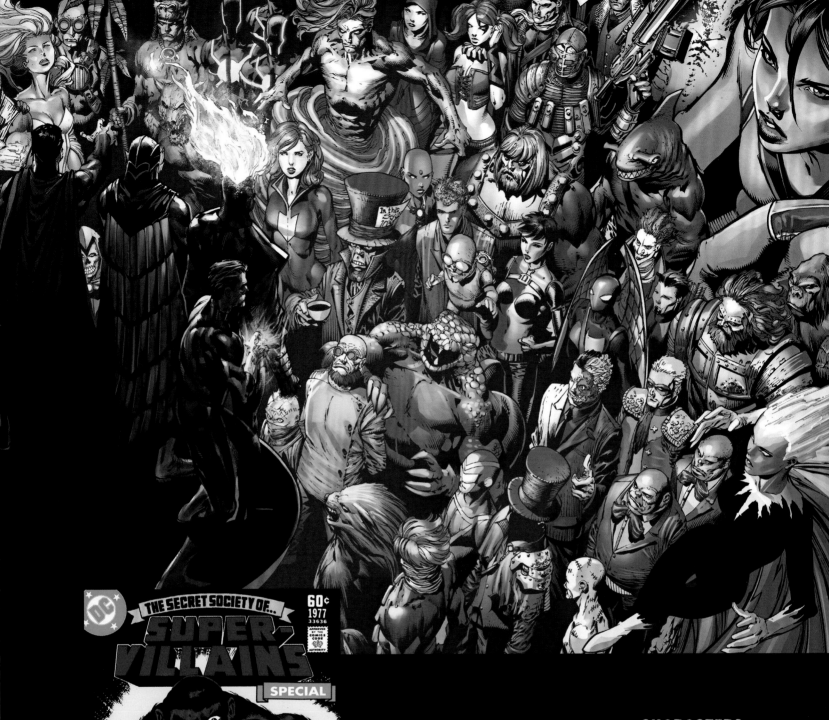

"Fans react very POSITIVELY when you put CHARACTERS together you normally wouldn't see WORKING TOGETHER."

ABOVE: The Secret Society of Super Villains brings together some of the most malevolent characters in the DC Universe. [Art by David Finch and Richard Friend, *Forever Evil*, Vol. 1, #1]

LEFT: Our heroes are almost undone by the might of the Secret Society of Super Villains in this classic issue. [Art by Rich Buckler and Jack Abel, *DC Special Series*, Vol. 1, #6]

SECRET SIX

A half-dozen operatives who performed missions for the mysterious Mockingbird comprised the titular team at the time of its debut in *Secret Six* #1 (April/May 1968). A 1980s revival continued the secret agent template, but in the 2000s the team found new life as a showcase for B-list villains and the dysfunctional family dynamics that united them.

Deadshot, Catman, Cheshire, Ragdoll, Scandal Savage, and Parademon became the new Secret Six in *Villains United* #1 (July 2005), written by Gail Simone. At first the team had its own Mockingbird (later revealed as Lex Luthor), but the refusal of the Secret Six to sign on with the Secret Society of Super Villains marked its members for death.

Their trial by fire persuaded the surviving members to stick together. A *Secret Six* limited series brought fresh characters into the rotation including Knockout, the Mad Hatter, and Harley Quinn.

DC Comics launched a *Secret Six* ongoing series in September 2008. Deadshot, Catman, Scandal Savage, and Ragdoll returned, joined by new character Jeanette and Batman's muscular nemesis Bane. Despite attracting hostility from heroes and villains alike, the Secret Six's teammates found personal validation within their weird fellowship. The series ran for thirty-six issues.

The crew returned in late 2014 for an all-new series set within DC's New 52 continuity. With the Riddler as the mastermind behind the team's formation, the Secret Six now included newcomers like Strix, Porcelain, and a female version of Ventriloquist.

"They don't see themselves in that fashion, not as villains," explains Dan DiDio. "The Secret Six might be driven by self-interest, but they also have good things they accomplish along the way. They walk the line between hero and villain."

> ## "The SECRET SIX might be driven by SELF-INTEREST, but they also have good things they ACCOMPLISH ALONG THE WAY."

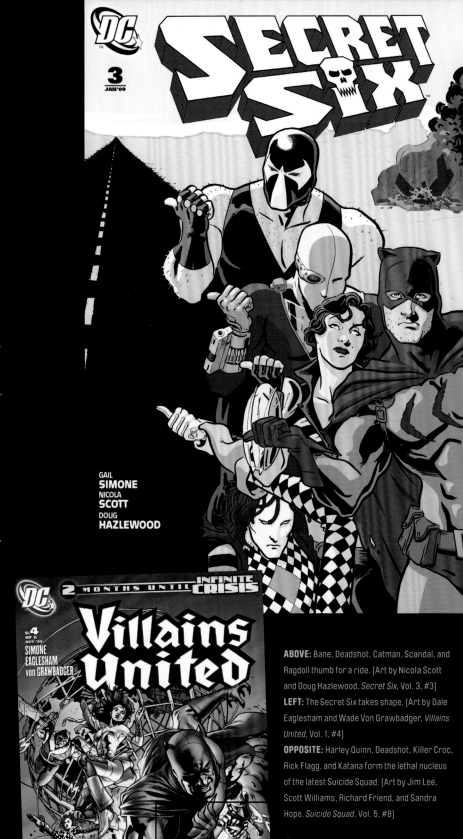

ABOVE: Bane, Deadshot, Catman, Scandal, and Ragdoll thumb for a ride. [Art by Nicola Scott and Doug Hazlewood, *Secret Six*, Vol. 3, #3]

LEFT: The Secret Six takes shape. [Art by Dale Eaglesham and Wade Von Grawbadger, *Villains United*, Vol. 1, #4]

OPPOSITE: Harley Quinn, Deadshot, Killer Croc, Rick Flagg, and Katana form the lethal nucleus of the latest Suicide Squad. [Art by Jim Lee, Scott Williams, Richard Friend, and Sandra Hope. *Suicide Squad*, Vol. 5, #8]

SUICIDE SQUAD

The 2016 *Suicide Squad* movie showed audiences that, in a world populated with Men of Steel and Dark Knight Detectives, sometimes it's fun to root for the bad guys. This big-screen adaptation included a surprisingly deep bench of DC Comics characters, including Deadshot, Harley Quinn, Captain Boomerang, El Diablo, the Enchantress, Killer Croc, Katana, Slipknot, and square-jawed military overseer Rick Flag.

Most of these characters—including their leader, morally ambiguous government operative Amanda Waller—were already familiar to fans exposed to the Squad's comic book adventures over the previous 30 years. Created by writer John Ostrander, the Suicide Squad debuted in 1987 and its self-titled comic continued into the early '90s. (An unrelated group also known as Suicide Squad had appeared in a half-dozen issues of *The Brave and the Bold* during the 1950s). Ostrander's crew immediately won infamy as incarcerated criminals working toward governmental pardons—provided they could pull off hazardous missions against impossible odds.

Not every character survived their time with what the US government officially called "Task Force X," their deaths providing a dash of realism and supporting the implied premise of the title. Some of those who lived, Deadshot and Captain Boomerang in particular, became breakout stars.

The series that debuted in 1987 reached its end with issue #66, but the Suicide Squad popped up in other comics until a new standalone series arrived in 2001. This version of the Squad operated with the blessing of Lex Luthor, who was president of the United States at the time.

Ostrander returned to the team in 2007 for an eight-issue miniseries, and in 2011 the Squad saw its New 52 debut. After a successful run, the team experienced another relaunch as part of DC's Rebirth event, which lined up neatly with the squad's foray into theaters. This incarnation boasted a lineup strongly influenced by the team's cinematic portrayal, with Deadshot, Harley Quinn, Killer Croc, Katana,

EPILOGUE

DC Comics' super-villains have been shaped by thousands of creators and loved by millions of fans. They're not just characters, they're icons, and in this role their ultimate goal isn't to defeat their archnemeses or even to rule the universe: It's to achieve pop culture immortality.

"All creators like the characters they create," says Mike Carlin. "But characters don't really become major players until another writer or artist hooks onto that character, and runs with it on their own."

That act of passing the torch from creator to creator has allowed DC's villains to become more and more compelling under each new set of hands. Collaboration and consistency, tradition and innovation. Through this formula, these villains have remained dangerous through the decades.

No matter whether it's the Joker or Giganta, Deadshot or Doomsday—narrative fiction requires certain outcomes. The villain's triumphs will always prove short-lived. The evil scheme inevitably crumbles at the eleventh hour, and the Super Hero is certain to rally from the brink of defeat.

But in readers' imaginations, the villains live on, never to be forgotten. So don't feel too bad for the bad guys. They've already won.

OPPOSITE: The DC Universe's heroes are mirrored by their dark counterparts in this piece by Alex Ross.

[Art by Doug Braithwaite and Alex Ross, *Absolute Justice*]

www.insightcomics.com

Find us on Facebook: www.facebook.com/InsightEditions

Follow us on Twitter: @insighteditions

Published by Insight Editions, San Rafael, California, in 2017. No part of this book may
be reproduced in any form without written permission from the publisher.

Library of Congress Cataloging-in-Publication Data available.

ISBN: 978-1-68383-012-2

PUBLISHER: Raoul Goff
ACQUISITIONS MANAGER: Robbie Schmidt
EXECUTIVE EDITOR: Vanessa Lopez
SENIOR EDITOR: Chris Prince
ART DIRECTOR: Chrissy Kwasnik
DESIGNERS: Jon Glick & Chrissy Kwasnik
PRODUCTION EDITOR: Rachel Anderson
PRODUCTION MANAGER: Jane Chinn
EDITORIAL ASSISTANTS: Elaine Ou & Kathryn DeSandro

Cover Art by Frank Cho
Endpaper art by Phil Jimenez

INSIGHT EDITIONS would like to thank Josh Anderson, Scott Beatty, Kurt Busiek,
Mike Carlin, Dan DiDio, Marco DiLeonardo, Chuck Dixon, Romulo Fajardo Jr.,
Lisa Fitzpatrick, Patrick Flaherty, Sterling Gates, Van Jensen, Phil Jimenez,
Dan Jurgens, Kevin Kiniry, Steve Korte, Christopher Kosek, Jim Lee, Ron Marz,
Peter Milligan, Fabian Nicieza, Elaine Piechowski, Ethan Van Sciver,
Adam Schlagman, Kevin Smith, John Wells, Marv Wolfman, and Yousef Ghorbani.

 REPLANTED PAPER

Insight Editions, in association with Roots of Peace, will plant two trees for each tree
used in the manufacturing of this book. Roots of Peace is an internationally renowned
humanitarian organization dedicated to eradicating land mines worldwide and
converting war-torn lands into productive farms and wildlife habitats. Roots of Peace
will plant two million fruit and nut trees in Afghanistan and provide farmers there
with the skills and support necessary for sustainable land use.

Manufactured in China by Insight Editions

10 9 8 7 6 5 4 3 2 1